Digital Plant Photography

Adrian Davies

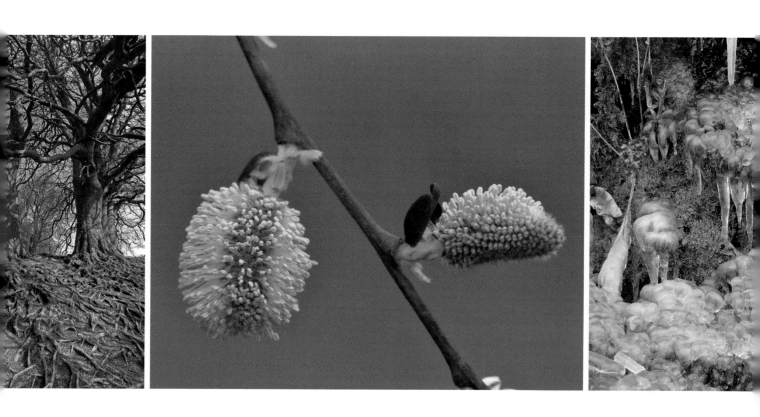

B L O O M S B U R Y

LONDON · NEW DELHI · NEW YORK · SYDNEY

Digital
Plant Photography

Adrian Davies

Contents

First published in 2013

Copyright © 2013 text by Adrian Davies
Copyright © 2013 photographs by Adrian Davies

The right of Adrian Davies to be identified as the author of this work
has been asserted by him in accordance with the Copyright,
Designs and Patents Act 1988.

Bloomsbury Publishing Plc, 50 Bedford Square, London WC1B 3DP

www.bloomsbury.com

Bloomsbury Publishing, London, New Delhi, New York and Sydney

A CIP catalogue record for this book is available from the British Library

Commissioning Editor: Jim Martin
Project Editor: Jasmine Parker
Design by Rod Teasdale, White Rabbit Editions

ISBN (print) 978-1-4081-7129-5

Printed in China by C&C Offset Printing Co Ltd.

This book is produced using paper that is made from wood grown
in managed sustainable forests. It is natural, renewable and recyclable.
The logging and manufacturing processes conform to the environmental
regulation of the country of origin.

10 9 8 7 6 5 4 3 2 1

BELOW Rose hip. Seeds and berries and other fruits make great subjects for photography. One of my favourites are roses and their hips, which come in a huge variety of shapes and colours. This one is *Rosa roxburghii*, growing in the rose garden of a large botanic garden. I have deliberately included some leaves as a frame for the hip.

105mm macro lens, 1/60 sec at f/8

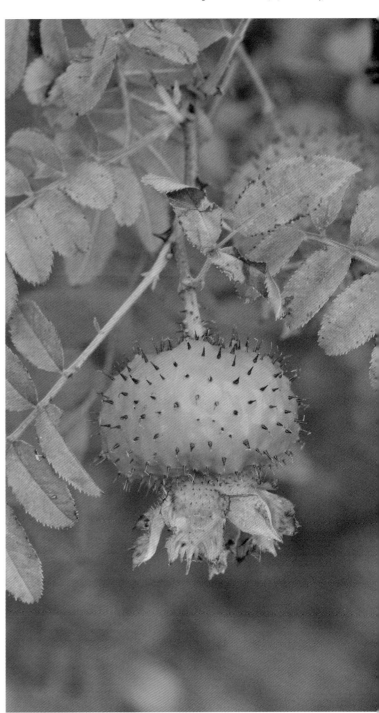

Introduction

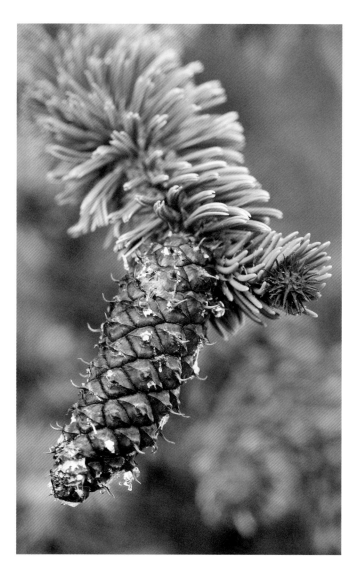

Since the invention of photography, photographers have used plants (usually flowers) as subjects for their cameras. In fact, the first book to be illustrated with photographs (Fox Talbot's *Pencil of Nature*, published in 1844) had images of flowers, ferns and other plant materials.

Plants are found in all habitats on earth, from the highest mountains to the deepest oceans, range in size from the largest trees to the smallest mosses, and include the oldest life forms on earth (such as the Bristlecone Pines of California).

Some species growing today are virtually identical to those living 200–300 million years ago, such as the Ginkgo tree (*Gingko biloba*). Fossil plants make interesting subjects, such as the fossil forest shown here.

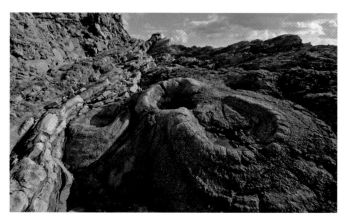

ABOVE AND LEFT Great Basin Bristlecone Pine trees (*Pinus longaeva*) in the White Mountains of California are amongst the oldest living organisms on the planet. The image of the cones shows why they are called bristlecones!

Cones: *90mm lens, 1/30 sec at f/4 in heavy rain*

Tree: *17–55mm lens at 32mm, 1/60 sec at f/11*

ABOVE Fossil forest, Lulworth Cove, Dorset, England. I used a wide-angle lens close to this fossil tree stump to show it in its environment on a cliff in the Jurassic coast of southern England.

10–24mm lens at 16mm, 1/500 sec at f/11

RIGHT Ginkgo fossil with leaf. I photographed this fossil of a Gingko tree dating back to the Eocene period, with a leaf from a living tree to try to show just how little the species has changed, other than in size. It was photographed on a table in the garden using diffuse sunlight, against a background of black velvet.

105mm macro lens, 1/125 sec at f/11

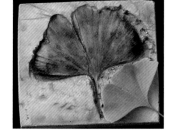

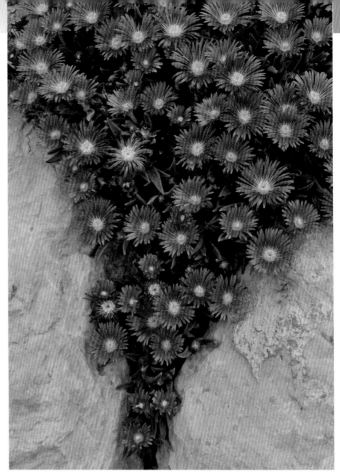

RIGHT This stunning Ice Plant (*Delosperma brunnthaleri*) was photographed in the alpine house of a botanic garden. I loved the contrast, both colour and texture, between the flowers and the sandstone rock over which the plant grew. I took great care to align the camera parallel with the plant to gain maximum depth of field.

17–55mm lens at 44mm, 1/60 sec at f/16

Plants and especially flowers are among the most popular photographic subjects. Many photographers will set themselves projects, such as photographing all British native orchids, or photographing poisonous and edible plants. Other photographers are less interested in cataloguing species but are attracted to plants for their shape, structure, form or colour. There are some plant groups greatly under-represented by photographers, such as lichens, liverworts, ferns and mosses, and these can make great, if challenging, subjects. I have made a great effort to include as many different types of plant and plant photography techniques in this book as possible.

As with most forms of photography, the weather's unpredictability can make or break a plant photography expedition. Bad weather may supply wonderful stormy skies, or wash out a journey entirely. Several of the images planned for this book were not possible due to the high rainfall experienced in the UK during the early part of 2012.

It might be thought that photographing plants should be one of the easier forms of nature photography, and in one sense it is – they don't run or fly away like birds or insects when you get too close. However, they often grow in difficult terrain, where wind may cause them to move continuously.

These practicalities aside, taking pictorially interesting and informative images of plants can be just as difficult as other forms of nature photography, and will require patience, perseverance and attention to detail. While many images can be obtained with simple cameras, good plant photography will often require a selection of lenses and other equipment, and this will be discussed in chapter one. Luck will play a part too – finding the right specimen in the right place with the right light.

When shooting colour transparency film it was often very difficult to achieve the right colour of some plants, in particular blue and purple flowers, or brown seaweeds for example. The situation with digital cameras is much better. It is far easier now to achieve the right colour, and this will be discussed in various sections throughout the book.

As with any photographic image, the background is just as important as the subject, either providing a non-distracting canvas on which to display the main subject, or to add extra information to the image. Control of depth of field is one of the key skills a plant photographer needs to acquire.

This book will deal with the photography of all plant types (and also fungi, which are not, under the strictest biological definition, plants, but which do conveniently fall into the same category for most purposes). It will look at the equipment and accessories required for good plant photography, for both biologically informative images as well as more creative, pictorial images.

It will look at both wild plants in their habitats and cultivated plants in gardens, as well as various studio techniques. For all plants discussed in the text, the scientific name is given on the species' first mention.

Equipment

Digital photography has opened up a wealth of possibilities previously unimaginable in the days of film. There is a plethora of cameras, lenses and other equipment on the market to meet all needs and budgets, and being able to make an informed choice about what equipment will best meet your needs is important in the route to taking great pictures.

Digital cameras

There is no such thing as the perfect camera for photographing plants. Your choice will depend on a number of factors including weight and portability, price, and ultimate use of the images. If you enjoy climbing mountains, looking for alpines in their natural habitat, a DSLR with a range of lenses will probably not be practical.

With the plethora of models on the market, and new technologies becoming available all the time, generalisations are difficult, but I will here outline those cameras, and features, that I have found most useful for my plant photography.

CAMERA TYPES

There are three main types of digital camera commonly used for plant photography: compact cameras with a built-in lens, more advanced 'bridge' cameras with a built-in lens that usually has a large zoom range, and digital single lens reflex (DSLR) cameras, which are interchangeable lens systems. There are several variants, including the relatively new mirrorless interchangeable lens camera systems, and the boundaries between the various types are becoming increasingly blurred.

RIGHT I love the way plants seem to be able to grow almost anywhere. This Polypody fern (*Polypodium vulgare*) was growing from a seemingly sterile mass of iron pipework at an old pumping station on Dartmoor, England.

70–200mm lens at 100mm, 1/30 sec at f/6.3

PIXELS

The image sensor in the camera, usually either a CCD or CMOS device, contains a grid of millions of light-sensitive cells called pixels (short for 'picture elements'). Each pixel acts like a light meter, measuring not only the amount of light falling on it, but also the colour, by means of a system of overlaid colour filters. While the number of pixels is a good indicator of image quality, there will be other factors which contribute, such as the quality of the lens, and the processing applied to the image data after capture.

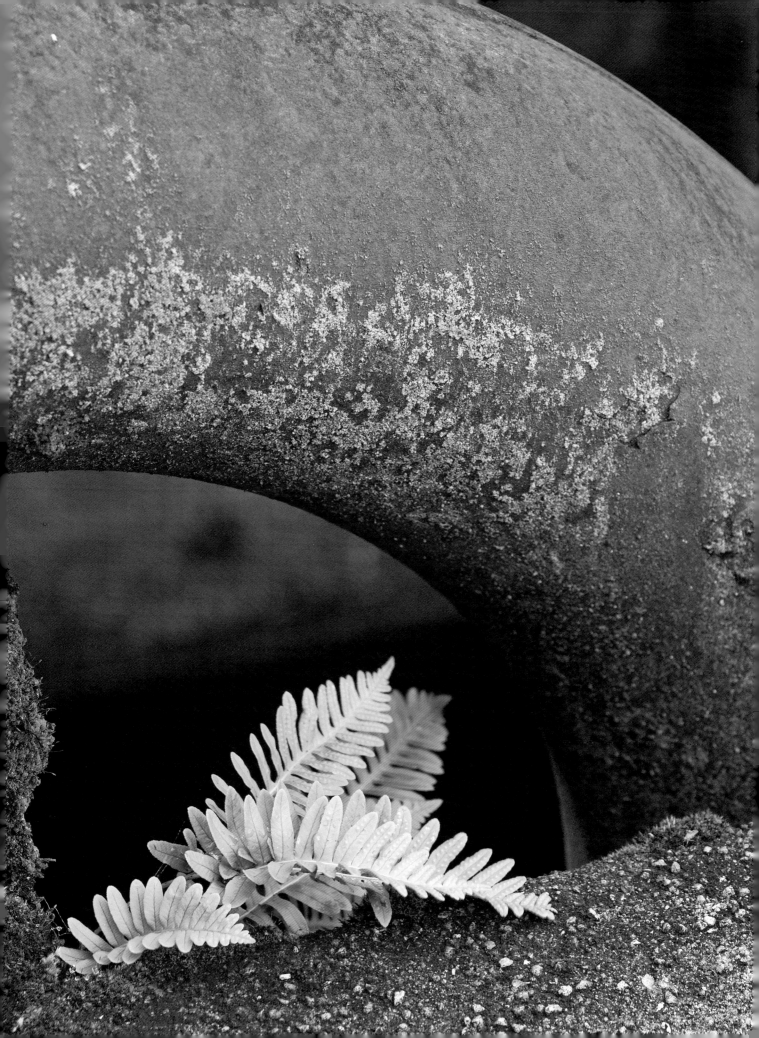

COMPACT CAMERAS

As the name implies, compact cameras are small and portable, and many are capable of outstanding results. It is always worthy carrying one in your pocket to capture unexpected subjects. Most models today do not have a separate viewfinder – composing the image is done on the LCD screen on the rear of the camera. This can often be difficult to see in bright light, and it is not always easy to see small distracting items in the frame. Models with viewfinders do tend to be at the top end of the price range, but I would recommend these.

Due to the small size of the sensor in compact cameras (see section on depth of field in Close-up and macro photography), controlling depth of field can be tricky. It is often difficult to achieve shallow depth of field to throw a background out of focus, for example. Compacts are, however, generally excellent for close-up and macro photography.

ABOVE Compact cameras without viewfinders are good for general views such as the Bluebell (*Hyacinthoides non-scriptus*) wood on the screen, but for more exacting work I would definitely recommend an optical viewfinder.

BELOW Compact camera with optical viewfinder.

A potential problem with compact cameras is that of 'shutter lag', where there is a distinct delay between pressing the shutter button and the exposure being made. This is not a problem with static subjects, but can be annoying if your subject moves in between the time you press the shutter release and the shutter actually opening.

BRIDGE CAMERAS

A bridge camera is a single lens reflex, without the facility of interchangeable lenses. One potential issue with interchangeable lens systems is that of dust entering the camera body and falling onto the sensor. By sealing the lens and camera body, this issue is negated. Most models do have large zoom ranges, covering most of the subjects you are likely to want to photograph. The viewfinder on this type of camera is electronic – in effect a video image of the subject, which can be coarser than the optical system in a DSLR.

MIRRORLESS INTERCHANGEABLE-LENS CAMERAS

This is a relatively new type of camera, intermediate between the compact and DSLR. This type is basically a compact with interchangeable lenses. It thus has many of the advantages and disadvantages of each type. The body is small and compact, but most of the models have no viewfinder. Extra viewfinders can be attached to some models. Some are based on a reflex viewing system, with an electronic viewfinder.

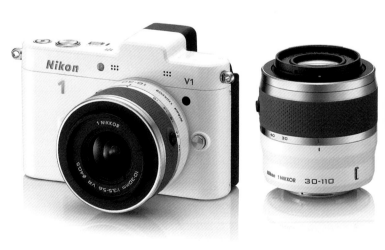

ABOVE One of the new generation of small interchangeable lens cameras, which either have a built-in viewfinder, or the facility to add one.

The sensor sizes vary according to the manufacturer, from the APS-C size used in Sony and Samsung cameras, to the Micro Four Thirds system, used by Panasonic for example. Nikon announced the 'One' system based on a smaller sensor in 2011.

A huge range of lenses, including those from film cameras and even old cine cameras, can be fitted to some models, via appropriate adapters.

DIGITAL SINGLE LENS REFLEX

By far the most versatile camera for plant photography is the DSLR, with its facility for interchangeable lenses, and numerous other accessories. There is no doubt that most DSLRs are bulkier and heavier than compacts, but as far as I am concerned that is a small price to pay for the increased versatility they offer. In my experience their viewfinders are much brighter and sharper than other camera types.

One important issue with DSLR cameras is whether to opt for a 'full frame' or cropped sensor. Essentially, a full frame digital sensor is the same size as 35mm film – 24 x 36mm. Several other sizes of sensors are available, usually in the region of 16 x 24mm. The main deciding factor is the ultimate purpose of the image. Will the images be used in presentations, or exhibition prints up to around A3, or do you aspire to double-page spreads in glossy magazines for example? Generally you will get better quality from a full frame sensor, though in most instances the difference will be negligible. Some lenses are designed specifically for cropped sensors (such as Nikon DX lenses) and will not cover the whole frame if used with a full frame sensor.

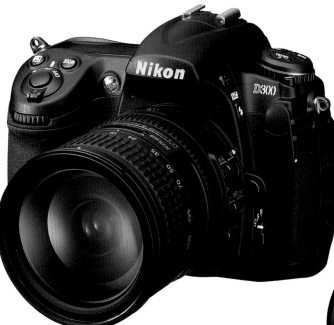

ABOVE A typical digital single lens reflex (DSLR) camera.

RIGHT The rear of a DSLR showing the viewfinder and image review screen.

AVOIDING SENSOR DUST

As mentioned above, interchangeable lens systems can suffer from dust on the sensor – the smallest speck of dust may cover several pixels. Whenever you change lenses, make sure the camera is switched off (when the camera is on there is a static charge on the surface of the sensor which may attract dust), and always try to change lenses in a sheltered spot, away from strong wind. If you do get dust on your sensor, there are numerous cleaning kits on the market, or manufacturers and other companies offer a cleaning service.

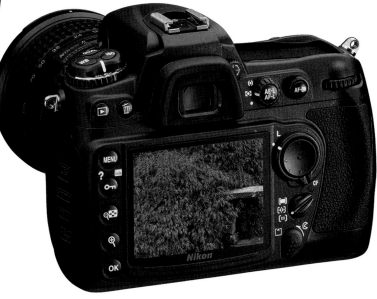

MAIN FEATURES TO LOOK FOR IN A DSLR

Live view Many models of DSLR offer a 'live view' facility nowadays. This gives a live image on the rear screen of the camera, which can be useful, particularly if the screen tilts so that you can look down into it. It is useful for zooming into the image for checking fine focus and depth of field. My Nikon D300s allows a 13x magnification of the image in live view mode, allowing very precise checking of focusing. I use it for much of my photography, when manually focusing.

Depth of field preview This allows you to preview the depth of field you will get in the final image. With the lens set to a small aperture such as f/11 or f/16, press the depth of field preview button. The image in the viewfinder will go dark as the lens is stopped down to the 'taking' aperture, but if you allow your eye to become adapted to the darker image, you will be able to see the depth of field within the image. I consider this to be an essential feature for my photography.

Mirror lock-up This facility helps to reduce camera movement when the shutter is depressed. See the section on camera supports for further details on its use.

MEMORY CARDS

Memory cards are the recording medium for your images. There are several different types, such as CompactFlash and SD, available in different sizes and speeds. For plant photography, speed will not be an issue. I tend to use either 4 or 8Mb cards. Larger ones are available, but should a card fail, I would rather lose 8Gb of data rather than 32Gb! If I am working abroad without a computer, I carry an external storage device, into which I can download the images to free up the cards. Always protect your cards from dust and sand – the holes in a CompactFlash card can easily get clogged and stop them from working.

PC socket At some time you will probably want to use an external flash gun, to improve the light on a subject. Many cameras nowadays do not have a socket (PC) into which you plug the lead from a separate flash gun. Inexpensive adaptors which plug into the hot shoe socket on top of the camera are available which contain a PC socket. It is well worth getting one of these.

USEFUL FEATURES AND ACCESSORIES

Right-angle viewfinder When photographing subjects that are low to the ground, such as flowers or fungi, a useful accessory is a right-angle finder. This clips onto the viewfinder eyepiece, and allows you to look down (or at an angle) into the viewfinder. Most swivel so that if you turn the camera vertically the viewfinder will still point upwards. This is a really valuable accessory for plant photography, and I would thoroughly recommend one.

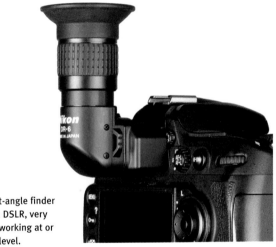

RIGHT A right-angle finder attached to a DSLR, very useful when working at or near ground level.

Spirit level When photographing plants in the landscape it is essential to keep the camera horizontal so that the horizon is straight. I always used to carry a small spirit level with me to help do this. Many modern cameras now have a digital spirit level (Nikon call theirs the 'virtual horizon') built into the camera, which I now use all the time when doing landscapes, or any image with a horizon.

Histograms One of the most valuable features on a digital camera is the histogram display, and the ability to correctly interpret it will tell you if the image is correctly exposed at the time of taking the picture, enabling you to re-shoot if necessary. See chapter five for a fuller description of histograms.

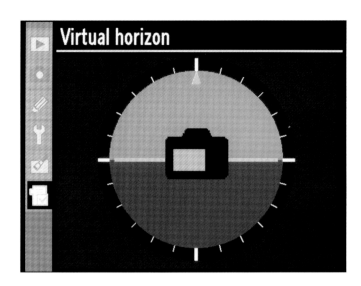

Virtual horizon

ABOVE The digital spirit level or 'virtual horizon' found in some advanced cameras, for ensuring the camera is level, particularly useful when shooting habitat shots.

HOW MANY PIXELS DO YOU NEED?

Over the last few years, camera manufacturers have been increasing the number of pixels in cameras, though the trend does seem to be levelling off. Most cameras now have between 12 and 14 million pixels (1 million pixels is known as 1 megapixel, 1Mp). With good technique, 12 megapixels will enable you to easily print an image to photographic quality on an inkjet printer to A3 and larger, or reproduce it in a book of this quality to a double-page spread.

Highlight flashing facility One of the most important features within the histogram display is the 'highlight flashing' facility when displaying an image in playback mode. It is always worth keeping this switched on. Any burnt out, overexposed highlights flash, or blink, showing that there is no detail in that area, and indicating that you might want to re-shoot the image with less exposure.

White balance Digital cameras have the ability to measure the colour of the light in which you are shooting and balance it to a neutral tone. In most instances, setting the camera to 'auto white balance' will give excellent results, which can, if necessary be tweaked in Adobe Photoshop™. If you are shooting in cloudy or shady conditions, then selecting these settings in the camera may be slightly better. More details are given in chapter three.

Image quality and format I would always recommend setting your camera to shoot on the highest quality possible. Even if you know you are shooting images specifically for a Powerpoint™ presentation for example, or web use, there is always the chance that you might be asked for a high quality A3 print from one of the images. You can always make low-resolution versions from high-resolution files. It is not so easy the other way.

I have my camera set to record both Raw files and high-quality JPEGs for each exposure. In most cases, the JPEG will give a perfectly good image, requiring very little processing. The reason for shooting Raw files as well is to give you the potential for making corrections to things like white balance and exposure, or enhancing high-contrast images.

BELOW This deceptively simple close-up of an Alpine Columbine (*Aquilegia alpine*) in the Picos de Europa in northern Spain required both good equipment and technique to get any sort of acceptable result. The day was overcast with a constant fine drizzle and mist, and there was a strong breeze blowing the plant around. I used a plant clamp to hold the stem of the plant against an adjoining sapling. I wanted to throw the background out of focus but get maximum depth of field on the flower itself, so took four 'focus stacked' images (see chapter six) with a 105mm macro lens and converter. A right-angle finder was used on the camera, which was mounted on a sturdy tripod. Each image was optimised in the Raw converter before being 'stacked'.

105mm macro lens with 1.4x converter.
Four images each at 1/100 sec at f/6.3

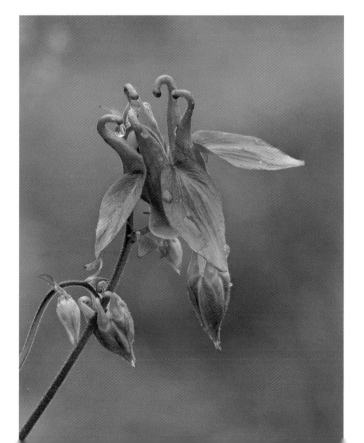

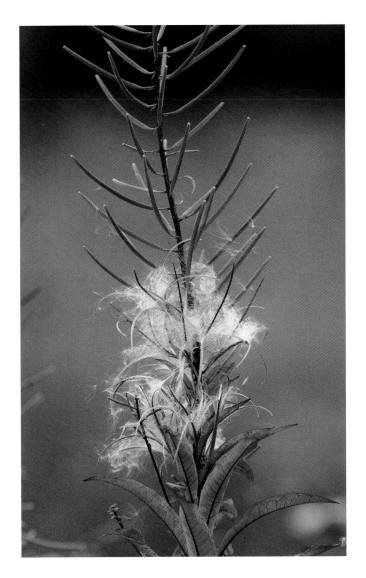

Lenses

There is no such thing as the perfect lens for plant photography. As we have already seen, the range of subject material is vast, and, together with the variety of approaches required, a range of lenses (or wide range zoom) will probably be needed.

Try not to categorise your lenses. It can be an easy trap to fall into – don't just think of wide-angles for landscapes, or telephotos for long distance subjects for example. I routinely use lenses of 300 or 400mm for close-ups of single flowers. Experiment until you are happy that you know the potential for each one.

WIDE-ANGLE LENSES

These are lenses with focal lengths in the region of 10–30mm. Don't just think of a wide-angle lens as a 'landscape' lens. They are excellent for showing plants in their habitat. Try to get close to your subject so that it is recognisable, but still shown within its environmental context.

LEFT **Rosebay Willowherb (***Epilobium angustifolium***) seeds. I wasn't able to get close to this specimen, so shot it with a 300mm lens. This also had the effect of throwing the background nicely out of focus.**
300mm lens, 1/320 sec at f/6.3

FOCAL LENGTH AND SENSOR SIZE

There are many different sizes of image sensor in digital cameras, including 'full frame' (24 x 36mm – the same size as 35mm film), 'APS-C', '4/3' and many more. The focal length inscribed on a lens is valid when used on a camera with a full frame sensor, but will have a different effective length when used with a smaller sensor. Small sensors have a magnifying effect, and to work out how much they magnify you need to know the ratio between the sensor in your camera and the 35mm size frame. This will be shown in your camera manual. For example, my Nikon D300 has a magnifying factor of approximately 1.5x. The effect of this is to multiply the effective focal length of a lens by 1.5. For example, a 200mm lens effectively becomes a 300mm lens, whilst a 50mm lens effectively becomes a 75mm lens. This is known as the 'focal length equivalency'.

From a practical point of view you do not need to worry as you will soon learn how different focal lengths work with your camera. It is worth bearing in mind, though, when buying new lenses. Some lenses are designed specifically for small sensors, and will not work properly with full frame sensors. Nikon call their lenses either DX (for APS-C sensors) or FX (for full frame sensors) for example. If you currently have a camera with a small sensor, but envisage buying a full frame camera in future, this could affect your lens choices. Throughout this book, the captions show the focal length actually inscribed on the lens.

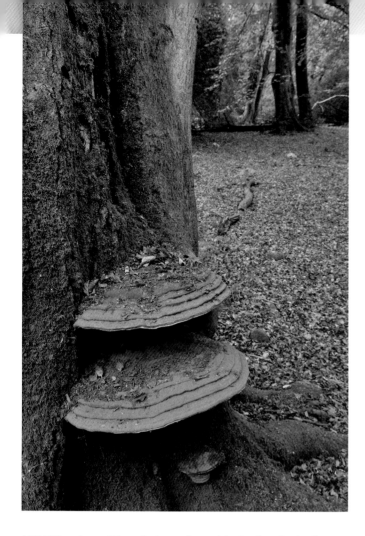

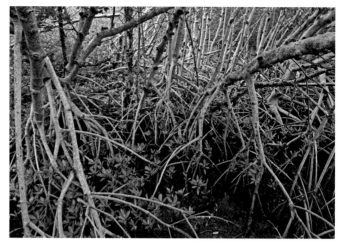

ABOVE In this image I used a wide-angle lens to try to convey the tangled mass of Red Mangrove (*Rhizophora mangle*) roots. I was on a boardwalk cut through the mangroves in the Everglades, and stopped the lens down to a small aperture to get maximum depth of field.

17–55mm lens at 20mm, 1/3 sec at f/16

ABOVE I have known this particular specimen of the Southern Bracket fungus (*Ganoderma australe*) for many years, growing on the side of a large Beech tree (*Fagus sylvatica*) in an ancient wood in Sussex. Here I used a wide-angle lens to show it together with the trees in the background. Note the brown spores underneath the bracket.

17–55mm lens at 20mm, 1/10 sec at f/7.1

Even high-quality wide-angle lenses may suffer from geometric distortion, particularly if used at an angle. Horizons may become concave or convex, known either as 'barrel' or 'pincushion' distortion. Software such as Adobe Photoshop™ has excellent lens correction facilities for straightening such distortions. Later versions of Photoshop™ (and Adobe Camera Raw™), together with dedicated programs such as Nikon Capture NX, even have the characteristics of individual lenses programmed in, so that any corrections required are automatically applied.

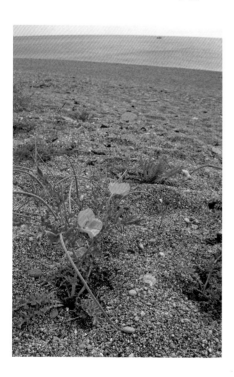

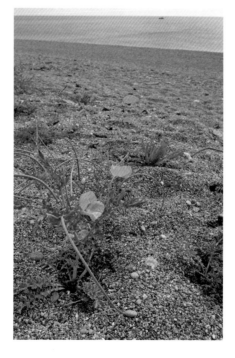

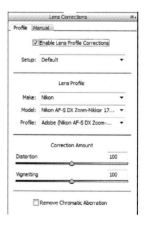

In the first image of Yellow Horned Poppy (*Glaucium flavum*) I used a wide-angle lens quite close to the plant, to show the shingle beach and sea in the background. The horizon is curved due to distortion with the lens. In Adobe Camera Raw™, I checked the 'enable lens profile corrections' box to straighten it. Note the lens listed in the drop-down menu.

17–55mm lens at 17mm, 1/320 sec at f/8

STANDARD LENSES

A 'standard lens' is one which gives a similar field of view to the human eye when relaxed. For a full frame sensor it is around 50mm (35mm for an APS-C sensor). It is probably the focal length I use least for my plant photography.

TELEPHOTO LENSES

These are lenses with focal lengths greater than standard lenses, such as 100mm, 200mm and 300mm. Bird photographers will use lenses up to 800mm but many plant photographers will use maybe 100, 200, 300 or even 400mm. They are useful for photographing subjects that are a distance away, such as alpines on a mountain ledge, or for throwing a background out of focus when used as a 'portrait' lens.

PERSPECTIVE CONTROL (TILT/SHIFT) LENSES

A rather specialist (and expensive) lens used by many landscape and architectural photographers is the perspective control (PC) lens (also known as a tilt/shift lens). Nikon, Canon and several other manufacturers make them in a range of sizes. For plant photographers, their main use is to help maximise depth of field when looking across an oblique surface such as a carpet of flowers. In the example shown, of an English Lavender field, the first image has a zone of sharpness through the middle of the frame, but falls off towards the front and rear of the image. By tilting the lens slightly, I have brought more of the field into focus. I have deliberately kept the aperture wide open to illustrate the effect. The basic principle (derived from large format technical cameras) is to take imaginary planes through the camera back, the subject and the lens, and bring them to a point of coincidence by tilting the lens.

USE OF A PERSPECTIVE CONTROL (PC) LENS TO MAXIMISE DEPTH OF FIELD

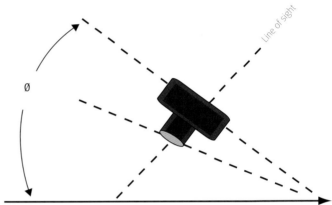

ABOVE The lens is swung (or tilted) around its axis so that planes through the subject, camera back and lens coincide at an imaginary point.

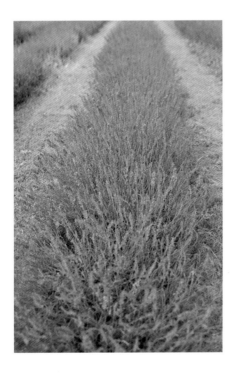

ABOVE Lavender field. Note the narrow zone of depth within the image with the PC lens.
24mm PC lens (no tilt), 1/200 sec at f/4

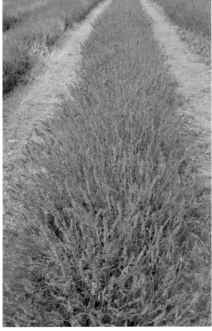

ABOVE Nikon 24mm PC lens tilted to maximise depth of field.
24mm PC lens (with tilt), 1/200 sec at f/4

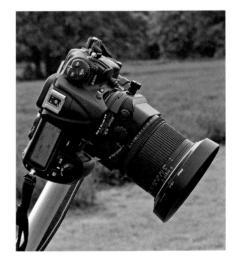

ABOVE A PC lens tilted down so that planes through the camera back, the subject and the lens coincide, to maximise depth of field.

ZOOM LENSES

Today, most cameras are supplied with zoom lenses covering a range of focal lengths, such as 17–55mm or 70–200mm. Some 'super-zooms' are available, for example 18–200mm, which cover a huge range. I use the latter lens as my 'travel' lens if weight is an issue when travelling abroad. Such lenses are remarkably good considering the range they are covering.

MACRO LENSES

Also known as micro lenses, these are designed specifically for close-up and macro work, and are discussed more fully later in the section on close-up and macro photography. Many zoom lenses have a macro facility.

TELECONVERTERS

These are effectively magnifying glasses, which fit between the camera body and lens. They magnify the image given by the lens. There are generally three strengths: 1.4x, 1.7x and 2x. I routinely use my 105mm Micro Nikkor lens with a 1.4x Nikon converter, giving an effective focal length of 147mm. There is no perceptible loss of quality with this particular combination and it is of course more lightweight than carrying separate 105mm and 150mm lenses.

The only real downside to their use is the loss of light. A 1.4x converter needs one extra stop of light; a 2x converter needs two stops of light. Hence my 105mm f/2.8 lens becomes effectively a 147mm, f/4 lens when used in conjunction with a 1.4x converter.

Don't be tempted by relatively cheap converters. If you have paid several hundred pounds for your lens, you do not want to risk downgrading the image quality with an inferior quality converter. Companies like Nikon, Canon, Sigma and Tamron make 'matched' converters, specifically designed to work with certain lenses.

LENS HOODS

Your lens should be supplied with a lens hood, and, if not, you should aim to get one. Make sure you use it at all times, particularly when the camera is pointed in a direction towards the sun. Rather like the visor inside the windscreen of a car, a lens hood will help reduce flare, which can cause a loss in contrast and colour saturation in an image.

FILTERS

When I used film I carried a range of filters with me, for correcting colour as well as protecting lenses. Today, most filter effects can be simulated in image-processing programs such as Photoshop™. I now only use three filters.

SKYLIGHT

I protect all of my lenses with a 'skylight' or U/V (ultraviolet) filter – I would rather replace a filter rather than the whole lens if it gets splashed with sea water for example.

POLARISING

Polarising filters are useful for minimising reflections from shiny surfaces, such as shiny leaves or water. There are two types, linear and circular – you will need a circular one. To photograph freshly exposed fronds of seaweed, for example, a polariser will be essential. When photographing through the surface of a rock pool or pond, an angle of roughly 37 degrees to the water surface will work best, though this can obviously be checked through the camera viewfinder. Polarising filters are made in a rotating mount. You can check the effect of the filter as you rotate it in front of the lens. When seen for the first time the effect can be quite remarkable.

A rock pool with Bladder Wrack (*Fucus vesiculosus*) and Thongweed (*Himanthalia elongata*). The first image shows reflections on the water surface, giving it a rather milky appearance. The seaweed too is dull and lacking colour. In the second shot I used a polarising filter. I rotated it in front of the camera lens until the water cleared. The effect is extraordinary when seen for the first time. This does two things: firstly, removing the reflection from the water surface allowing you to see down into the water. The second effect is to remove reflections from the surface of the weed, increasing the colour saturation. One extra stop was required with the polarising filter set to maximum effect.

*17–55mm lens at 50mm. **First image:** 1/15 at f/11; **second image:** 1/8 at f/11*

A polarising filter will absorb around one stop of light, requiring a slower shutter speed or wider aperture.

Another use of a polarising filter when shooting habitat images is to darken a blue sky without affecting other colours. It is most effective when used at an angle of around 90 degrees to the sun. This will also reduce reflections and glare from leaves and other vegetation, increasing the saturation of the colours.

NEUTRAL DENSITY GRADUATES

Neutral density (ND) graduated filters are rectangular filters which are slotted into a special holder which screws onto the front of the lens. The filter can then be slid up and down in the holder until the gradation is aligned with the horizon. The holder can be angled for darkening areas of sky or rock for example. These filters are useful when showing plants within their habitat, though their effect can be largely simulated in Photoshop™. Unlike polarising filters they will not affect the colour of your subject. They are available in different strengths and colours. Several strengths are available, typically 0.3, 0.6 and 0.9 for example. Each 0.3 step absorbs one stop of light, so a 0.6 ND filter will reduce the density of a sky by two stops.

A USEFUL KIT

Having seen the wide range of lenses and accessories that are available, how many do you actually need? Looking through the captions to the images in this book, well over 50 per cent were shot with my favourite 105mm macro lens. My typical 'kit' for a day when visiting a nature reserve or botanic garden would be:

- DSLR body (with right-angle finder)
- 17–55mm lens
- 105mm macro lens
- 70–200mm lens
- 1.4x converter (this can be used with both the 105 and 70–200mm lenses, converting them into 147mm and 105–300mm lenses respectively)
- Reflectors
- One or two flash guns
- Spare batteries and memory cards
- I might add to this a 10–20mm and/or a 300mm lens for different applications. When travelling abroad, or walking any great distance, I might swap the two zooms for an 18–200mm zoom, and take that, together with my 105mm macro lens. I also have a 60mm macro lens, which I use primarily for indoor studio work.

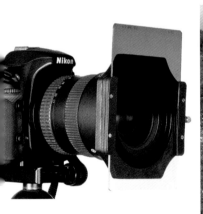

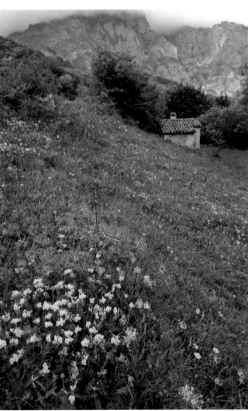

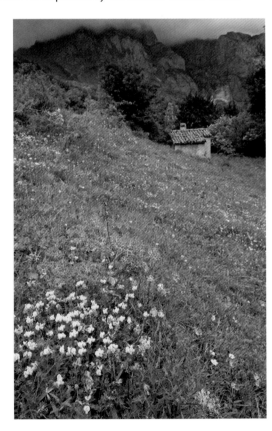

A neutral density graduated filter is a useful accessory when photographing plants in their habitat. Here I have used a 0.6-strength graduated ND filter to darken the sky in this scene of an alpine flower meadow in the Picos de Europa in northern Spain.

17–55mm lens at 25mm, 1/60 sec at f/16

BOKEH

Bokeh, or boke, is a Japanese word literally meaning 'become blurred or fuzzy'. It is now commonly used to describe the appearance of out-of-focus areas in an image. Are the tonal transitions smooth and uniform, or coarse? Many lens reviews now comment on the bokeh of the lens. In general, the more blades that are used in the construction of the aperture diaphragm the more circular is the aperture, giving smoother transitions, i.e. better bokeh.

Uniform out-of-focus backgrounds can be prone to banding, or posterisation, showing up as bands of tone rather than smooth gradations. The best way to avoid this is to shoot Raw files, and process the images in 16 bits per pixel. More detail is given in chapter five.

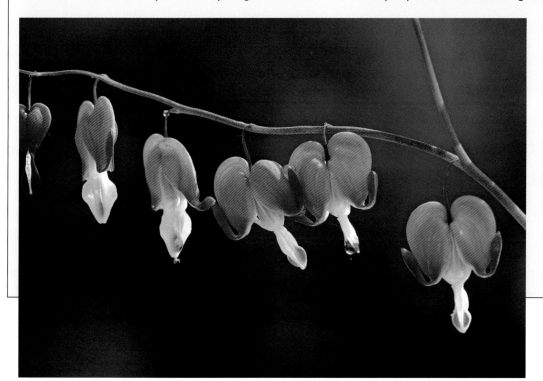

Bokeh refers to the quality of the out-of-focus areas of an image, and can vary with the lens used. Here, this image of Bleeding Heart (*Dicentra spectabilis*) has a superb background with very smooth tonal transition given by the high class Nikon 105mm micro-Nikkor lens used. I grew the plant in a pot and moved it to a suitable position in my garden for photography – the background is some shrubs about 25 metres away.
105mm lens, 1/1,250 sec at f/4

AUTOFOCUS

Most cameras today have the facility for autofocus, where the lens focuses automatically on the chosen part of the subject. As a rule, I do not use autofocus for plant photography, preferring manual focusing for the vast majority of my work. There are two main reasons for this. Firstly, there isn't really any need for autofocus – unlike birds or mammals, plants are not going to run or fly away so you can take your time. Secondly, although you can select a very specific part of the image for the camera to focus on, sometimes the part of the subject you want to focus on doesn't quite match the focus point in the viewfinder. This is particularly the case with high magnification close-up photography, where you might want to focus very precisely on the tip of a stamen, or vein of a leaf.

VIBRATION REDUCTION

Most lenses today offer some form of vibration reduction (VR) or image stabilisation (IS). In some systems the facility is built into the camera body, in others it is built into the lens. The main aim is to reduce vibrations at the time of taking the picture by using motion sensors to detect motion before and then during the exposure of the photograph. Various methods are then used to counteract the movement, such as moving the sensor, or moving an element within the lens.

The facility is a great help when handholding the camera – some manufacturers claim that you can set a shutter speed three or four stops slower than you would normally to achieve a sharp image. However, it is generally thought best to turn the facility off when the camera is securely mounted on a tripod.

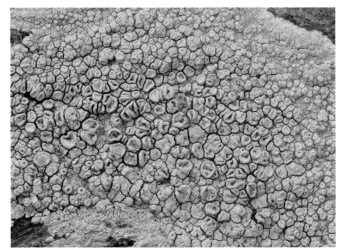

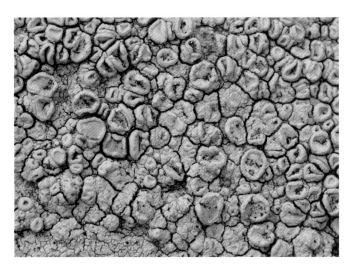

ABOVE I photographed this lichen (*Ochrolecia parella*) on the seashore, at approximately a quarter life size (top), half life size (middle), and life size (above) in the frame. Even with a relatively flat subject like this, notice the extremely small depth of field in the life size image, when using an aperture of f/11 – less than 1mm. Lichens make very good subjects for testing equipment!

105mm macro lens, all at f/11

Close-up and macro photography

A large proportion of plant photography could be classified as 'close-up', and the term doesn't really have a firm definition. Macro photography, however, does have a strict definition, though the term is often used nowadays for 'big close-ups'! The true definition of macro photography is where the magnification in the camera is greater than 1, or greater than life size. For example, a typical image sensor might be 24 x 16mm (see your camera manual for exact dimensions). If you have a subject that is 24mm in size and it entirely fills the frame, or more, then you are entering the true realm of macro photography. One way to find the magnification of your sensor is to focus on a ruler. When the ruler is in focus, if 24mm of it fits the long side of a 24mm sensor exactly, then you have a magnification of x1, 1:1, or life size. If only 12mm of ruler fits the frame, then you have a magnification of x2 or twice life size.

Many compact and other small cameras are remarkably good at close-up photography.

Many non-macro lenses on DSLRs will focus reasonably close, but maybe not close enough for your needs. There are two ways of enabling them to focus closer – either using close-up lenses, or by extending the distance between the lens and camera body by means of extension tubes or bellows.

CLOSE-UP LENSES

These are lenses which screw onto the front of your main lens, allowing closer focusing. They are available in different strengths (known as dioptres) giving different focusing distances. It is worth bearing in mind that if you have spent several hundreds of pounds on a lens, putting a close-up lens costing just a few pounds on the front may not necessarily give very good quality. Those made by Canon are two-element lenses, and are outstanding, though expensive.

EXTENSION TUBES AND BELLOWS

For larger magnifications, extension tubes and extension bellows are available (sadly, Nikon and Canon no longer make bellows units). The longer the extension, the greater the magnification achieved. Adding 100mm of extension

to a 50mm lens gives 1:1 magnification, for example. Several extension tubes can be used in combination to give higher magnification.

MACRO LENSES

While many lenses will focus quite close nowadays, and accessories such as extension tubes and close-up lenses are available, if you are intending to do a lot of close-up or macro work, there is no substitute for a good macro lens.

A macro lens is designed specifically for the job of getting close to subjects, and performs best when it is used close to the subject. Many zoom lenses have a 'macro' facility. Some will allow true life size photography, whilst others will allow close focusing. If you need a true macro lens, do check before you buy one.

Macro lenses come in a variety of lengths, such as 50mm, 100mm or 200mm. Most macro lenses will give a x1 or 1:1 magnification, so a 20mm subject will be imaged at a size of 20mm on the sensor.

The longer the focal length, the greater the distance between you and the subject, and the better the chance of throwing the background out of focus. My favourite lens for plant photography is a 105mm macro lens, often used in conjunction with a 1.4x teleconverter, giving an effective focal length of 147mm. The lens gives a life size magnification without any extra accessories.

One particularly interesting model for those wanting extreme close-ups is the Canon MP56E. This lens will only give images from x1 to x5, useful for picking out extremely small details, or maybe small insects on a plant.

DEPTH OF FIELD

One issue that all close-up photographers face is that of depth of field, or lack of it. Depth of field is the amount of the subject that is in acceptably sharp focus in front of and behind the main point of focus. Depth of field is dependent on aperture and magnification. Contrary to popular opinion, focal length does not affect depth of field – if a wide-angle lens and telephoto lens are used for the same subject, and the magnification of the subject is the same, then the depth of field will be the same.

The term's rather dull technical definition includes two main points of practical interest to the plant photographer. Firstly, sharpness is subjective – what is sharp to one person may not be sharp enough to another. The word 'acceptable' is used to reflect the fact that it is a personal opinion.

The second point to note is the fact that depth of field is a zone or band of sharpness, which can be expanded or contracted by the use of the aperture. As we will see throughout this book, there will be some instances where a large depth of field is required, with both the subject and background being in focus, and others where you will want to show a subject against a completely out-of-focus background.

In terms of the aperture, a wide aperture such as f/2.8 or f/4 will give very shallow depth of field, whilst a small aperture like f/16 or f/22 will give a much greater depth of field. It is well worth shooting images at different apertures to see what effect you get. With experience you will be able to predict what depth of field you will get under a wide variety of conditions. A depth of field preview button is available on some models of DSLR camera, and I consider this to be essential for my macro work.

The closer you get to the subject, the shallower depth of field becomes. With extreme close-up and macro work, depth of field may be just a millimetre or less. The following tables of magnification versus aperture give some examples.

FULL FRAME 35MM EQUIVALENT SENSOR (APPROX. 24 X 36MM)

magnification	f/2.8	f/4	f/5.6	f/8	f/11	f/16	f/22
0.2	3.36	4.8	6.5	9.6	13	19	27
0.5	0.67	0.95	1.3	1.9	2.6	3.8	5.3
1	0.22	0.32	0.44	0.64	0.88	1.3	1.8

APS-C-SIZED SENSOR (APPROX. 24 X 16MM)

magnification	f/2.8	f/4	f/5.6	f/8	f/11	f/16	f/22
0.2	5.04	7.2	9.75	14.4	19.5	28.5	40.5
0.5	1	1.42	1.95	2.85	3.9	5.7	7.95
1	0.33	0.48	0.66	0.96	1.32	1.95	2.7

Figures are in millimetres

Figures in black squares indicate where the diffraction limit has been exceeded, and where image quality may be degraded.

Notice how depth of field falls sharply with increasing magnification. Also, that stopping down by two stops (e.g. from f/5.6 to f/11) doubles the depth of field.

If maximum depth of field is required, it would be logical to assume that you should stop the lens down as far as it will go. However, lenses suffer from an optical effect called 'diffraction', where light passing through a very small aperture spills out around the edges, degrading the image. This effect does not suddenly cut in, but appears gradually as the lens is stopped down, so the figures on p.21 are not rigid, but merely given as a guideline. Generally, a lens performs best when stopped two stops down from its maximum, and performance gradually worsens as it is stopped down further.

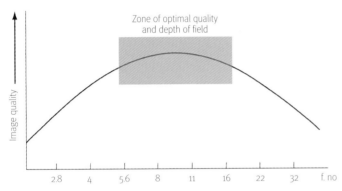

ABOVE Graph showing how image quality increases as the lens is stopped down for two or three stops, then the quality starts to fall due to the effects of diffraction.

ABOVE The Nikon Close-up Speedlight kit, seen here with two flash units mounted on a ring around the lens. The camera flash unit is covered with an infrared transmitting baffle. When the flash fires the infra red triggers the flash units. Each unit can be controlled independently.

ABOVE AND BELOW This pair of images of the lichen *Xanthoria parietina* illustrates how stopping the lens down can cause image degradation due to diffraction. The whole image area was approximately 10cm (4 inches) across giving a magnification of roughly a quarter in the frame. The first image was shot at f/5.6, the second at f/32. Whilst greater depth of field can obviously be seen, the whole image is now much softer.

105mm macro lens, 1/500 sec at f/5.6, and 1/15 sec at f/32

This helps to explain why compact cameras, with small sensors, generally do not have apertures that go past f/8 or f/11. The image quality would be too highly degraded.

Despite the technical limitations, there are practical things you can do to help with the depth-of-field issues. First, make sure that you focus on the most important part of the subject, so that your eye is drawn immediately to that bit. It is surprising how often people do not notice out-of-focus areas if the most interesting area is in focus.

ABOVE One of the identifying features of milkcap (*Lactarius*) fungi is the way they exude a white 'milk' when they are damaged. I found this specimen lying on a path, having been knocked over. I made a small tear in the gills and waited for the milk to appear. The magnification was approximately half life size in the frame of the camera.

105mm macro lens, 1/15 sec at f/11

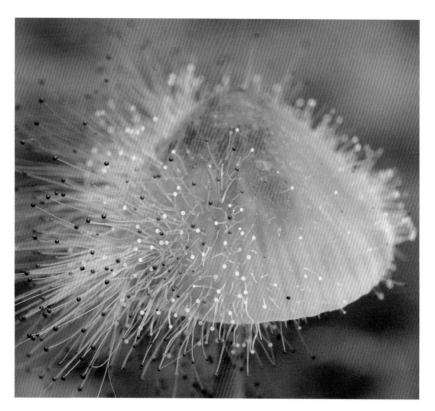

ABOVE A typical close-up, in this case a mould growing on the cap of a toadstool. Even at f/11 there is very little depth of field.

105mm macro lens, with 1.4x converter, 1 sec at f/11

Second, use depth of field limitations creatively. Focus on the subject, and deliberately keep the background out of focus, to highlight the subject. Don't be afraid to experiment. A relatively new technique, known as focus stacking, is starting to revolutionise macro photography, and is discussed later in the book. This allows you to get a large depth on the subject, whilst still retaining an out-of-focus background.

LIGHTING

Because you are by definition close to the subject, lighting might be a problem. Be careful that you are not casting a shadow, either of the camera or yourself.

If you need to use flash, it is best to use one that can be separated from the camera and held to one side (see section on lighting). Specialist macro-flash units are available, such as the Nikon Close-up Speedlight kit. This enables you to put small flash units on a ring surrounding the lens, or in other positions, perhaps to the side or even behind the subject. I often have two lights on the ring around the lens, and handhold a third pointed towards the background, or to backlight the subject. This particular system is wireless, operating via infrared signals, so no cables are used which might get in the way.

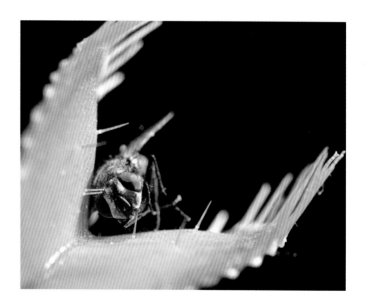

ABOVE The Venus Fly Trap (*Dionaea muscipula*) is the classic insectivorous plant with its miniature mantrap leaves. These snap shut over unsuspecting insects attracted by the scent of the leaves. Small trigger hairs on the inside of the leaf cause the trap to shut when touched. If only one hair is touched nothing happens, but if two are touched within the space of 20 seconds or so, the two parts close rapidly, trapping the insect. This was shot in my studio, with a black velvet background to help show up the trigger hairs, at a magnification of approximately three quarters life size in the frame. A fly was approaching the trigger hairs inside a Venus Fly Trap. Seconds later the trap was sprung and the fly caught.

105mm macro lens, 1/125 sec at f/8. Two macro flash units

Case study: Asphodel

The Asphodel (*Asphodelus albus*), a member of the lily family, is a common plant in southern Europe in spring and early summer, growing in meadows and wasteland. I have visited many countries where it grows, and have accumulated a large collection of images of it. With any new species I try to get an image of it in a typical habitat, in this case a high alpine meadow in the Picos de Europa in northern Spain. I used a wide-angle zoom lens set to 19mm for the first 'establishing' shot. I then shot a close-up of the flowers with a 105mm macro lens.

With many plants, such as Asphodel, Woody Nightshade (*Solanum dulcamara*) and Rosebay Willowherb, it is possible to see several stages in its development on one stem. Here, starting at the top of the image, are flower buds still to open, then flowers, and lower down there are older flowers starting to decay. At the bottom of the images are developing seed pods. I shot this with a 105mm macro lens fitted with a 1.4x teleconverter.

Many of the plants I found in Mallorca had numerous specimens of the White-spotted Rose Beetle or Barbary Bug (*Oxythyrea funesta*). This is a common insect, and can be found visiting numerous flowers including the Grey-leaved Cistus (*Cistus albidus*) discussed in chapter seven.

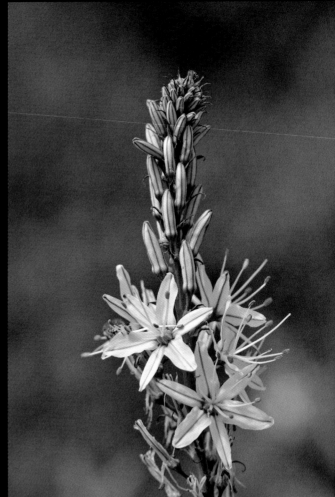

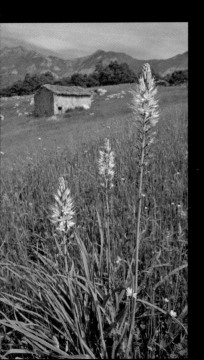

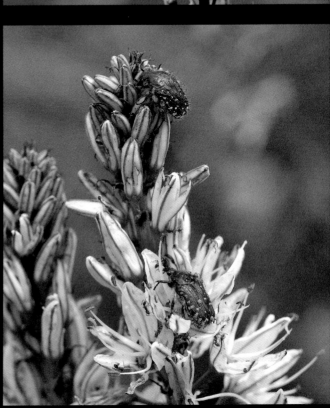

LEFT Asphodel in the Picos de Europa
17–55mm lens at 19mm, 1/125 sec at f/8, with polarising filter

TOP RIGHT Close-up of Asphodel flowers
105mm macro lens with 1.4x converter, 1/800 sec at f/6.3

RIGHT White-spotted Rose Beetle or Barbary Bug on Asphodel
105mm macro lens with 1.4x converter, 1/250 sec at f/9

OPPOSITE Stages in the development of the Asphodel
105mm macro lens with 1.4x converter, 1/800 sec at f/6.3

Camera supports

Having spent a lot of money on a good camera and lens, it is false economy not to hold it perfectly still at the moment of exposure, ensuring the sharpest possible image. When photographing plants there are two possible sources of movement – the plant and the camera. By using some form of solid camera support (and good technique) the camera movement can be minimised, leaving you to concentrate on the plant and its surroundings. Having the camera firmly supported also slows you down, enabling you to examine both the subject and the background for any distracting elements. I firmly believe that supporting your camera firmly at the time of exposure is crucial to getting a good image – all but one of the images in this book were shot from a tripod or one of the other supports mentioned below.

HANDHOLDING

In general, handholding the camera is not to be recommended, though there will be cases where using a camera support is not practical, for example, alpine flowers on mountain ledges. Many lenses or cameras now have image stabilisation ('vibration reduction') facilities built into them, enabling sharper pictures with slower shutter speeds. Even so, try to brace the camera as best you can, for example by resting your elbows on the ground.

IMAGE STABILISATION AND TRIPODS

Most manufacturers recommend that you turn off the image stabilisation system when the camera is mounted on a tripod. It is worth checking your instruction manual for your own particular camera or lens.

TRIPODS

There are dozens of tripods on the market, from flimsy aluminium models to more expensive lightweight but extremely rigid ones constructed from carbon fibre. The key feature for a tripod for plant photography is versatility. Your subjects may be growing at ground level, or high up on a tree branch. The ability to splay the legs to get the camera at or near ground level is very important. Check to see if the legs can be positioned at different angles for working on slopes, or use different lengths of leg. If your tripod has a centre column, see if this can be removed or shortened to enable the tripod to get close to the ground. With some models the centre column can be removed and re-positioned horizontally.

One particularly popular tripod amongst plant photographers is the British-made Benbo™. All three legs are independently moveable, and there is a centre column which can be placed in virtually any position. One central handle both locks the legs and centre column in place, making it very quick to use, though it will take some time to master. There are several different sizes. I

BELOW A carbon fibre Gitzo tripod. This particular model will go down nearly to ground level, and extend to around 146cm in height.

BELOW RIGHT A Benbo™ tripod. All legs move independently and this, together with the central arm, makes it a hugely flexible tripod.

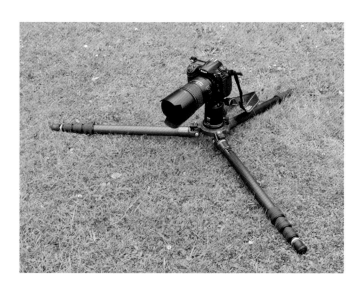

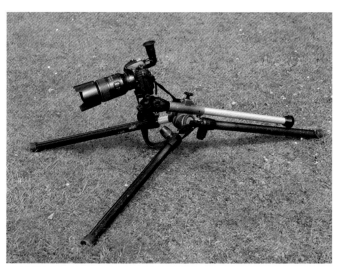

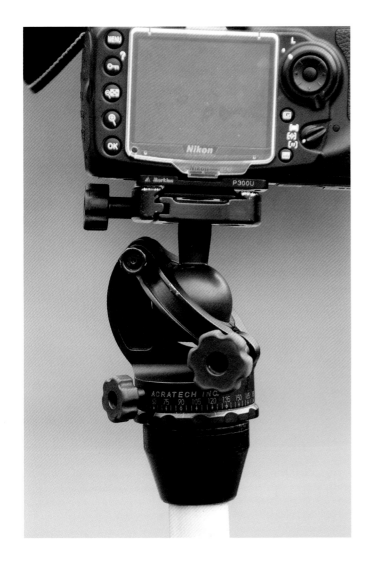
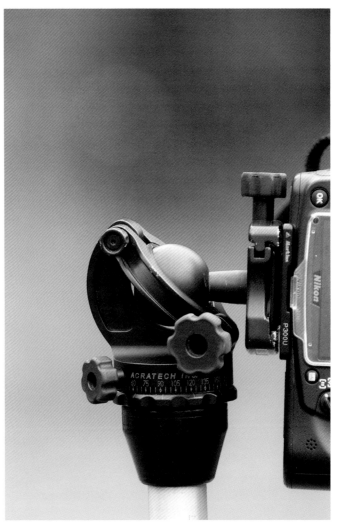

ABOVE LEFT AND RIGHT An Acratech ball and socket head, using the Arca Swiss type of quick-release system. A good head should hold a reasonably heavy camera and lens both horizontally and vertically. This particular model has a separate rotating base, calibrated in degrees, to help with shooting panoramas.

use the Mark 1 for most of my work, and the lighter weight Trekker when travelling by air. A word of caution – it is possible to position the Benbo™ in such a way that the centre of gravity is in the wrong place, and the tripod may topple over, particularly in a high wind. Take great care before letting go after having tightened the locking handle.

TRIPOD HEADS

Once you have a decent tripod, it is worth investing in a good solid tripod head. There are two basic types: the pan and tilt, and the ball and socket. I prefer the ball and socket, which is more flexible than the pan and tilt, and does not have arms protruding from it, though some

photographers do not find it as precise as a pan and tilt. See if you can try out various models before you buy one. It is a good idea to have a ball and socket head with a separate rotating base, particularly if you want to shoot panoramas. This enables you to lock the camera at a particular angle, then rotate the base separately.

Many heads have a quick-release system, enabling you to put the camera on, or remove it from the head quickly. A dedicated plate is screwed onto the base of the camera, which is then slotted onto the tripod head. I have several different models of head, all using the Arca Swiss type of quick-release clamp.

If you intend to do a lot of panoramic imaging a pan and tilt head may be preferable, as the tilt control can be locked once the head has been levelled, allowing just the panning action in one horizontal plane.

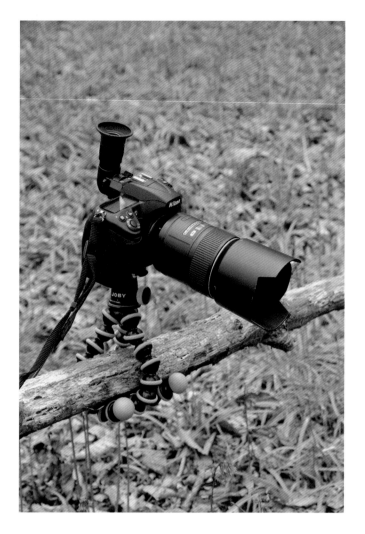

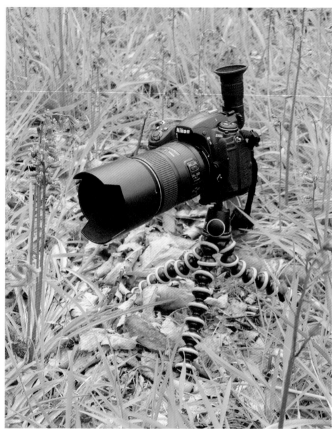

LEFT AND ABOVE The Gorillapod™ is a lightweight, versatile but surprisingly sturdy support, which can be used at ground level, or wrapped around branches for example. This one is light enough to be carried in the pocket, but will still hold a heavy DSLR and lens firmly.

GORILLAPOD™

The Gorillapod™ is an extremely lightweight, highly flexible and surprisingly sturdy tripod which can be carried in the pocket. The legs have numerous articulated joints enabling them to be bent into a variety of positions, including being wrapped around posts or branches. They are available in various sizes, some of which are strong enough to hold a DSLR and zoom lens. I fit a large ball and socket head onto one and it makes a remarkably firm support for my DSLR. I also use them indoors in my studio for holding small flash guns.

BEANBAGS

A beanbag is a cloth bag filled with beans, rice or perhaps polystyrene beads, into which the camera lens can be pushed. It gives a remarkably firm support. Bean bags are used a lot by wildlife photographers shooting from Land Rovers, for example, where the bag is draped over the window ledge of the vehicle.

For plant photography their use is more limited. You can rest them on the ground when photographing fungi, for example.

When travelling abroad, I often carry an empty bag with me and fill it with a suitable filling (rice or dry beans for example) at my final destination.

PLANT CLAMP

When photographing flowers and other delicate plants, one constant problem is wind, causing the plant to move around. One possible answer is a clamp to hold the stem of the plant still. They can be cheaply made from canes and clothes pegs, and there is at least one model available commercially, the PLAMP™. One end of this is designed to fit around a tripod leg, whilst the other end has a gentler clamp for holding a plant stem. I often use mine to hold a reflector in place.

KNEELING MAT

A really useful (sometimes essential) and often overlooked accessory is a good kneeling mat, available from garden centres. They are lightweight, cheap, and will ease the pain of kneeling on hard ground, as well as covering thistles and thorns on the ground. Alternatively you can buy trousers with built-in knee protectors.

SHOOTING TECHNIQUE

Even with the camera mounted on a sturdy tripod, you need to use good technique to achieve the best results. Firstly, use a remote release, so that you do not actually have to physically push the shutter release button. There are also two shooting options available on most cameras. The 'self-timer' mode delays the exposure for several seconds after the shutter is pressed, which allows any movement in the camera to settle down. The drawback of this method comes when there is a breeze blowing the plants around – the plant may be still when you press the button, but be moving when the shutter actually fires. Another feature found on some cameras is the 'mirror up' mode. This is a two-stage release of the shutter. When you press the release button once, the mirror flips up out of the way. Wait a few seconds for the vibrations from this action to settle down, then depress the button again, which just fires the shutter. This is the mode I use most often, in conjunction with a remote release.

LEFT **A beanbag can make a remarkably firm support, though is obviously rather limited in terms of where you can use it. This one is filled with dried beans. Note the right-angle finder on the camera.**

ABOVE **A Wimberley PLAMP™ used for supporting plant stems, or holding reflectors, in this case supporting a Teasel (*Dipsacus fullonum*) stem.**

CARRYING YOUR GEAR

People are often surprised when they see how much gear I carry with me. My typical 'bag' for a day in a botanic garden or nature reserve (see A useful kit on p.18) comprises camera body, four lenses and assorted accessories. Add a tripod and it adds up to a considerable weight. I generally use a rucksack type of camera bag such as the LowePro Mini-Trekker to ease the strain on my shoulders and back. Recently, particularly when working in botanic gardens, I have been trying out various wheeled shopping trolleys and custom-made trolleys such as the Eckla Beach Rolly™. This particular model has pneumatic tyres to help pull it over rough terrain.

Getting Started

Your camera and lens does not go out and take great pictures by itself – you do, firstly by knowing what it is you are trying to achieve with your image, then composing it, and then applying the right settings to your camera to enable your vision to be realised. It is really worth the investment in time in getting to know your camera, even if, for most of the time you are using only a fraction of the features that it contains.

Basic considerations

Whenever I start to photograph a plant, I run through a mental checklist of points that might be relevant to the image, to add to its illustrative or botanical value. There will of course be many other aspects to consider, depending on the subject and intended use of the image, particularly if I am looking for an abstract image, but I usually try to consider the following.

Scale Can you tell the size of the subject from the image? It may not always be relevant to indicate scale, but it is always worth shooting at least one shot of your subject with some sort of comparative natural object to act as a scale, such as a leaf, or pine cone for example.

RIGHT **Bristly-fruited Silkweed** (*Gomphocarpus fruticosus*) is a plant that I have found on numerous occasions growing primarily on waste ground in Mediterranean regions. I hadn't paid it much attention until I found one where the seed pod had split open, and the seeds were starting to be dispersed. I chose a viewpoint where I could get the sun behind it to backlight it, and used a long lens to throw the background out of focus. I used a small silver reflector to bounce some light into the interior of the seed pod.

105mm macro lens with 1.4x converter, 1/200 sec at f/11

LEFT **It would be difficult for a non-specialist to guess the size of this lichen (*Xanthoria parietina*) growing on rocks on the seashore, from the first image. I persuaded a 2.5cm Sea Slater (*Ligia oceanica*), a seashore invertebrate similar to a woodlouse, to crawl over the lichen, to give a comparative scale.**

105mm macro lens, 1/125 sec at f/11

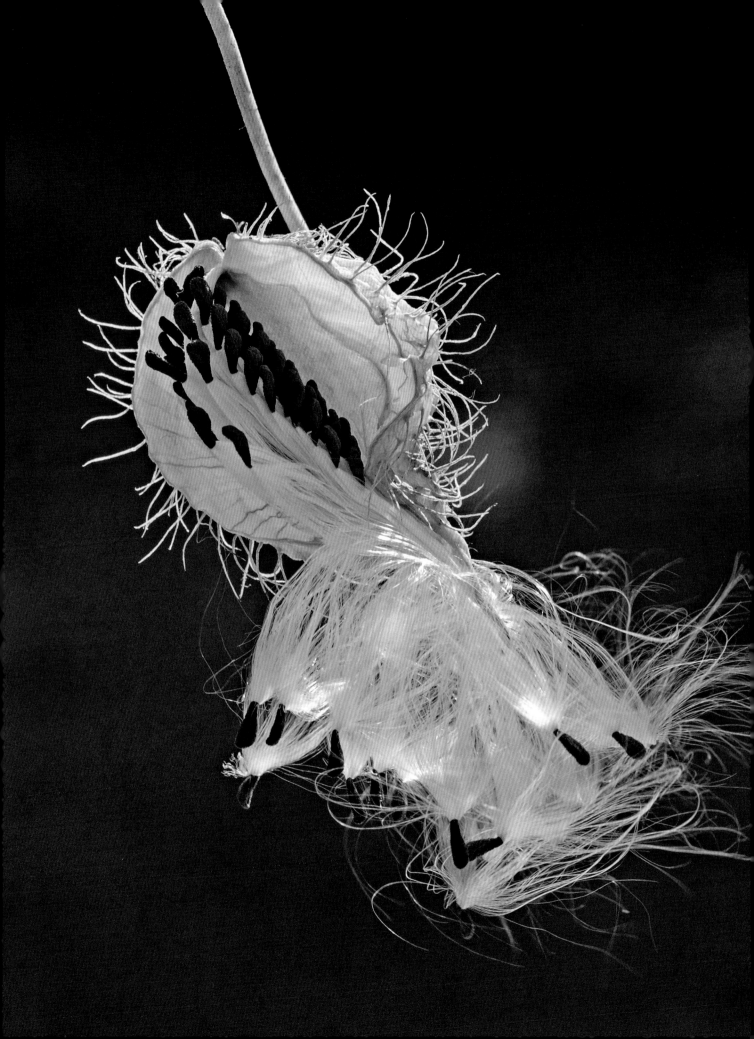

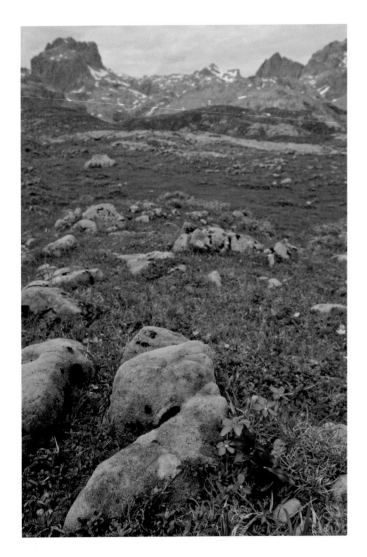

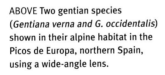

ABOVE Two gentian species (*Gentiana verna and G. occidentalis*) shown in their alpine habitat in the Picos de Europa, northern Spain, using a wide-angle lens.

17–55mm lens set to 17mm, 1/100 sec at f/11

ABOVE RIGHT I used an extreme wide-angle lens to show this large clump of Oyster Mushrooms (*Pleurotus ostreatus*) growing on a fallen Beech trunk in an ancient wood. The shot required climbing up onto the trunk with my camera and tripod.

10–20mm lens at 10mm, 1/3 sec at f/11

Habitat Does the plant grow in a specific habitat, and is this shown in the image? Good examples are coastal plants growing on clifftops with the sea in the background, fungi growing in woodland, or alpines in a mountainous region.

Association Does the plant grow in association with other plants that would be useful to include in the image, such as a parasitic broomrape (*Orobanche* sp.) with its host plant, or Mistletoe (*Viscum album*) growing on its host tree, for example?

Timing Is the timing for the image right? Some plants are very specific in their emergence or flowering. For example, Goatsbeard (*Tragopogon pratensis*), also known as 'Jack go to bed at noon', opens in the early morning and closes at around midday, and must therefore be photographed in the morning to ensure getting an image of the open flowers.

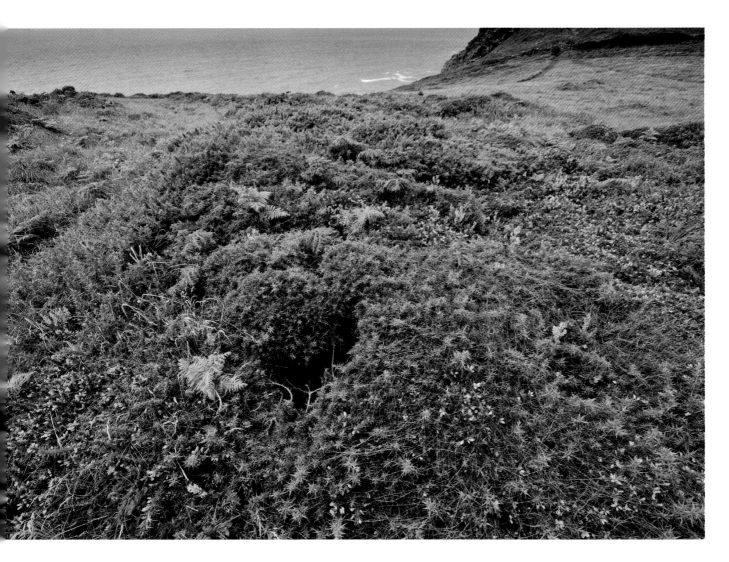

RIGHT Broomrapes can be difficult to identify, but can often be identified by the presence of their host plant, such as this Slender Broomrape (*Orobanche gracilis*) growing parasitically on Birdsfoot Trefoil (*Lotus corniculatus*) in an alpine flower meadow in the Picos de Europa in northern Spain. I deliberately used a small aperture to show some of the other plants growing in the meadow.

105mm macro lens, 1/40 sec at f/16

FAR RIGHT Common Dodder (*Cuscuta epithymum*) is a parasite on a range of plants, including Gorse (*Ulex europaeus*), shown here. It grows well on clifftops near the sea. I particularly wanted to show the red threads and small pink flowers of the Dodder alongside the yellow Gorse flowers.

105mm macro lens, 1/250 sec at f/8

ABOVE The Dodder in its habitat on a clifftop Gorse bush, to give an impression of how extensive the growth can be.

10–20mm lens at 15mm, 1/200 sec at f/8, with polarising filter

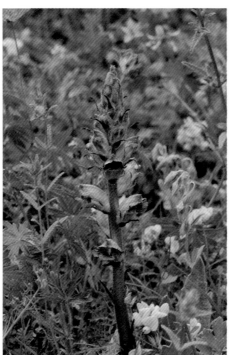

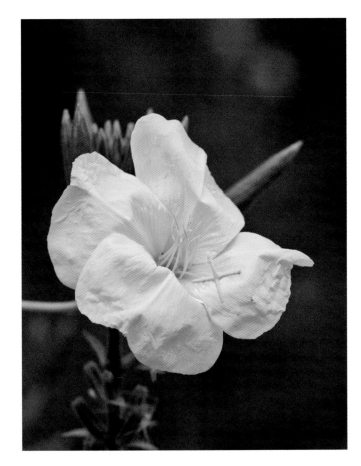

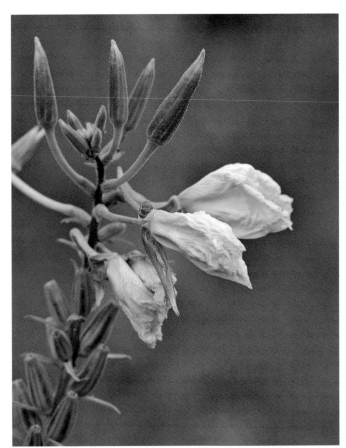

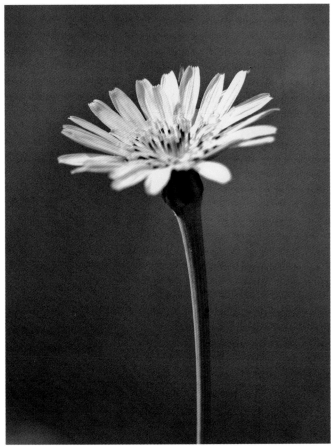

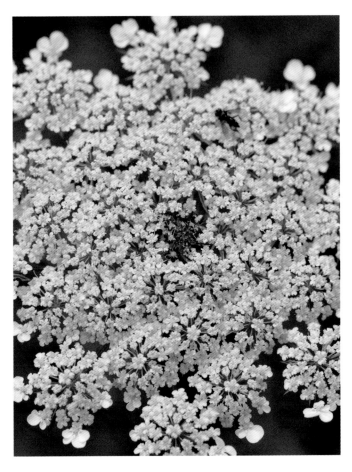

FAR LEFT **Evening primrose flower early in the morning in a stiff breeze.**

105mm macro lens, 1/800 sec at f/5.6

LEFT **Closed flowers of evening primrose with buds ready to open the following evening.**

105mm macro lens, 1/640 sec at f/5.6

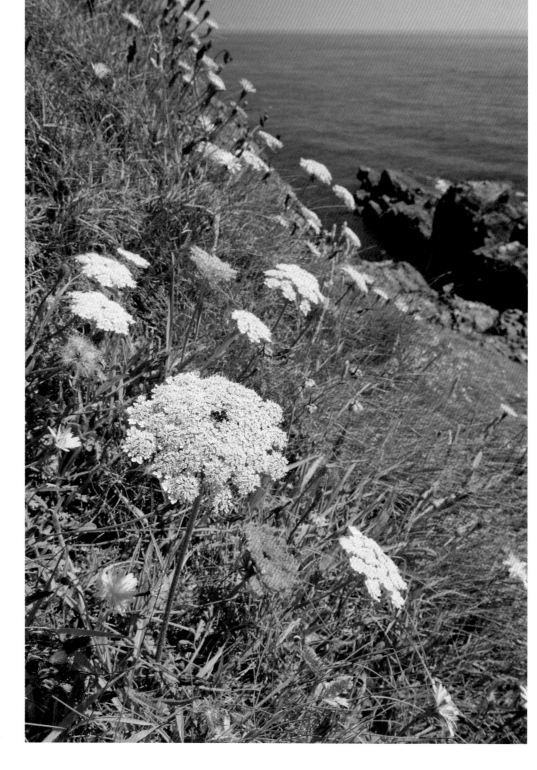

FAR LEFT **This Goatsbeard flower was photographed at 10am on a sunny morning. By midday all flowers had closed.**

105mm macro lens with 1.4x converter, 1/1,000 sec at f/4

LEFT **Wild Carrot (*Daucus carota*). This umbellifer is common in many coastal areas, and many (though not all) of the flower heads or umbels have a single central purple flower, a major identifying feature.**

105mm macro lens, 1/800 sec at f/8

RIGHT **A habitat view of Wild Carrot on a coastal clifftop.**

17–55 lens at 25mm, 1/80 sec at f/11, with polarising filter

Many fungi emerge overnight, and will be at their best during the morning. As their name suggests, evening primrose (*Oenothera* sp.) flowers open in the evening (to be pollinated by night-flying moths), and have generally closed by mid-morning.

Identifying features If the image is to be used to help identify the plant at a later date, are all necessary identifying features shown, such as a hairy or hairless stem or distinctive leaf shape?

Case study: Heathland fires

Southern England, where I live, has a good number of lowland heathland areas, internationally important for their wildlife, but a rapidly declining habitat type. Controlled burning is used as a management tool, reducing the areas of bracken and coarse grasses, and encouraging the new growth of heathers. However, each year, particularly in dry summers, uncontrolled fires break out, often causing devastation to an area. Unfortunately, many of the fires are started deliberately, and rapidly run out of control. However, it is remarkable how nature recovers, and over the years I have documented several local areas of burnt heathland as the vegetation recovers from the fire. While the visual appearance of the damage can be shocking in the immediate aftermath of a fire, the after-effects can be stunning.

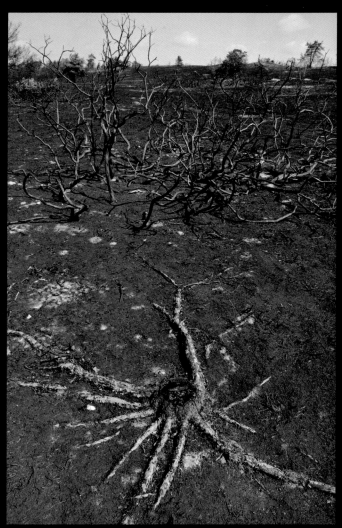

ABOVE The immediate aftermath of a fire can be shocking. This is the remains of a mature Silver Birch tree (*Betula pendula*) three days after the fire was extinguished. The smell of burnt vegetation was almost overpowering.

17–55mm lens at 25mm, 1/60 sec at f/16

LEFT Just a week after the fire and the first signs of life start to sprout. Here, fresh growth of Gorse is starting to appear.

105mm macro lens, 1/100 sec at f/11

FAR RIGHT Several weeks after the fire, heather reappears, colouring the area with its fresh green foliage and purple flowers. I deliberately left a burnt tree in the image to contrast with the fresh growth.

17–55mm lens at 55mm, 1/60 sec at f/11

RIGHT Warning notices like this are placed all around my local heaths.

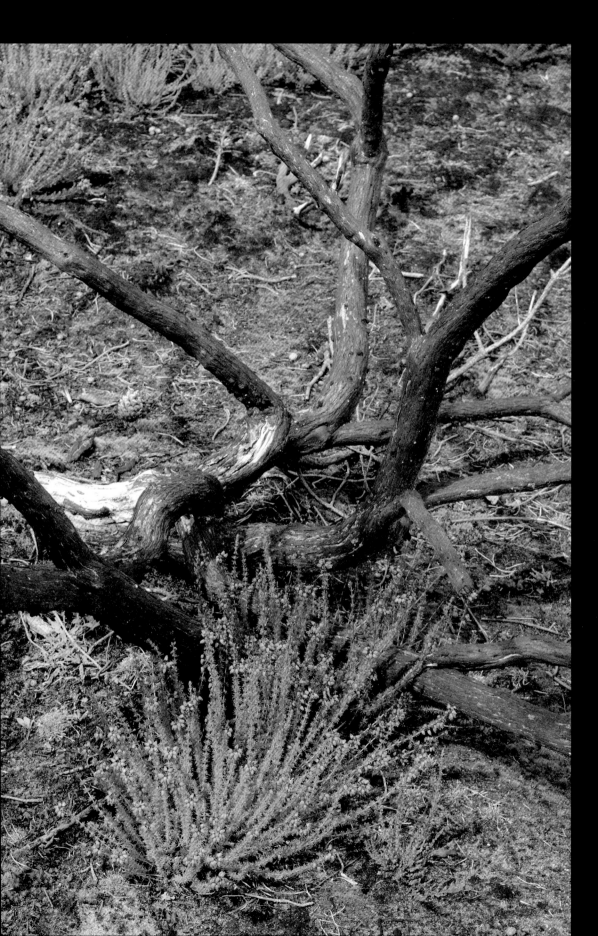

Other camera settings

The manual for my Nikon DSLR is 400 pages long, with the camera having literally dozens of menus and settings. Most cameras are capable of performing a huge range of operations, from stitching panoramas in-camera, to producing black and white and sepia toned images. For most plant photography, however, you will only need to access a small number of settings, and will probably use those same settings for the vast majority of your work. In many cameras, a group of frequently used settings can be saved in a 'user defined' section, so that you can easily revert back to it if necessary.

A major feature of digital photography is the metadata recorded alongside each image. This contains all the information relating to shutter, aperture, ISO, white balance, as well as date and time, for example. You no longer need to record all these settings in a notebook, and can refer back to them at any time afterwards.

Metadata is displayed on the rear screen of the camera when reviewing your images, and also in browser programs like Adobe Bridge™.

Most digital cameras will have all or some of the settings listed below, but different manufacturers may call them different names. The same principles still apply though. There are many more settings than outlined here – these are some of the ones that I find most important.

ISO

This is the effective speed, or sensitivity, of the imaging sensor (like film speed) – the higher the figure, the higher the sensitivity to light. Best quality will generally be gained from the lowest figure (usually around 100–200 ISO). As this figure increases, you may see an increase in 'noise' in the image, though modern cameras produce remarkably good images at high ISO settings, even up to 1,000 ISO or above. All of the images in this book were shot using 200 ISO.

LEFT This relatively simple shot of a nasturtium (*Tropaeolum* sp.) was shot with the following camera settings:
Shutter: 1/250 sec
Aperture: f/8
ISO: 200
Matrix metering
Auto White Balance (AWB)
Aperture Priority mode
Lens: 105mm

ABOVE These settings can be seen in the metadata displayed on the rear screen of the camera.

BELOW The metadata displayed in Adobe Bridge™.

FILE FORMAT

Most cameras today have options for saving images either as JPEG or Raw files. JPEG is an image compression routine for storing images, enabling a larger number of images to be stored on the memory card. However, any settings, such as white balance and sharpening, will be embedded into the file, and cannot be undone at a later stage.

When saving JPEG files, most cameras offer different levels of compression, such as 'good', 'better' or 'best' quality. The names are self-explanatory but may vary from one camera to another. Choose the highest quality wherever possible.

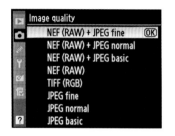

The Image quality menu on a Nikon D300s camera. Note the ability to shoot Raw, JPEG or both together, and different levels of JPEG compression.

Raw files are like exposed but unprocessed film – you choose the type of processing the image receives. On top of this, if you decide at a later date to re-process the image, then you can do so, with different settings if appropriate. Raw files need appropriate software to open them (such as Adobe Camera Raw™ in Adobe Photoshop CS6™, Photoshop Elements™ or Lightroom™, or the camera manufacturer's own software, for example Nikon View™). When a new camera is introduced, the Raw software will also need to be updated.

Some cameras allow the recording of both a Raw file and JPEG version at the same time. This may or may not be of use to you. Further discussion of Raw files can be found in chapter five.

RESOLUTION

Although your camera may have 8, 10, 12 or more million pixels (megapixels, Mp), you don't necessarily need to use them all for your images. You can set a different resolution (for example 640 x 480 pixels) if you know you are only shooting images for Powerpoint™ presentations, or the web, for example. However, if you have shot your images at low resolution you will almost certainly lose quality if you subsequently want to increase the resolution. I would

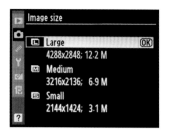

The Image size menu. I would always recommend setting this to the highest setting, unless you are certain you do not need the high quality.

recommend that you always use the highest quality setting unless you are certain you will not need it.

COLOUR/WHITE BALANCE

Most cameras have an 'auto white balance setting' (AWB) whereby the camera will automatically adjust itself to the colour of the light source (whether it be bright sun, overcast daylight, tungsten, fluorescent), but better results may be obtained by setting the actual light source in the camera menu. Remember, daylight can be very variable!

SHARPENING

Most cameras offer the ability to sharpen images before they are saved. Many offer different amounts – low, standard, high, for example. For various reasons, all digital images need to be sharpened, but usually by different amounts for different uses (web versus magazine publication, for example). The whole issue of sharpening is somewhat contentious, but it is best to turn off sharpening in the camera, or at least keep it on a low setting, and apply Unsharp Masking (USM) in Photoshop™ or another imaging program at the end of your workflow. If the images are destined for publication, or an image library, no sharpening should be applied, as printers of books and magazines usually apply their own sharpening during the printing process. Sharpening should be the very last operation in your imaging workflow, after any retouching or re-sizing. Further details are given in chapter five.

FILE NUMBERING

Most cameras apply a sequential numbering sequence to all images in a folder (0001, 0002 and so on). When the card is changed, or a new folder created, then the numbering starts all over again. This may result in a number of your images, taken at different times, having the same number, leading to possible confusion. I would suggest turning this feature off, and getting the camera to apply a sequential number to all your images. It will revert to zero after 9,999 images.

Exposure

The exposure metering systems in modern cameras are remarkably good, and give me well exposed images most of the time. I have not used a handheld meter for many years now, preferring to use the in-built technology of modern cameras, developed following years of research. There is some subjectivity regarding what is a well-exposed image – there will be instances where some people prefer slightly light or dark versions of an image. A certain amount of adjustment is possible in programs like Adobe Photoshop™, though you should, as far as possible, aim to get the exposure right at the time of shooting. Raw files give more scope for adjusting exposure in the computer. The histogram on the back of the camera, available immediately after the exposure has been made, gives a very good indication of whether the exposure is correct, and you should learn how to interpret it.

EXPOSURE MEASUREMENT

Digital cameras measure the amount of light which passes through the lens, and take into account any filters that are placed in front of it. There are three main methods by which exposure is measured in a modern camera.

- Spot metering
- Centre-weighted metering
- Evaluative (matrix or multi-segment) metering

Different manufacturers will have different names for these, but all essentially use the same methods.

Spot metering As the name implies, this method takes a reading from a small spot from within the subject. It can be useful if your main subject, such as a flower, occupies a small part of the frame, and is much brighter or darker than the surrounding area, but needs experience to get right.

Centre-weighted metering takes a reading from the whole picture area, but gives priority to the centre of the frame, assuming that the subject will be in the centre, which it may not of course.

Evaluative or matrix metering takes readings from several areas from the frame and effectively averages them. However, it is far more complex than that simple explanation implies. The matrix metering system in a Nikon, for example, takes into account the scene's contrast and brightness, subject distance (with the right lens), the colour of the subject within the scene and RGB (red/green/blue) colour values in every section of the scene. The meter then accesses a database of over 30,000 actual images to determine the best exposure for the scene. I find this method extremely reliable, and use it for the vast majority of my plant photography.

EXPOSURE MODES

The exposure mode dial on a modern DSLR camera, showing the aperture priority (A), shutter priority (S), manual (M) and program (P) mode, as well as various other modes.

There are four basic exposure modes on most cameras, together with a variety of 'scene' modes – preprogrammed settings for a variety of image types (portraits, night-time, fireworks or close-ups, for example). The four main modes are:

Aperture priority This is the mode I use for more than 95 per cent of my plant photography. I decide the aperture I would like to use, based on the subject and its situation, and the depth of field I want, and the camera then automatically selects the correct shutter speed to go with my selected aperture.

Shutter priority With this mode, you select the shutter speed, and the camera automatically selects the correct aperture. This is most often used by photographers

shooting fast action sequences, but is generally not appropriate for most plant photography. However, if there is a strong breeze blowing, and flowers on stems are constantly swaying, then you may want to use shutter priority, and select the fastest possible shutter speed to freeze the movement of the plant.

Program/auto Here, the camera automatically gives you the correct exposure based on various programs built into the camera. Whilst you will get a well-exposed image, you have little or no control over the aperture or shutter speed.

Manual With this mode you set both the aperture and shutter speed yourself, either using information from the camera's built-in meter, or perhaps an external light meter. I no longer use an external meter, relying entirely on the camera meter.

THE HISTOGRAM

One of the great advantages given to photographers by digital technology is the ability to see an image immediately after it has been taken, so that it can, if necessary, be reshot before leaving the location. The screen on the rear of the camera can show a small preview of the image, to allow the checking of composition, lighting and exposure. One feature, perhaps the most important of all, is the ability to show a 'histogram' of your image alongside the image preview.

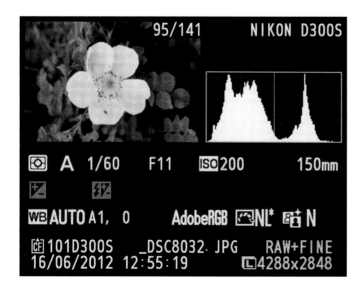

The rear screen of a modern DSLR, showing the captured image with its associated histogram, together with details about aperture, shutter speed, ISO, quality and white balance setting, and date and time.

INTERPRETING THE HISTOGRAM

The image histogram represents the image as a graph, showing the distribution of pixels against a scale from black (left-hand end) to white (right-hand end). Interpretation of the image histogram shows if the image is under- or over-exposed, and if certain areas of the image have lost detail. An image containing a dark background and pale-coloured flower, for example, will show a histogram with two peaks, one at the left and another at the right end.

'HIGHLIGHTS' OPTION

One of the most important features within the histogram display is the 'highlights' facility when displaying an image in playback mode. Any burnt-out, overexposed highlights flash, or blink, showing that there is no detail in that area, and indicating that you might want to reshoot the image with less exposure. It is always worth keeping this option switched on.

There is no such thing as a perfectly shaped histogram, as the content of all images will be different. However, unless you are specifically aiming for pure white or black backgrounds, generally you should aim for an exposure where the pixel values fall within the two ends of the graph. If the graph butts up against one end of the other, as though they are falling off one end, it is a good indication that the image is over- or underexposed.

NOTE ON HISTOGRAM DISPLAYS

When shooting Raw files, the image histogram is generated from a JPEG version of the image rather than the Raw file itself. Although they will be very similar, and good enough for checking exposure and composition, they will be slightly different.

The histogram shown on the rear camera screen is replicated in programs such as Photoshop™, where it is referred to as 'levels' (image › adjustment › levels). Here, various adjustments are possible, as outlined in the chapter Workflow and Image Processing.

LEFT This beautiful orchid (*Disa uniflora*) was shot in bright but diffuse light in a glasshouse. There is detail in all parts of the subject, as shown in the histogram, which extends to both ends of the scale without appearing to fall over at either end.

105mm macro lens, 1/60 sec at f/8

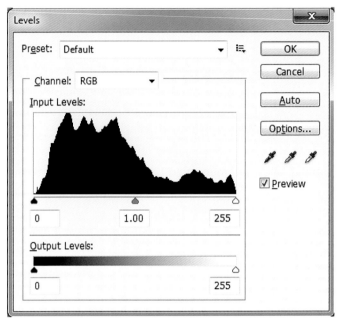

ABOVE **Histogram in Adobe Photoshop™ for the orchid.**

EXPOSURE COMPENSATION

Camera metering systems work by assuming that the scene they are measuring consists of a range of tones based around a mid-tone or pale grey. Many scenes conform to this pattern, but there will be others, such as white flowers against a pale-toned background, or dark subjects against a dark-toned background, where the meter may struggle, and give over- or underexposed images. It is situations like this where the exposure compensation button can be used to manually add or subtract from the camera meter.

If you have, for example, a pale flower against a pale background, known as a high key image, the camera meter may give a you an underexposed image, appearing as grey rather than white. In this case, adding perhaps +0.3, +0.7 or more on the exposure compensation dial will lighten the image to give a cleaner white. Be careful that you don't add too much or the white will become overexposed.

Similarly with a generally dark-toned subject, known as a low key image, dialling in -0.3, -0.7 or more will darken the image.

ABOVE **The exposure compensation button, allowing you to give more or less exposure according to the subject.**

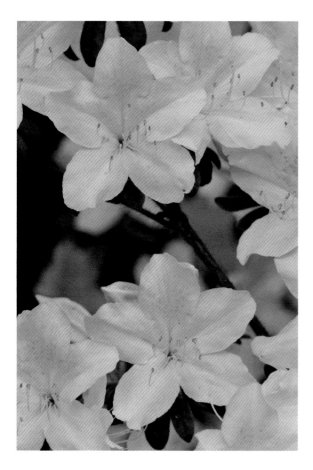

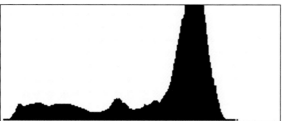

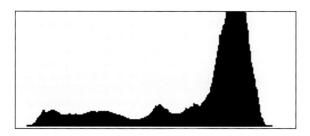

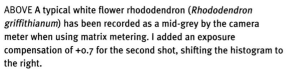

ABOVE A typical white flower rhododendron (*Rhododendron griffithianum*) has been recorded as a mid-grey by the camera meter when using matrix metering. I added an exposure compensation of +0.7 for the second shot, shifting the histogram to the right.

105mm macro lens, 1/60 sec at f/11

Composition

Even when trying to produce botanically informative images, it is the composition of the image which will make it ultimately successful or not. Many books have been written on the subject, giving 'rules' or guidelines to follow. While these rules are fine, and will help beginners in particular, many successful images break all rules of composition, so don't stick rigidly to them – experiment as much as you can. There really are no right or wrong answers. Composition seems to come naturally to some people, who can produce interesting pictures seemingly effortlessly, whilst others struggle. Making use of compositional rules can help enormously.

THE 'RULE OF THIRDS'

One rule or guideline often quoted when discussing composition is the rule of thirds. Imagine that your frame is divided horizontally and vertically into thirds. Positioning the

most important part of the subject on one of the intersections leads to a more dynamic and interesting composition.

The cropping tool in Adobe Photoshop™ has an option for overlaying a grid over your image, showing it divided into thirds, to help when cropping an image.

CIRCULAR SUBJECTS

Many circular subjects such as some flowers work very well if they are positioned in the centre of the frame, creating a symmetrical composition. Cropping the image to a square format may enhance the effect.

VERTICAL OR HORIZONTAL?

Whilst many subjects lend themselves naturally to a vertical or horizontal framing, do ask yourself if an alternative is worth trying. On many of my workshops I see people taking horizontal format images, where a vertical shot would be better, both from a botanical point of view and compositionally. This is partly, I suspect, because it is generally easier to hold the camera horizontally. There will be instances too where a subject that is seemingly perfect for a vertical composition will work well in a horizontal format. From the point of view of the sales potential of an image, it is often worth shooting both a horizontal and vertical format shot of your subject, to give a designer more scope in the use of the image – for the cover of a magazine, for example.

LEFT **This simple image of a single flower of Purple Wood Sorrel (***Oxalis purpurea***) was shot in a glasshouse, and composed to conform with the rule of thirds.**
105mm macro lens, 1/125 sec at f/8

RIGHT **The crop tool in Adobe Photoshop™ can be configured to show an overlay conforming to the 'rule of thirds'.**

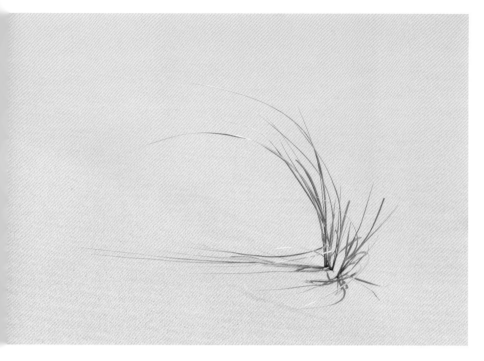

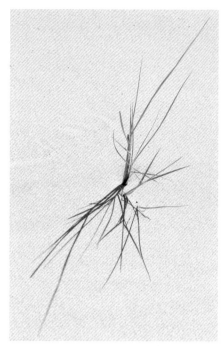

ABOVE I experimented with both horizontal and vertical compositions of this Marram Grass (*Ammophila arenaria*) growing on a Welsh sand dune.

105mm macro lens, 1/500 sec at f/8

BELOW Diagonals can work well in images to produce a dynamic composition, leading the eye into the frame – designers refer to this as a 'lead-in line'. I particularly like the way a single leaf of this Alpine Lady's Mantle (*Alchemilla alpina*) broke the diagonal line, and the three perfect leaves at the corners formed a triangle within the frame. It was shot on a very wet day in the Picos de Europa, in northern Spain.

105mm macro lens with 1.4x teleconverter, 1/25 sec at f/16

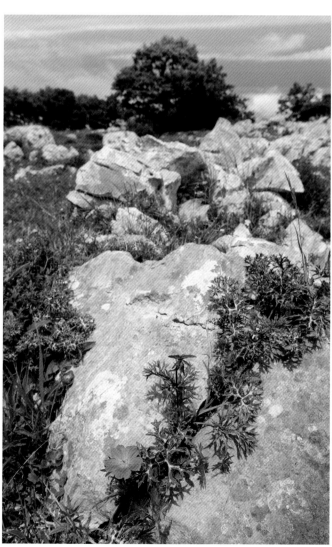

LEFT Another example of a diagonal line within a frame, to lead the eye into the image. Here, a single Bloody Cranesbill flower (*Geranium sanguineum*) was photographed growing out of a crack in a block of limestone, amongst the leaves of *Eryngium*. I particularly wanted to show the rugged terrain of the area, and that the flower was growing singly.

17–55mm lens at 17mm, 1/200 sec at f/8

Case study: The Burren

The Burren is an extraordinary area of limestone pavement in County Clare on the west coast of Ireland, renowned for its botanical richness. The area is an example of limestone pavement, and consists of limestone blocks (technically called clints) with water-worn cracks between them, called grykes. The grykes contain a wonderful range of plantlife – ferns, flowers and even trees, each one forming its own miniature garden. The pavement runs right down to the coast, and it is possible to find true alpine flowers such as Mountain Avens (*Dryas octopetala*) growing at or near sea level.

From a botanical and photographic point of view, May and June are the best times to visit, when a huge range of roses, orchids and other plants are in flower. It is a wonderful place to look for small details, such as small flowers growing from a large gryke, or textural contrasts between rock and plant.

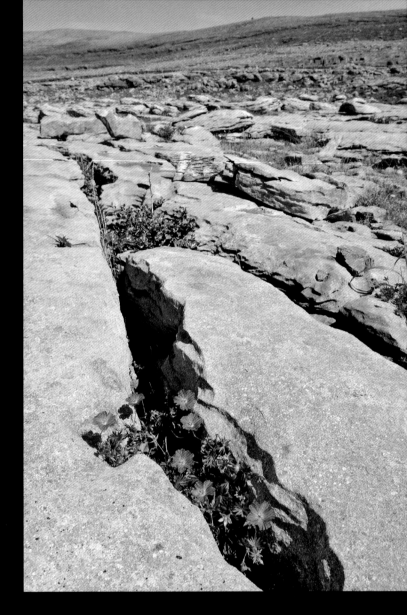

ABOVE Bloody Cranesbill growing in a gryke, with the Burren landscape in the background. I used a wide-angle lens close to the plant to show it in its environment.

17–55mm lens at 20mm, 1/640 sec at f/8

LEFT This Juniper (*Juniperus communis*) is rather like a bonsai tree growing flat on the limestone rock. The low-angled sun has created shadows, giving the image a more graphic feel.

17–55mm lens at 55mm, 1/640 sec at f/8

ABOVE LEFT One of the special plants of the Burren is the Mountain Avens, a beautiful alpine, usually found growing at high altitude in mountain regions. I have deliberately included one of the delicate seed heads in the image.

105mm macro lens with 1.4x converter, 1/250 sec at f/9

ABOVE Herb Robert (*Geranium robertianum*) growing in a gryke, safe from grazing cows.

105mm macro lens, 1/200 sec at f/8

LEFT This Blackthorn (*Prunus spinosa*) looks like a flattened miniature tree growing out of a gryke.

17–55mm lens at 35mm, 1/125 sec at f/10

CHAPTER 3

Basic Field Techniques

Most of my plant photography is done outdoors on location, in nature reserves, botanic gardens or the general countryside, where, for the most part, I use daylight as my light source, and backgrounds that cannot be changed. However, it is possible to easily modify the quality of the lighting, and decide if you want your background to be in or out of focus. Getting the colour right is vital too, and simple steps taken in the field can help with this enormously.

Light

There is no such thing as the perfect light for a plant photograph. Virtually every situation will be different – fungi in dark woodland, flowers in an open meadow, or seaweed on the seashore, for example. Dark dramatic skies after a rain shower can be a great way of picking trees out from a landscape, but will probably not be appropriate for a delicate orchid.

I always prefer natural light for my plant photography if at all possible, but of course both the beauty and the problem of natural light is that it is constantly variable, in terms of quantity, quality and colour.

Most digital cameras are remarkably good nowadays at low-light photography, so if you have a specimen in deep shade, you are still likely to get a reasonable image with a high ISO setting. I generally would prefer to use a low ISO and long shutter speed rather than high ISO, though again, many cameras now will give perfectly acceptable results with ISO settings up to 1,000 ISO and beyond.

Colour too is relatively easy to deal with nowadays. The auto white balance feature will deal with most situations, but you can also set the colour balance on your camera to 'cloudy' or 'sunny', or 'artificial' light if you are working in a glasshouse with growing lights, for example. Using a grey card can also help to achieve the correct colour.

RIGHT This is one of my favourite images, a simple shot of Bramble leaves growing out of a water-worn gryke in the Burren on the west coast of Ireland. It was important to get the camera directly overhead so that the sensor was parallel to the main plane of the leaves.

105mm macro lens, 1/250 sec at f/8

By quality of light we are referring to whether the light is harsh and 'contrasty', or low contrast and dull. Very often, light quality is referred to in very subjective terms, such as 'flat', 'harsh' or 'dull'. For many plant specimens my own preferred light quality is 'bright overcast', by which I mean there is a good quantity of light, with neutral colour, and it is not too harsh. A good way of visualising this is a bright sunny day with a thin veil of cloud over the sun to diffuse it. Other subjects such as trees may require dramatic skies and contrasty lighting to bring out their shape.

ABOVE This Tawny Grisette toadstool (*Amanita fulva*) was lit by my favourite type of light – bright overcast. There is detail in all parts of the subject from shadows through to highlights.

105mm macro lens, 1 sec at f/14

Dappled light in woodland can make it difficult, if not impossible, to get acceptable images on occasion, and if you are shooting wide-angle habitat shots there is no real answer other than waiting for a cloud to cover the sun.

Backlighting can dramatically emphasise hairy stems or translucent flower petals. Be careful when using back-lighting to check that the light is not shining directly into the lens, causing flare, and remember to use a lens hood.

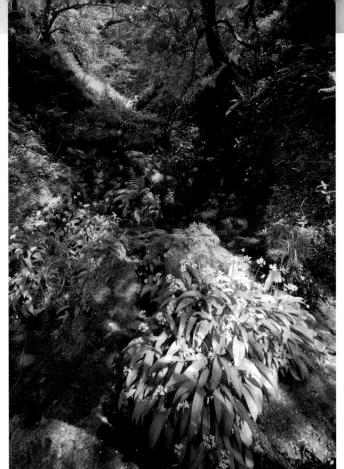

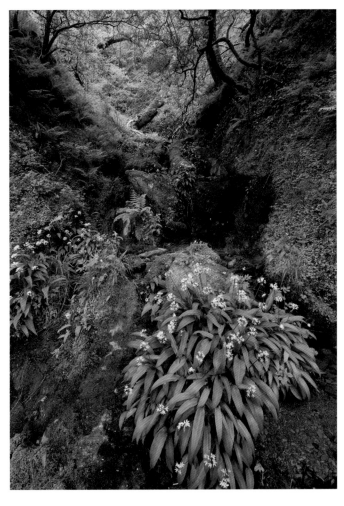

LEFT Ramsons, or Wild Garlic (*Allium ursinum*) growing in a stream bed, Snowdonia, North Wales. The first shot was taken in bright sunshine, giving burned-out highlights and dense shadows. I waited for a few minutes for a cloud to pass over the sun, effectively diffusing it and making the contrast range fit better with the recording capabilities of the imaging sensor, particularly important when dealing with white flowers. The effect lasted just a few seconds before the cloud moved on.

10–20mm lens at 12mm.
First image 1/15 sec at f/13,
second image 1/8 sec at f/13

RIGHT I found these Pasque Flowers (*Pulsatlilla vulgaris*) in a raised bed in a botanic garden. The light was behind them, emphasising the hairy nature of the plant. I used a 70–200mm lens with a 1.4x converter (effectively a 98–280mm lens) at its longest focal length to throw the background out of focus.

70–200mm lens with 1.4x
converter (effectively 280mm),
1/640 sec at f/5.6

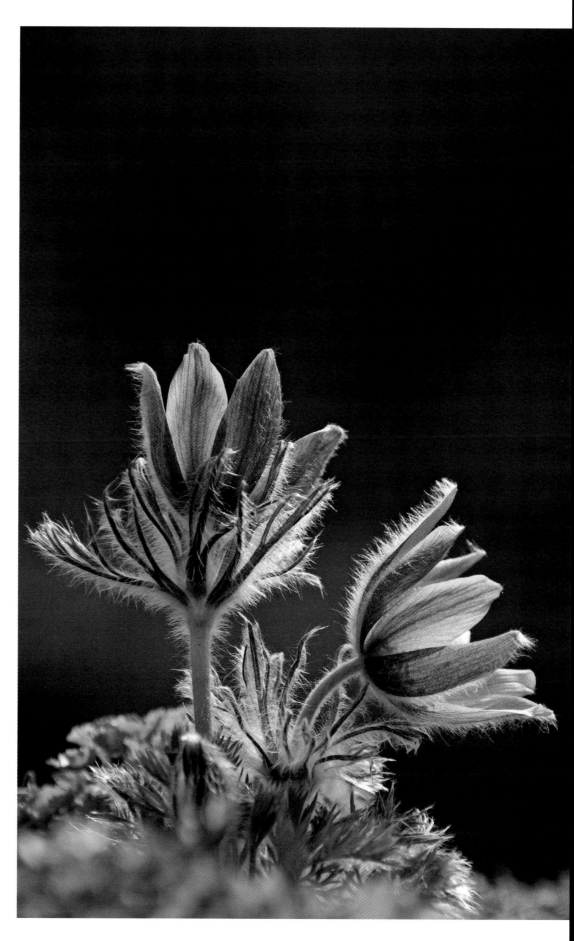

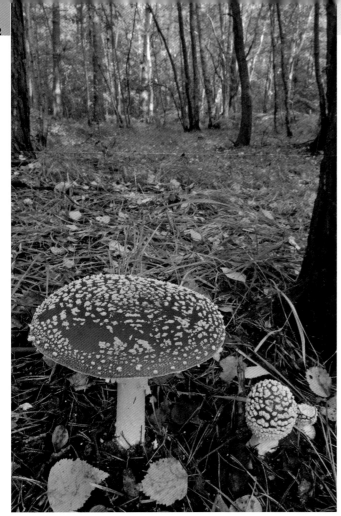

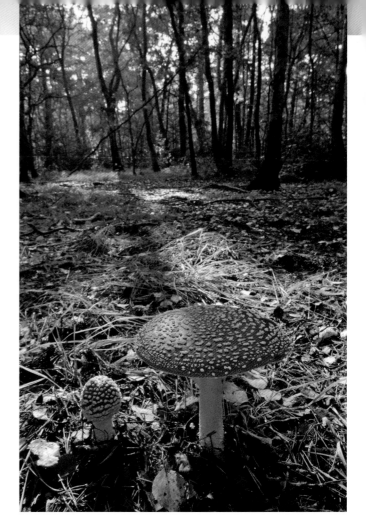

ABOVE I found these Fly Agaric (*Amanita muscaria*) toadstools growing in a Birch wood on a day when the light was constantly changing. For the first shot the light was bright, overcast. For the second, I moved to the other side of the specimens to get a backlit shot. Neither is right or wrong, but they do have a very different 'feel' to them. It is always worth going right round a specimen if the lighting conditions are appropriate.

17–55mm lens at 17mm. First image: 1/3 sec at f/16, second image: 1/8 sec at f/16

The same subject can be completely transformed by changing the direction of light, and it is always worth viewing your subject from all directions to see which works best.

Of course, you will not always have the right lighting conditions, and may need to modify the existing light in some way. Various options are available such as the use of reflectors to 'fill in' shadows, diffusers to soften the light and reduce contrast, or flash to work either in combination with daylight, or provide the entire light for the subject. Whatever method you use to modify natural light, remember you are trying to retain the original character of the light, and just make it more acceptable for recording by a digital camera.

REFLECTORS

The human eye is remarkable in being able to see detail in a very high contrast subject, and may be able to see detail in both shadows and highlights where the ratio of brightnesses may be 10,000:1 or more (the highlight is 10,000 times brighter than the shadow), which may well be the case in places like the Mediterranean in high summer. Digital cameras cannot record anything like this range (maybe only 200:1), and may give blocked up, totally black shadows, or burnt-out highlights in extreme conditions. A reflector can be used to reflect light into shadowed areas of a subject. Take the example of a pale-toned toadstool in direct sun. The top of the toadstool may reflect 1,000 units of light, whilst the shadow underneath may only reflect one unit of light – a brightness ratio of 1,000:1. If the reflector bounces just one unit of light back into the subject, the highlight now reflects 1,001 units, whilst the shadow reflects two units, a ratio now of 500:1 – the contrast is halved.

A reflector can be made from any white or silver-surfaced paper or card. I have used stick-on plastic silvered wall

Harsh sunlight on a solid subject such as a toadstool gives very dark shadows and bright highlights.

A white or silver reflector fills in the shadow area, reducing the contrast.

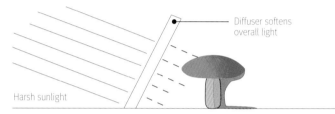

A diffuser softens the overall light, reducing contrast.

tiles, or sheets of polystyrene, though these disintegrate easily. The silver-sided cardboard lids of some take-away food containers are also very useful. Other good reflectors that I have found recently are the cardboard bases known as cakeboards, sold for cake makers. They are made from fairly thick cardboard, with a silver surface. The nice thing about the surface is that it is wrinkled rather than smooth, which gives a much softer reflective surface.

Several companies, such as Lastolite, make circular reflectors which fold down to a small size. Probably the most useful for most plant photography are those that open to 30cm, and fold down to around 15cm, and will fit into a jacket pocket easily. Several surfaces are available: white, silver and gold being the most useful. They are double-sided – white and silver, or silver and gold, for example. Even these surface types come in different variants – I use the 'soft silver' and 'sunlight' combination routinely – the soft silver is not so harsh as the ordinary silver surface.

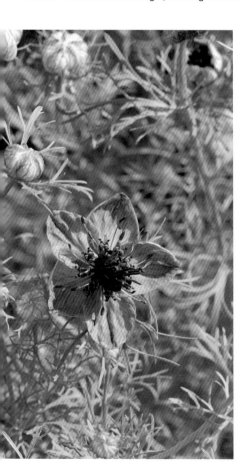

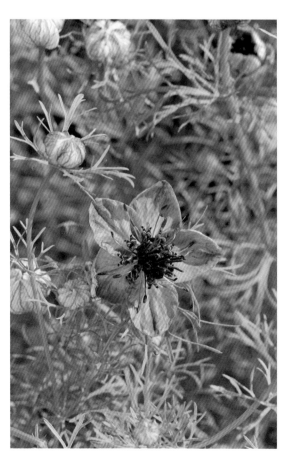

LEFT I photographed this Love-in-a-Mist (*Nigella hispanica*) flower in midsummer in a mixed border, on a bright sunny day. Although the contrast was not too harsh, I felt it needed reducing a little, so used a small white reflector to bounce some light into the shadow on the left-hand side of the flower.

105mm macro lens,
1/320 sec at f/8

 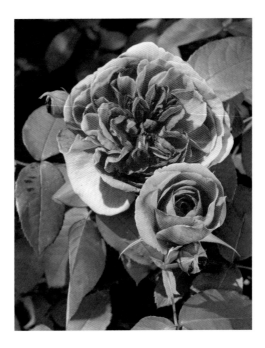

LEFT This garden rose 'Gertrude Jekyll' was growing in a very sunny spot in a garden border. I felt that it needed quite a large amount of fill in the shadows, so used a large silver reflector held at the bottom right of the frame, to bounce light into the shadowed areas. Note in particular the area at the bottom left of the image.

105mm macro lens, 1/200 sec at f/11

ABOVE This dog lichen (*Peltigera* sp.) was growing on a sunny hedgebank in the Picos de Europa in northern Spain. With undiffused sunlight the contrast was too great, and the highlights were burnt out. I used a large diffuser between the sun and the subject to soften the light, bringing detail to all parts of the image. This reduced the exposure from 1/4 sec at f/11 to 1/2 sec at f/11.

105mm macro lens. First image: 1/4 sec at f/11, second image: 1/2 sec at f/11

Gold or 'sunlight' surfaces are useful for warming the tone of an image in dull weather, or dark woodland. Take care not to overuse this surface, though, as the colours within the image may become too 'warm'.

It is important, when using reflectors, not to overdo the effect. Subjects are naturally lit from above, and to have a subject appearing to be equally lit all over will be misleading and look unnatural.

The angle of the reflector can be critical. It is always worth looking through the viewfinder whilst you adjust the angle – a perfect job for an assistant if you have one.

DIFFUSERS

A diffuser is held between the sun and subject to soften the light, just like a cloud. It generally needs to be larger than a reflector, and can be difficult to handle in the field if you are by yourself. Diffusers will obviously reduce the amount of light reaching the subject, thus necessitating a longer shutter speed (or wider aperture).

CAST A SHADOW

One trick you might employ in bright sunny conditions is to cast a shadow over your subject, either by standing between the sun and plant, or maybe using your camera bag to cast a shadow. Like the diffuser, this will make the subject darker, but will soften the light considerably.

 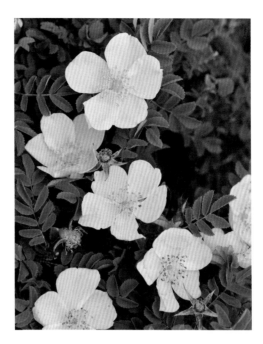

LEFT These Burnet Roses (*Rosa pimpinellifolia*) were growing in the middle of limestone pavement in the Burren, in western Ireland. I had gone for a final walk before catching my plane, with only my camera, macro lens and tripod. The first image was lit by harsh sun, which washed out the white petals, and created harsh shadows. To get the second image I put myself in between the sun and plant, casting a shadow. This softened the light, toning down the white petals and creating a much better tonal range.

105mm macro lens. First image: 1/1,000 sec at f/8, second image: 1/250 sec at f/8

FLASH

Although I always prefer natural light for my images, and the vast majority in this book were shot with natural light, there will be instances, on very dull days for example, when no amount of reflection or diffusion is going to work, and the image is just going to look very dull and flat. This is when you might consider using flash, either to light the whole scene, or merely add a 'sparkle' to your subject. Most cameras have built-in flash units, which might be useful for adding a sparkle to an image. However, being immediately above the lens axis means that the flash will be aiming straight at the subject, giving very flat, ugly lighting.

A much better technique is to use a separate external flash gun, which can be linked to the camera via a cable (or in some instances fired wirelessly from the camera). Setting the flash to 'TTL' will give the correct exposure automatically. The flash output can be modified, so that more or less flash is added to the image.

Some units such as the Nikon Speedlights have a 'TTL BL' setting (automatic balanced), which automatically balances the flash with the ambient daylight, effectively acting as a 'fill-in' light. When the daylight and flash contribute equally to the image the effect can look unnatural. Reducing the flash output, by dialling in -0.3, -0.7 EV or more on the flash gun will give a more natural look to the image. You will need to experiment to see which setting you prefer.

Specialist macro flash units are available, which fit close to the lens, and allow you to direct the light onto the subject when working at very close range.

Various diffusers and other accessories are available for external flash guns to soften the light emitted from them. These include diffusers, mini soft-boxes and mini-umbrellas which fit onto the flash unit. I often use either soft white freshly laundered linen handkerchiefs, or even tracing paper. You can also try bouncing the light off a piece of white card.

ABOVE This heliconia was growing among dark leaves low down in the glasshouse of a botanic garden. I felt that it would look rather dull using natural light, so used a small flash gun to brighten the colours and add some depth to the image. Note how the leaves look rather 'cool' in the daylight image but are a much better green when taken with flash. The flash was set to auto TTL BL, meaning the flash output was balanced with the daylight.

105mm macro lens. First image: 1/30 sec at f/8, second image: 1/60 sec at f/8

Getting the colour right

Of all areas of nature photography, plants perhaps demand the highest level of colour fidelity. Subtle greens of foliage, vivid red roses, subtle blue flowers, or the dull browns of seaweeds can all be difficult to get right. In the days of film, Kodak published 'recipes' for combinations of filters to be placed in the front of the lens to correct the colours of blue flowers, for example, in particular the garden plant ageratum, which was notoriously difficult to photograph correctly. They even called it the 'ageratum effect'. The problem is mainly due to the fact that flowers such as ageratum reflect not only visible light, but also infrared and ultraviolet light. These wavelengths, while invisible to the human eye, were recorded by the film, leading to purple flowers rather than the blue ones that we see. Fortunately, modern digital cameras are much better at recording true colours (though some still struggle with bright red in particular), and of course, the images can be tweaked in Adobe Photoshop™ afterwards.

The colour balance settings on your camera are generally very good, and I use auto white balance (AWB) most of the time, though will switch to 'shady', 'cloudy' or 'incandescent' where appropriate. It is probably best, though not essential, to shoot Raw files for best control.

USING A GREY CARD

As a check, when using auto white balance or one of the colour presets in the camera, it is often worth photographing a photographic grey card (or similar device) and using this to help get the correct colour. Good examples are the Kodak 18 per cent Grey Card, the Colour Confidence Total Balance tool™, and the Lastolite XpoBalance™. The grey cards are supplied as A4 sheets.

BELOW A Bluebell wood in spring, in sunshine and overcast conditions. Note how not only the blue colour becomes more saturated in the second image with overcast light, but the green foliage changes colour too.

17–55mm lens at 55mm.
First image: 1/125 sec at f/9, second image: 1/60 sec at f/9

I cut these into four, and keep one, in a plastic CD wallet, in my camera bag at all times.

Place the card in front of the subject, so that it receives the same light as the subject. Use a manually set exposure, and use an appropriate pre-set colour setting (sun, shade or incandescent for example) and shoot a frame. Then,

using the same exposure, remove the card and take an image of the subject without the card. The reason for using manual settings is that the camera meter would adjust itself for the inclusion of the grey card in the image.

The procedure for colour adjustment is now different depending on whether or not you have shot JPEG or Raw files. With Raw files, open both images (the image of the subject, and the image of the grey card) in the Raw converter, such as Adobe Camera Raw™. Select the image with the grey card, and look at the histogram. If this shows a colour cast (see example) then select the white balance tool, and click inside the image of the card. This should neutralise any colour cast on the card. Now go to

ABOVE Colour balance menu on DSLR. I find that 'auto' works well most of the time.

ABOVE The auto white balance can be fine-tuned to give warmer or colder images.

BELOW I accidentally shot this Madagascar Periwinkle (*Catharanthus rosea*) on the wrong colour setting on my camera (shady).

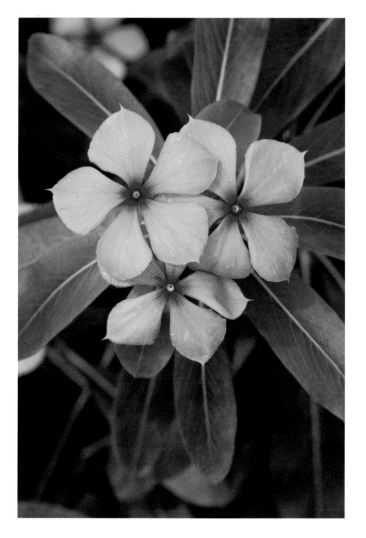

ABOVE I opened both images in the Raw converter and selected the one with the grey card. Note the histogram showing three coloured 'peaks', indicating that the image of the grey card is not grey.

ABOVE Using the colour balance dropper tool, I clicked on the grey card, which neutralised the card (note the histogram). I then selected both images and pressed the synchronise button. This applies the settings from the grey card to the final image.

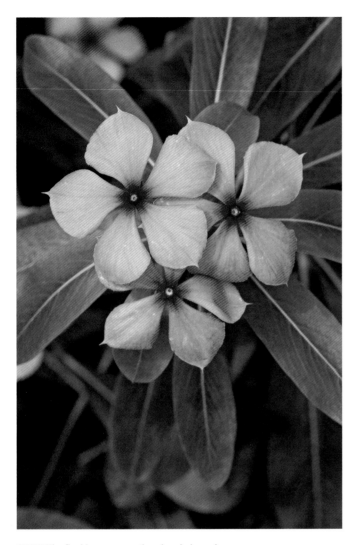

ABOVE The final image correctly colour balanced.

105mm macro lens, 1/60 sec at f/11

ABOVE The same image shot as a JPEG file.

BELOW The levels dialog box, showing the grey point dropper.

the left-hand panel, select both images and click 'synchronise'. This will apply the setting required to neutralise the card to the image of the flower, and neutralise that.

With JPEG files, open the image of the grey card in Adobe Photoshop™ and select the 'info' dialog box (window › info). Place the cursor on the grey area, and look at the readings for RGB. If the three readings are the same, then you have a grey image of a grey card and no correction is necessary. If one of the values is significantly higher than the others, then the image has a colour cast and can usually be corrected. There are a number of ways of doing this. Probably the easiest method is to open the levels dialog box (image › adjustments › levels). Select the 'grey point' dropper

ABOVE The image with the grey card, with the preset applied.

BELOW The levels dialog box showing the settings saved as a preset, to be applied to the image without the grey card.

ABOVE The final image. I have lightened it slightly after the colour adjustment.

(see image) and click inside the grey card. This should bring it back to a neutral grey tone. The settings used to do this can then be applied to the image without the grey card, neutralising that.

MANUAL WHITE BALANCE

You can also manually adjust the white balance of your camera for a particular lighting condition. Point the camera at a white surface, preferably the reverse side of a photographic grey card, but if this is not available, any white piece of card paper or material. Make sure the white surface is receiving the same light as the subject. Different camera models will now differ in terms of method, but most DSLRs, and some compacts, allow you to adjust the light reflected from the card until it is a neutral tone. I do this only rarely.

Backgrounds and foregrounds

LEFT Nickerbean.
A long focal length lens was used to isolate the seed pods from their background. I chose a position where the pods were backlit to highlight the bristles, and would have a dark background behind them. I used a wide aperture primarily to throw the background out of focus, but also to help freeze the movement of the pods which were swaying in a stiff breeze.

200–400mm lens at 260mm,
1/200 sec at f/4.5

LEFT In the second image of Nickerbean seed pods I wanted to show a typical assemblage of coastal plants from the region. I used an aperture of f/11 with a zoom lens at 150mm length to gain as much depth of field as possible.

18–200mm lens at 150mm,
1/60 sec at f/11

It may seem odd that one of the largest sections in this book is concerned with the background behind your subject, rather than the subject itself, but a poor background can destroy an otherwise good image. Any image of a plant really consists of two components, the subject itself, and the background behind it. The background can contain important information about the subject, be it an indication of the habitat, or some of the other plants which are associated with it, or it can act as a non distracting coloured backdrop, complementing the subject. A cluttered, highly distracting background should be avoided in most instances.

There will often be a compromise between needing a large depth of field to bring the whole subject into focus, yet still trying to keep the background out of focus. Sometimes it will be impossible to throw a background out of focus, and it may be better to use a small aperture to bring more of it into focus.

On recent visits to southern Florida I have become fascinated by the Nickerbean (*Caesalpinia bonduc*), with its bristly seed pods. I first photographed a pair of seed pods, backlit against a relatively dark background, to isolate the pods from their surroundings, and highlight their bristly nature. I used a 200–400mm lens (taken with me to photograph birds), at an aperture of f/4.5 to throw the distant background completely out of focus. I also used a small silver reflector to lighten the front of the pods. I found the seed pods in the second image growing in a small marina in south Florida. I knew immediately that I wanted to get both the seed pods and their leaves, together with the leaves of the Sea Grape (*Coccoloba uvifera*) in focus, to show a typical assemblage of coastal plants from the region. I used an aperture of f/16 with a zoom lens at 150mm length to gain as much depth of field as possible.

ABOVE I love the subtle shades of Apple (*Malus domestica*) blossom in spring. I wanted to photograph this attractive group against an out-of-focus background, but because there were so many other flowers and branches in the background it took a long time to get the exact position right. The tripod was extended to its full height. Even here I would have preferred it without the bright, white, out-of-focus flower at the top of the frame.

105mm macro lens with 1.4x converter, 1/160 sec at f/5.6

It can be difficult to obtain an out-of-focus and non-distracting background – there always seem to be blurred twigs, branches or other flowers in the shot if the background is too close to the subject, and no amount of careful positioning will help. Long lenses can help to throw a background out of focus. I often use 200mm, 300mm or longer lenses for this purpose. If your subject is too close for the lens to focus then you can use a small extension tube to enable the lens to focus closer. I frequently use a 12mm tube with a 300mm lens for this purpose. Longer tubes are available – the longer the length of tube, the closer the lens will focus. Sometimes, a small change in viewpoint is all that is needed to achieve a better background. If you are photographing a flower growing on the ground, a low viewpoint may help, with the lens looking over the vegetation behind your specimen to the background beyond.

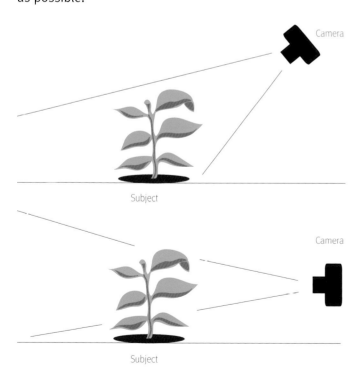

Lowering the camera viewpoint shows less of the distracting area behind the plant and more of the background, which, if far enough away, will appear out of focus.

In general, the smaller the subject, the greater the chance of achieving an out-of-focus background. This image of Snakeshead Fritillary stamens (*Fritillaria meleagris*), exposed when the petals have fallen from the flower, was shot with a 105mm macro lens, coupled with a 1.4x teleconverter, giving an effective focal length of around 150mm. I used an aperture of f/4.5, and a low viewpoint so that the background (a flower meadow) was distant from the subject.

Tip: If there is a distracting blob or blurred line in the background behind your subject, and you cannot see what is causing it, refocus the lens on the background, which will bring the distracting element into focus. Having identified the offending item, and hidden or removed it, refocus the camera back onto the subject. Make sure to use the depth of field preview too if you have one on your camera.

ARTIFICIAL BACKGROUNDS

A technique used by some photographers is to use artificial backgrounds, such as mounted inkjet prints of out-of-focus vegetation, or spray-painted boards. This can be highly effective if the boards are lit well, without glare to give the game away.

ABOVE Stamens of Snakeshead Fritillary. It is much easier to blur the background when doing close-ups, particularly with a long focal length lens. The bokeh with this lens is superb.

105mm macro lens with 1.4x converter,
1/1,250 sec at f/4.5

RIGHT I shot these scenes in my garden with a 300mm lens, deliberately well out of focus, printed them to A3, and mounted them onto polyboard. I can use them in the studio, or occasionally outdoors, behind a pot plant for example.

THE FOREGROUND

Whilst the subject and its background are fundamental to the success of an image, another element worth considering is the foreground. A messy foreground can be as distracting as a messy background, whilst a dull, uninteresting foreground can also detract from an image. With tall plants in particular, there can be quite a sizeable redundant area of the image in front of your subject. Throwing the foreground out of focus can be a useful device, with photographers often referring to the resulting area as 'mush'.

Shooting through out-of-focus vegetation can be very effective, though it does need to be very soft to work well. A long lens, 300mm or longer, and wide aperture will help. To achieve the out-of-focus vegetation it will need to be quite close to the camera, with the main subject a good distance away.

RIGHT It was difficult to isolate this Greater Stitchwort (*Stellaria holostea*) flower from its surroundings, so I deliberately shot through a curtain of vegetation with a long focal length lens to create an out-of-focus 'mush' around it.

70–200mm lens with 1.4x converter, 1/125 sec at f/4

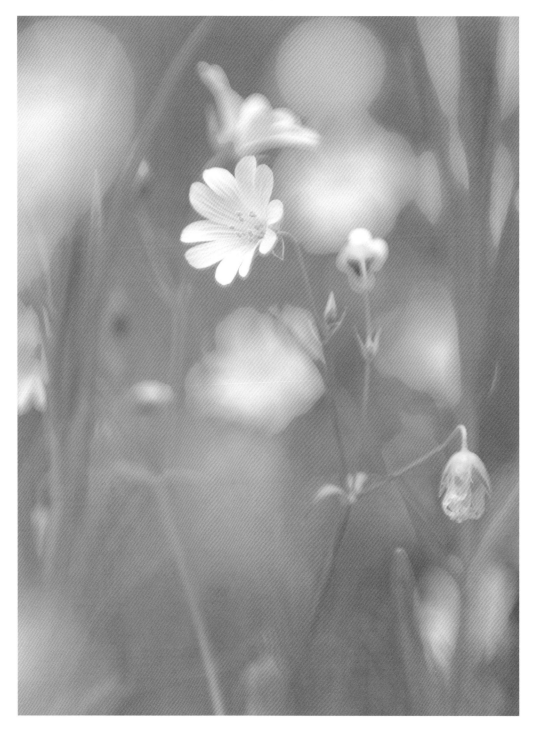

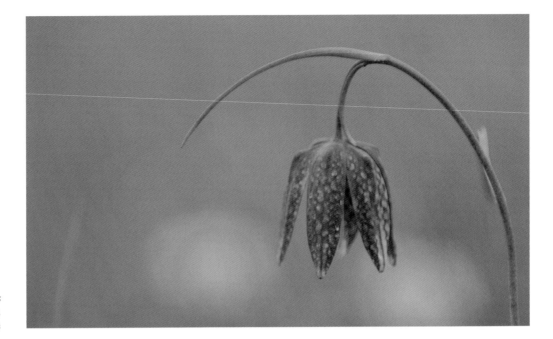

RIGHT AND BELOW
Snakeshead Fritillary.
The first image has two very
distracting out-of-focus Dandelion
flowers in the background. For the
second shot I bent them under
vegetation to hide them.

*70–200mm lens
with 1.4x converter,
1/500 sec at f/4*

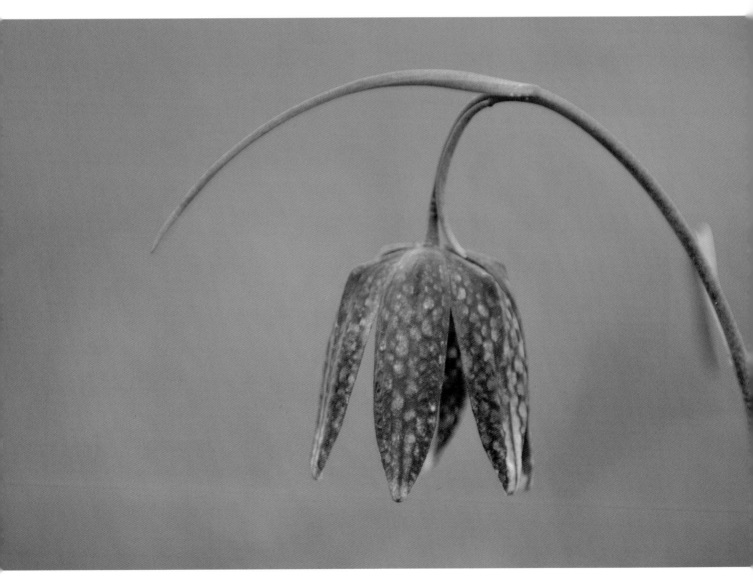

GARDENING

Talking about backgrounds usually brings up the somewhat controversial question of 'gardening' in plant photography. When plant photographers talk of gardening they are referring to the removal, or not, of distracting elements in the background or foreground of the image, such as grass blades or brightly coloured flowers. As an ardent conservationist I am passionate about not damaging the environment in order to get a picture, yet there may be some instances where a small amount of gardening may be acceptable – removing a blade of grass for, example. I always scan my image before pressing the shutter button for debris such as twigs or small stones that could be distracting. In some cases I may leave a distracting object in the background with the aim of removing it in Adobe Photoshop™ later.

In the case of the Snakeshead Fritillary shown here, the two yellow blobs are out-of-focus Dandelions (*Taraxacum officinale*). These, together with the leaf on the left side, were carefully bent out of the way to achieve a distraction-free background. It might be argued by some that the yellow colour adds to the image, and each case needs to be looked at individually.

With the second pair of images, I retouched the purple blob in Photoshop™ using the 'healing brush' tool.

BELOW White variety of Fritillary. In the first image there was a distracting purple blur of another flower in the background. I later removed it in Photoshop™ using the healing brush tool.

70–200mm lens, 1/800 sec at f/4

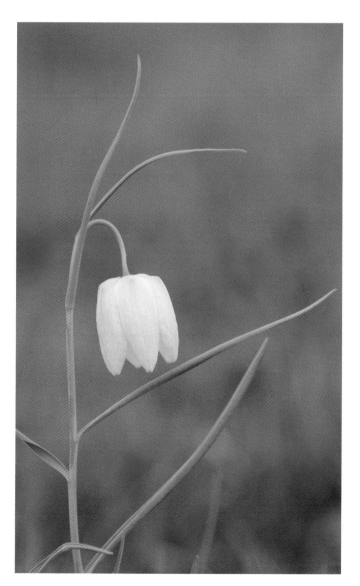
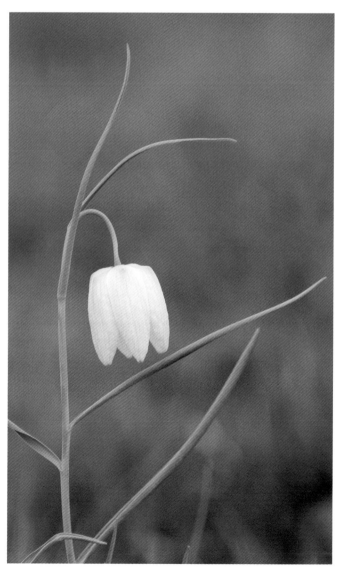

Case study: Scurvy grass

Whilst many plants are thought of as being found in one particular type of habitat, certain circumstances may cause them to alter their distribution, sometimes with disastrous ecological consequences, in other instances with no harm at all. For example, Japanese Knotweed (*Fallopia japonica*) was introduced as an ornamental plant into UK gardens in the 19th century, started to spread outside and is now a very invasive weed, costing millions of pounds each year in an effort to eradicate it.

Danish Scurvy Grass (*Cochlearia danica*) is a native plant of coastal regions of the UK, and around 30 years ago started to appear on inland railway sites and edges of major roads, where stone rubble from seashore sites had been used in the building process. Salt, used in winter as a treatment for icy roads, is thought to have helped it survive inland, together with traffic stirring up its seeds and blowing them around along the roads. Today it is found along many stretches of major roads in the UK, and is generally thought to be an attractive addition to our roadside flora.

I knew of many locations for this plant along local roads, but the most difficult aspect of the shot was to find a suitable spot where I could park my car and photograph it safely. (I wore a bright yellow high visibility jacket.) I needed to get close to the plant, while showing traffic in the background. I wanted to use a relatively long shutter speed to give an indication of the fast-moving traffic helping to spread the plants' seeds. However, when I used anything longer than 1/30 second, the plant was blurred due to the wind caused by the traffic.

ABOVE **Close-up of Danish Scurvy Grass on a rocky shore.**

17–55mm lens at 48mm,
1/250 sec at f/6.3

RIGHT **Danish Scurvy Grass** (*Cochlearia danica*) **growing alongside the busy A3 road in Surrey, UK.**

17–55mm at 17mm,
1/60 sec at f/16

CHAPTER 4

The Studio

Working in controlled conditions indoors has many advantages for a plant photographer – there is no wind to blow your subject around, for example, and you have complete control over the lighting and background. Obviously, though, the range of subjects available will be limited. I often grow plants specifically to photograph them indoors. Patience, an eye for detail and an ability to improvise are important to get the best results.

Studio and controlled conditions

There are many reasons why you might want to photograph plants indoors, in a controlled 'studio' setting. Apart from the obvious problems with weather, you might want to produce a consistent set of flower portraits, using a constant light source and background, or take extreme close-ups of plant features, for example. The 'studio' might be your study, a spare bedroom, conservatory or even the kitchen depending on the subject. I also frequently use a table on my sheltered patio as a makeshift studio. Don't just think of studio photography as using artificial lighting – daylight can be just as effective indoors as outdoors. I often use the light coming through my study window as a light source. On very sunny days I tape tracing paper over the window to diffuse it.

Never underestimate the space required for studio photography, even for small subjects. You will need a reasonable distance between the background and the subject, particularly if you want to use any backlighting, as well as the camera to subject distance. For a simple portrait of a flower for example, you might need a total distance of a metre or more. A lens in the region of 60mm length should be appropriate for much of the work.

RIGHT **This Strelitzia was photographed with the soft light coming through my study window, against a black velvet background.**

60mm macro lens, 2 secs at f/11

EQUIPMENT

Depending on the subject you can hold it in a vase, bottle, or, best of all, a laboratory retort stand, which can be found easily on internet sites such as eBay. These are really useful, and can also be used for holding reflectors and flash guns. I also have a couple of 'helping hands' devices used by model makers, jewellers and electricians. These too are readily available on sites such as eBay.

Another useful accessory if you intend to do much of this work is a laboratory 'scissor jack' which enables subjects to be raised or lowered easily and precisely.

If you are photographing flower stems or other live vegetation, place the stems in a flat-bottomed medicine bottle filled with water, or wrap wet cotton wool around the base of the stem, which will prevent it from drying out.

For dissecting out plant features for photography you will find a small set of instruments useful, this might include a scalpel, tweezers, pins, scissors and paintbrushes.

LIGHTING

For simple plant portraits, a single light source with a reflector may be all that is needed. Electronic flash is the obvious choice, though desk and reading lamps can also be used (you should switch the white balance setting on the camera to 'incandescent' when using one). If you use a flash gun, you need to use it separated from the camera, so that it can be held above and to one side of your subject. Extension cables are available for the purpose. A range of accessories are available to modify the light, such as umbrellas and soft-boxes, though you can equally use cheap diffusing material such as white Perspex, the white corrugated plastic used for stiffening envelopes, or even white cotton handkerchiefs.

BELOW You can create an outdoor studio very easily. Here, this simple shot of a Yellow Iris (*Iris pseudacorus*) from my pond was shot in the garden using diffuse daylight. The leaves and flower stem were placed in glasses of water, and held in place with laboratory retort stands. The background was the lawn.

105mm macro lens with 1.4x converter, 1/320 sec at f/8

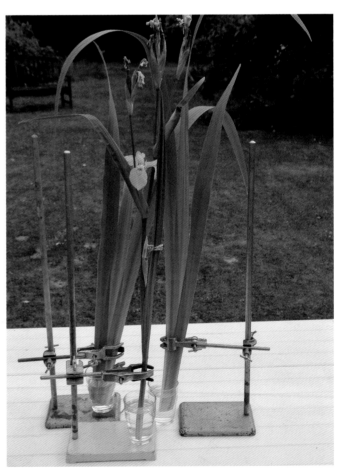

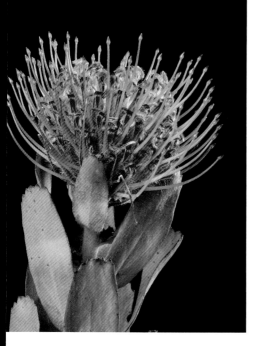

ABOVE A Pin Cushion Protea
(*Leucospermum cordifolium*) shot with
an electronic flash unit, fitted with a
white umbrella to give a soft light.

60mm macro lens, 1/125 sec at f/18

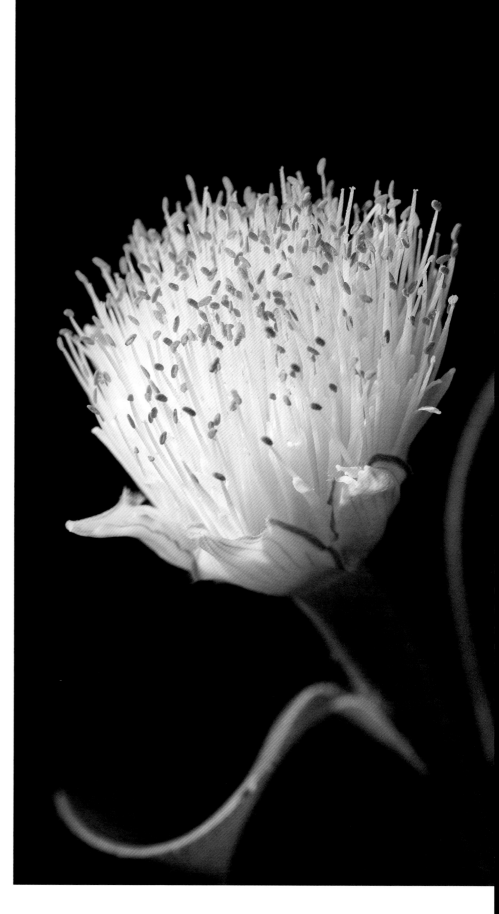

RIGHT This South African Paint
Brush (*Haemanthus albiflos*) was
photographed with a single
electronic flash gun with two layers
of tracing paper over the flash
window, and a black paper tube to
narrow the beam so that it would
just highlight the flower, allowing
the background to fade to black.

105mm macro lens, 1/125 sec at f/8

ABOVE A light tent in use on a table on the patio of my garden. Note the 'helping hand' device holding the Gazania flower. Different backgrounds can be inserted at the rear of the tent. Much larger versions are available for larger specimens.

RIGHT A Gazania flower photographed against four different backgrounds in the light tent. It is interesting to see the effect that background colour has on the overall image.

105mm macro lens with 1.4x converter, all images at f/11

LIGHT TENT

A range of simple, inexpensive light tents are available nowadays, marketed primarily for photographing objects that are to be sold on internet sites such as eBay. Effectively the subject is enclosed within a translucent tent, through which light can be shone, giving a very pleasant diffuse effect. A single electronic flash gun or a tungsten reading lamp are ideal, though I often use one on a table in the garden, using daylight. Different coloured backgrounds can be inserted at the back.

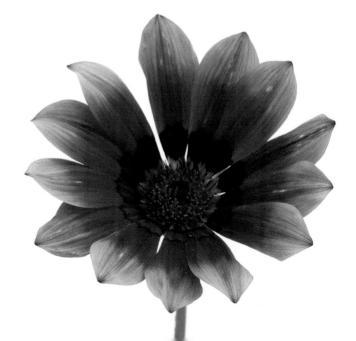

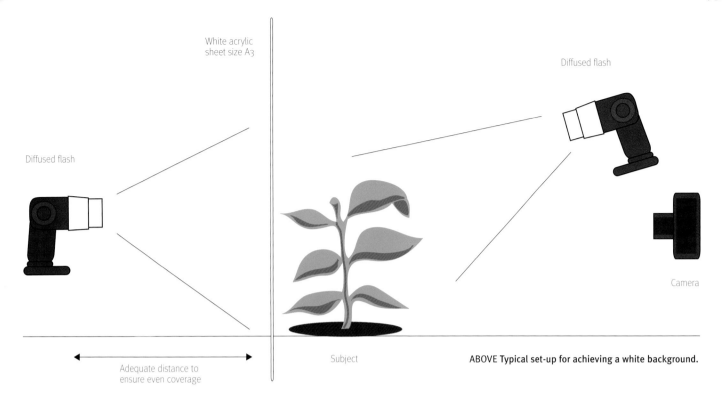

White acrylic
sheet size A3

Diffused flash

Diffused flash

Camera

Adequate distance to
ensure even coverage

Subject

ABOVE **Typical set-up for achieving a white background.**

WHITE BACKGROUNDS

Just like all other creative subjects, plant photography has current trends or styles. Several years ago it would have been common to see plants in their environment, with as much in focus as possible. Today, there is a trend for throwing the background out of focus, as we have seen. Another style currently in vogue is photographing plants against a pure white background, either in the studio, or outdoors in the field. This completely removes any distracting elements, reducing the image to the subject itself, allowing its shape and form to become predominant. It is not a technique I use very much, but I can certainly see the merits in certain circumstances. For me, it works best where the subject is partly translucent, and the background is pure white.

The style and technique is not new, but has been recently popularised by several photographers including Niall Benvie and Robert Llewellyn (see page 175).

There are several ways of achieving the effect. The simplest method is to photograph the plant against a white paper or card background. This will give a reasonable result, but the white background may not be a pure white unless it is lit separately and evenly.

Another method is to use a light box, onto which you can place your specimens. The subjects need to be translucent to allow some light to pass through them. Laying subjects onto a photographic lightbox causes them to flatten, losing their three dimensional shape.

A better method is to shine light through the background – this could be tracing paper, but white acrylic plastic works best, and then to light the subject separately. This allows light to pass through any translucent areas of the subject, giving the image a certain 'glow'.

You will need a fair amount of space, as you need to get a light behind the acrylic sheet, far enough away to light it evenly, then have space in front of the subject to photograph it.

Getting the balance right between the level of the light on the background and the subject will take some experimentation. The distance from the subject to the background will also affect the result – too close and the light will spill around the edges of the subject, causing flare and soft edges. If your subject is relatively dark, move it closer to the background. Very pale subjects may benefit from being further away. Again, you will need to experiment with your own equipment.

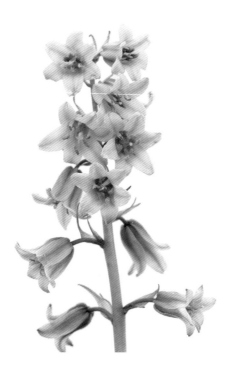

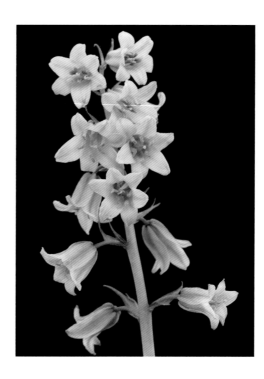

LEFT **A Spanish Bluebell (*Hyacinthoides hispanicus*) photographed in a light tent against a white and black background, in a conservatory, using diffuse sunlight.**

Black background:
105mm macro lens, 1/20 sec at f/11

White background:
105mm macro lens, 1/20 sec at f/11 with + 1.67 exposure compensation

The end result, when viewed in Adobe Photoshop™, should have a background that has an even reading of 255 in all three channels in the 'info' box when measured with the dropper tool.

This type of photography can be done on location, in the field (there is an ongoing project called 'Meet Your Neighbours' where all subjects are photographed like this, with some very interesting results – see the reference list) but you will need a fair bit of equipment – the white background, lights for the background and the subject, and clamps and supports to hold everything in place.

BLACK BACKGROUNDS

Photographing plants against a black background creates a totally different image from a white background, and needs to be done with some care if a good result is to be achieved. For a successful image the background needs to be totally black, not very dark grey, and most black surfaces such as black card will reflect some light. Black is an absence of light, and virtually any black material can be used to create a background, provided no light falls on it. The best material by far, though, is good quality black velvet. This is not cheap, but a large piece of high quality velvet will last for a very long time if looked after. It can be restored by steaming it on the back with the steam from a boiling kettle.

Even when using black velvet it is a good idea to keep light away from it, maybe by using card to mask the light. Try also to keep a reasonable distance from the background, to give space for backlighting. If you have a round subject such as a rose bud, for example, lighting from the front will fade off around the bud, and the edge of the bud may merge in with the background. Back lighting can be particularly effective with a black background, either from one side or two sides. Make sure the light doesn't shine into the lens. Hairy or spiky subjects such as cacti can look superb against a black background if lit carefully.

ARTIFICIAL BACKGROUNDS

To create a more realistic image in the studio you can use an artificial background. I have a range of images of out-of-focus backgrounds, printed to A3 and mounted on polyboard (see chapter three).

SAFETY

If you have been handling damp or wet plant material, make sure to dry your hands thoroughly before handling any electronic equipment, such as flash guns.

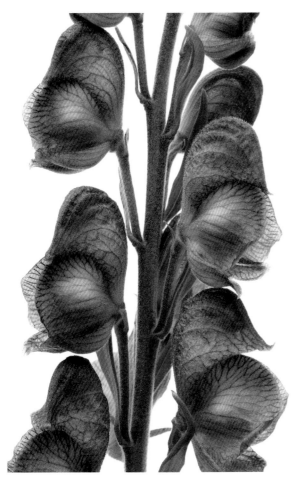

ABOVE The 'info' box in Adobe Photoshop™ showing values of 255 (the maximum possible) for each of the red, green and blue channels when measured from the background. This was lit from behind with an electronic flash gun, fired through a white acrylic sheet.

ABOVE, BELOW AND RIGHT Monkshood (*Aconitum* sp.), spider chrysanthemum (*Chrysanthemum* sp.) and Foxglove (*Digitalis purpurea*) flowers photographed against a pure white, backlit background. The subject was lit from the front by a diffused electronic flash gun.

60mm macro lens, 1/125 sec at f/16

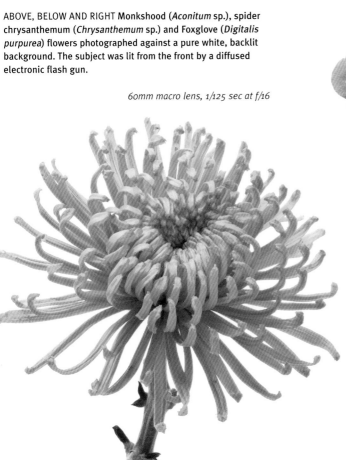

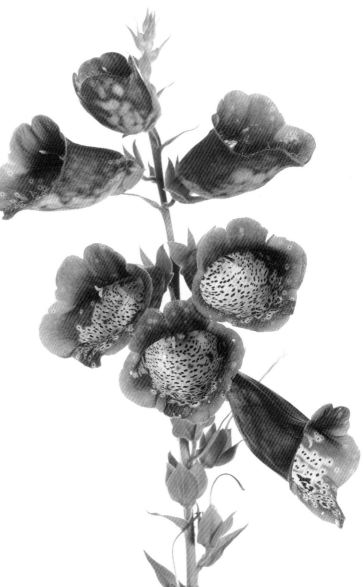

Scanning

The primary use for a scanner is to digitise analogue photographs or other flat documents so that they can be viewed and used on a computer. I have, for many years now, also used a flatbed scanner as a camera to record plant (and other natural history) specimens, both flat subjects such as leaves, as well as three dimensional subjects such as flowers.

There are two basic types of scanner: film scanners, specifically designed for scanning 35mm and medium-format film, and flatbed scanners. Although I have used film scanners to scan glass microscope slides, it is the flatbed that will be most useful for plants. A good scanner should yield excellent results, and can be a good alternative to a camera in certain circumstances.

FLATBED SCANNERS

The flatbed scanner is similar to a photocopier – you lift the lid, place the document or object onto the glass platen and scan it. Most scanners on the market have a platen that can take A4-sized subjects. Most are 'reflective' in that they shine light onto the surface of the subject, and measure the light reflected from it. Some models also have a light source in the lid (known as a transparency adaptor) which shines light through transparent or translucent objects.

When choosing a scanner there are two main considerations in terms of quality – optical resolution and optical density. A typical resolution of 1,200 dpi will be sufficient for most purposes, but if you envisage scanning very small objects, then you may want to go to 6,400 dpi. Figures for optical density (a measure of the ability of the scanner to record the highest level of shadow detail) are given as Dmax – a good figure would be anything in excess of 3.6 Dmax.

REFLECTIVE SCANNING

If you are scanning flat subjects, such as leaves, treat them like any other document. Place them on the glass platen, shut the lid and scan. This will give a white background. If you want a black background, leave the lid open, and make sure the lights are turned off in the room where you are scanning. If the leaf has a tendency to curl up it may need to be taped to the glass. I use transparent 'magic tape' for this purpose.

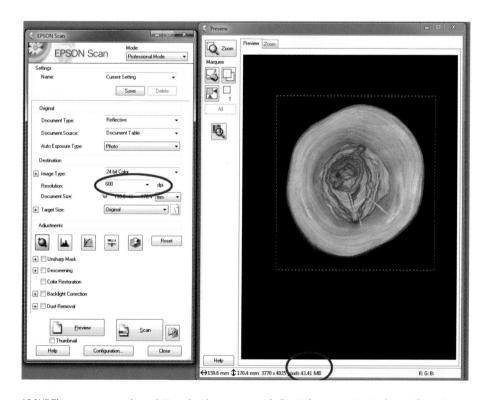

BELOW A typical flatbed scanner with a 3D object (seed head of lotus) with the lid open. This will give a black background. The white sheet inside the lid can be removed to reveal a light source, which can be used for scanning translucent subjects.

ABOVE The scanner control panel. Note the 'document type' (reflective), scan resolution (600 dpi) and final image size (43.41Mb). Note also that unsharp mask is unchecked. It is better to sharpen the images after scanning in a program such as Photoshop™.

Leaf mine in Bramble (*Rubus fruticosus*) leaf made by the micro-moth *Stigmella aurella*, scanned as follows:

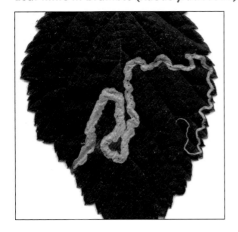

ABOVE Scanned in reflective mode with lid closed.

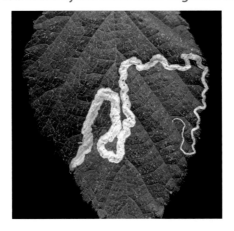

ABOVE Scanned in reflective mode with lid open, creating black background.

ABOVE Scanned in transmission mode with the image created by the light passing through the leaf.

If you are scanning three-dimensional objects such as flowers, then leave the lid open too. If you are leaving the lid open, turn off any lights in the room, and even cover the window to prevent extraneous light entering the scanner. If you prop the lid partially open, you will get a graduated grey tone. It's worth experimenting to see which suits you and the subject. If you are putting an object such as a flower onto the scanner, and need to keep the lid open, but still want a white background, spray the inside of a suitably sized box with bright white paint and cover your subject with that.

BELOW A cross-section through the branch of an Olive tree (*Olea europaea*) which I bought in Sardinia.

BELOW RIGHT A cut section through a loofah (*Luffa* sp.) from the bathroom.

RIGHT The dried seed head from a lotus (*Nelumbo* sp.) plant showing the seeds.

ABOVE I placed this garden rose face down on the scanner, and left the lid open to give a black background.

The lighting obtained with a scanner is very flat and even, but shows detail in all parts of the subject. With plants like roses it gives a really pleasant light.

Be careful to keep the glass platen clean and scratch-free. Any blemishes will be scanned along with the specimen, and will require retouching. If your subject is wet, it might be worth placing it on a sheet of clear acetate which you lay onto the glass platen, to prevent the moisture getting onto the scanner itself.

TRANSMISSION SCANNING

If you have a leaf or other plant material that is translucent, and you have a transparency adaptor on your scanner, then take the cover from the light source inside the lid of the scanner, and set the 'document type' to positive film. This will turn on the light source inside the lid of the scanner.

This light is often smaller than the platen, so you will need to choose a subject to fit. Also, it is often recessed into the lid, so does not always hold subjects such as curly leaves completely flat. Autumn leaves can look particularly impressive when scanned like this.

I have also used this method for scanning small specimens on microscope slides, with excellent results. You will need to use a high resolution for such small subjects, such as 9,600dpi or higher to obtain an A4 print.

BASIC SCANNING/SCANNER SOFTWARE

With the specimen in place on the platen, open the scanner software (use professional mode if the software has the option) and press the preview (or prescan) button. This will give a preview image of your subject, which you can crop. Do not scan anything you do not need or you will end up with file sizes that are excessive.

Having selected the area to scan, press the scan button. Whilst scanner software often has controls for modifying brightness, contrast and colour I prefer to do those enhancements in Adobe Photoshop™ afterwards.

ABOVE **A** hawkweed (*Hieracium* sp.) flower from my lawn looks stunning when scanned in high resolution.

FAR LEFT **A** Horse Chestnut (*Aesculus hippocastanum*) leaf scanned in transparency mode, showing the mines made by the Horse Chestnut Leaf Miner (*Cameraria ohridella*), which have become a major pest of these trees in recent years.

LEFT **A** Horse Chestnut leaf scan showing the actual larva in between the top and lower surface of the leaf.

WHAT SCAN RESOLUTION SHOULD YOU USE?

Rather than give scan resolutions for specific sizes of subject, I prefer to aim at a target file size. As a general rule of thumb, for a high-quality A4 inkjet print you will need a file size of around 12Mb, for an A3 aim for around 24Mb. If you are submitting images to picture libraries, they often require minimum file sizes of 48Mb for colour images. For a full-page reproduction in an A4-sized magazine, aim for a final file size of around 36Mb. The smaller the size of the subject, the higher the scan resolution will need to be to achieve the required file size.

CHAPTER 5

Workflow and Image Processing

As a photographer I want to be out taking pictures, rather than sitting for hours at a computer processing images. My aim is to always get the image as right as possible in the camera, but there will still be post-processing, captioning and printing to be done. An efficient workflow will help you get the best results consistently, but yet be flexible enough to help you deal with any unforeseen problems.

Workflow and image processing

Unless you intend producing creative digitally manipulated images of plants, the workflow you adopt for most plant photography will probably be relatively simple. With modern camera technology, exposure measurement will be largely accurate, as will colour balance. The old adage of 90 per cent of people using 10 per cent of a software program will likely be very true!

Probably, for most of your work you will want to enhance brightness and contrast, maybe tweak shadows and highlights, possibly enhance colour balance and then prepare for your chosen output.

Developing an efficient, consistent workflow for your photography will not only yield better results more often, but will also enable you to spend more time taking pictures rather than processing them! There is no such thing as the 'perfect' workflow. The best one is the one that suits you and the kind of photography that you do.

The main aim of developing a workflow is to use a consistent technique for most of your work, and yet be flexible enough to allow for variations with more challenging subjects.

RIGHT The Bermuda Buttercup (*Oxalis pes-caprae*) is a common plant in many southern European countries, often growing as a weed among cultivated plants. This specimen was growing on an old farm wall in Mallorca.

18–200mm lens at 95mm,
1/160 sec at f/8

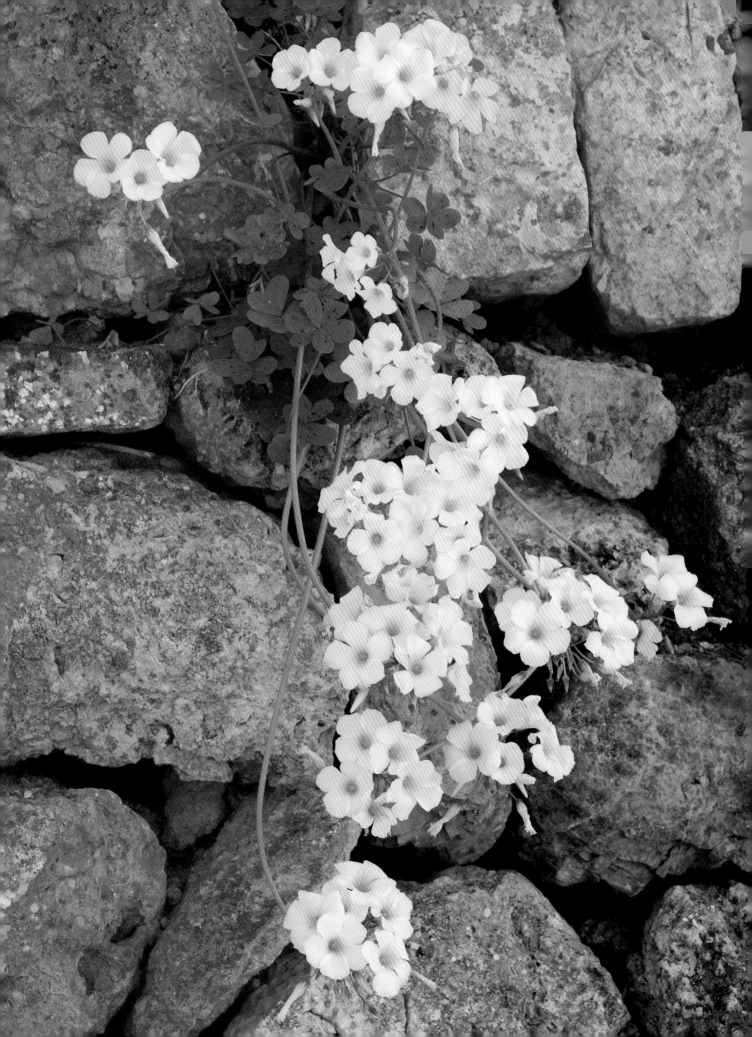

DOWNLOADING IMAGES

The first thing to do when you return from a trip is to download the images into your computer, and make a backup. I have pairs of 'mirrored' external hard discs. If you are dealing with large amounts of images it might be worth using backup software to make sure that any changes you make to one disc are transferred to the other one. Make sure you give folders a descriptive name and date – 'Picos de Europa 5.6.12', for example, to help start the process of cataloguing them.

CAPTIONING/KEYWORDING

Captioning your images has never been easier, and with programs such as Lightroom™ and Adobe Bridge™ the operation can be done quickly and easily. I try to do this as soon as possible after a shoot, while my memory is fresh. See the section later on storing and cataloguing your images for more information.

FIRST EDIT

Having captioned the images I will then do an initial sort in Bridge™, deleting any obvious failures, and adding any appropriate coloured labels and/or star ratings. Having selected an image I open it, and immediately resave it as a TIFF file, giving it a descriptive name like 'Fritillary1.tif'. Subsequent edited or resized versions are given similar names, such as 'Fritillaryfinal.tif', or 'Fritillaryweb.jpeg'.

HISTOGRAMS

Checking and adjusting the histogram (known as 'levels' in image-processing programs) is the first stage in my enhancement of images. In Adobe Photoshop™, the histogram is accessed via 'image › adjust › levels'. This will be similar to the histogram displayed on the rear of the camera.

It is possible to adjust the level of the shadows, highlights and midtones, to enhance the tonal range of the images. Each of the three sliders, white, black and grey, can be moved to alter the tonal balance of the image. For example, if you have photographed some white flowers, and they appear quite grey, slide the white slider to the left until it touches the graph. The tone that was previously light grey is now white. Do not go too far as the area will lose detail. Similarly, if you have an area

ABOVE A typical 'average' image of Orange Hawkweed (*Pilosella aurantiaca*) growing in a cemetery – with its associated histogram ('levels' in Photoshop™).

IMPORTANT TIP

Always resave camera JPEGs as TIFF files for editing. JPEG files have been compressed in the camera. Any subsequent editing and resaving as JPEG will add to the compression process, possibly degrading the image. TIFF files are not compressed during the processing and subsequent saving stages. You can always convert the final TIFF file back to JPEG at the end of the process if necessary.

that should be black, but is dark grey, slide the shadow slider to the right until it touches the graph. These two sliders adjust the white and black points of your image. The central grey slider is used to lighten or darken the overall image.

Tip: Holding the Alt key on the computer keyboard down whilst adjusting the shadow or highlight slider converts the dialog box into 'threshold' mode, where only the darkest shadows or brightest highlights are displayed. For most images you want to adjust the sliders until the 'threshold' point is reached, where the tone is just on

ABOVE **The Rain Tree (***Brunfelsia undulata***)** photographed in diffuse light in a glasshouse. The camera meter has struggled with this exposure, and the pure white flowers appear rather grey. The histogram shows a gap at the right-hand end.

105mm macro lens with 1.4x converter, 1/125 sec at f/8

ABOVE **The final corrected image.**

RIGHT AND FAR RIGHT Sliding the highlight slider on the histogram to the left until it touches the graph lightens the flowers and gives a much better white.

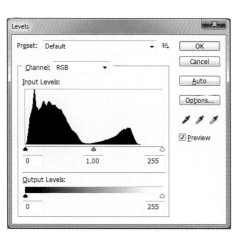

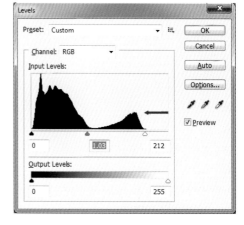

LEFT When processing this flowering cactus (*Haageocereus acranthus*) I needed to ensure that I retained all detail in the white flower.

70–200mm lens at 170mm, 1/100 sec at f/8

RIGHT I used the threshold control (hold the Alt key down while using the highlight or shadow slider) in the Levels dialog box to show just the image highlights. I would pull back a little from this stage, so that the merest hint of image was visible.

FAR RIGHT TOP I deliberately shot this Red Campion (*Silene dioica*) flower against a background in shadow.

105mm macro lens with 1.4x converter, 1/50 sec at f/11

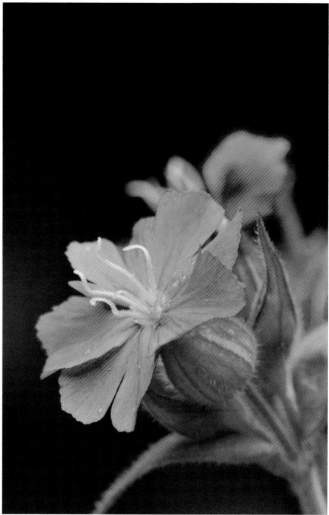

the point of being visible. In the example shown here, I have exaggerated the effect. In practice you would pull back from this so that just a hint of image is shown in the dialog box.

ADJUSTING COLOUR USING LEVELS

The Levels dialog box can also be used to adjust the colour balance of your image. In the 'channel' drop-down menu, adjustments can be made to each of the red, green and blue colour channels. If your image is too blue, select the blue channel, and slide the central slider to the right until you remove the blue cast.

If you have used a grey card in your image, the central dropper tool (grey point tool, found underneath the 'options' window) can be used to neutralise it. Select the dropper, and click it onto the image of the grey card. Any cast will be neutralised to a grey tone.

RIGHT The histogram shows a very slight gap at the left-hand end, showing that even though the shadows are very dark, they still retain some detail.

SHADOWS/HIGHLIGHTS

One particularly useful control in Photoshop™ is the Shadow/Highlights feature (image › adjustments › shadows/highlights). This allows you to lighten dark areas of the image, or darken highlights. It is a very powerful facility, and well worth getting to know.

RAW FILES

If you have shot Raw files, much of the enhancement process can be carried out in the Raw converter software, such as Adobe Camera Raw™ found in Photoshop™, Adobe Elements™ or Lightroom™. This software is extremely comprehensive, and warrants a book all to itself, but basically, adjustments can be made here to the exposure, shadow and highlights, contrast, saturation and colour balance, as well as things like monochrome conversion, lens distortion correction, graduated filters and various retouching and crop tools. Although it is not essential that you shoot Raw files, I would recommend that once you have mastered the basics of your camera and software, that you start to shoot Raw files. It offers huge potential for retrieving data from shadows or highlights that might have been lost with JPEG files for example.

The example shown here is of a superb clump of astilbe growing next to a pond in a botanic garden. The red areas within the image (in the pond and flower bed) are a visual indication of areas which have lost detail and need darkening. I firstly reduced the overall exposure of the image, then slid the recovery slider to the right (darkening the highlights until the red spots disappeared). I then chose the graduated filter tool and dragged it across the top right-hand corner of the image to balance it with rest of the image.

If you have shot a number of images under the same lighting conditions, these can be 'batch processed' so that adjustments made to enhance one of the series can be applied to all the others.

ABOVE AND RIGHT
Screen shots from Adobe Camera Raw™ converter, showing the original image, and processed version, as described in the text.

8 BITS VERSUS 16 BITS PER PIXEL

When working with Raw files, it is good practice to work with your files in 16 bits per pixel, and convert them to 8 bits per pixel for printing or other output. This is particularly so when dealing with out-of-focus backgrounds with smooth subtle gradations of tone. Because 8 bits per pixel cannot display as many tones as 16 bits per pixel the background may become stepped or 'posterised'. To open your images as 16 bits per pixel, select the 16 bits per pixel option in the Raw dialog box.

I normally keep my edited files as high resolution TIFF files until I need them for specific purposes, such as printing, PowerPoint™ presentations or web use.

The final stage in your workflow, after any retouching or resizing, will be to sharpen your images. This is covered in detail in the section on printing.

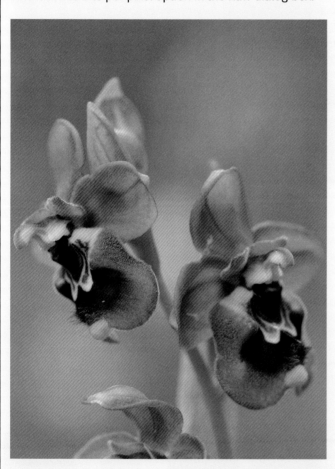

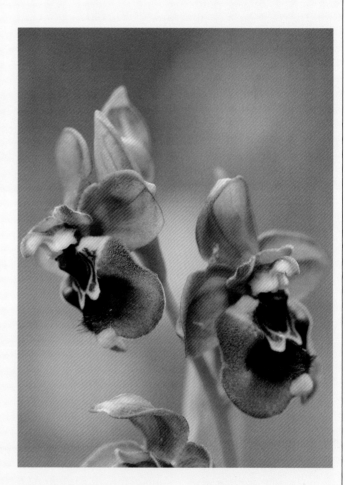

ABOVE An image opened as processed in 8 bits per pixel. Note the banding, or posterisation, in the out-of-focus green and pink areas of the background (the effect has been exaggerated for the purpose of illustration).

BELOW The Workflow Options in the Adobe Camera Raw™ converter, showing 16 bits per pixel selected. Note, too, options for image size and resolution.

ABOVE The image processed as 16 bits per pixel. The background tones are completely smooth.

Workflow Options

Space: Adobe RGB (1998)

Depth: 16 Bits/Channel

Size: 2848 by 4288 (12.2 MP)

Resolution: 240 pixels/inch

Sharpen For: None Amount: Standard

☐ Open in Photoshop as Smart Objects

OK

Cancel

ABOVE **Some of the options available in Bridge™ for producing contact sheets.**

RIGHT **A typical contact sheet of 16 images produced as a PDF file. I have added my name and date in Photoshop™ afterwards.**

MAKING CONTACT SHEETS

A contact sheet is a selection of images laid out on a grid system, which can be printed or saved as an electronic file. Depending on the software used to create the contact sheet the grid can be modified, the background colour changed, and image captions displayed or not.

I use Bridge™ for my contact sheets, producing PDF files which can be emailed to clients, or printed for future reference. Place the images you need into one folder. The more images you put onto a contact sheet, the smaller they will be, so I usually limit the number of images to 24 for an A4 sheet, but if you have more, the images will be resized.

One particularly useful form of contact sheet is one that is 12cm x 12cm. This will produce an 'index print' for insertion into a CD jewel case.

copyright Adrian Davies
9.8.2012

Storing and cataloguing your images

One of the first lessons we all learnt when starting to use computers was to make backups of our data in case of hard disc failure or other computer glitches. If you have paid a lot of money to visit exotic locations, or spent a lot of time doing a set of images, you need to make absolutely sure that your images are safe, and can be easily retrieved in future.

EXTERNAL HARD DISCS

I have a number of external hard discs which I use to store my images. They are 'mirrored' so that I always have two copies of my files. They are quite expensive, but can hold lots of data. I currently use one-terabyte (1Tb) discs. You can either back up data on your hard discs manually, on a regular basis, or use dedicated software to do this automatically.

CDS/DVDS

DVDs and CDs (which have largely been replaced by DVDs) can be a good, inexpensive, reliable and safe way of storing images. While there is some debate about their long-term durability, they offer a very convenient method of storage. I would always make two copies and store them in separate places to minimise the risk of damage.

THE 'CLOUD'

Cloud computing refers to the storage of large volumes of data remotely, on servers to which you upload your data, for a fee. It is a relatively new concept, and it will be interesting to see how the system develops over the next few years.

CATALOGUING

Software programs such as Adobe Photoshop™ and Lightroom™ have extensive facilities for captioning and keywording images so that they can be found at a later date. I would recommend very strongly that this becomes an integral part of your workflow. It is very easy to accumulate large numbers of images, which, if not catalogued, can languish on hard discs without ever being found again. Unlike a piece of film or a printed photograph, you cannot hold a disc up to the light to see what is on it.

ADOBE BRIDGE™

Adobe Bridge™ is an integral part of Photoshop™ and other Adobe programs, and can be used to caption, keyword and rank images, as well as retrieving data about your images.

Captioning your images can be divided into two parts, the main caption and then any keywords that might be used to search for that image later. For example, the image of the Cauliflower Fungus was captioned: Cauliflower Fungus (*Sparassis crispa*) growing at base of Scots Pine tree, Surrey, England, October.

Keywords are other words that can be associated with the image to help find it. They can be added using the 'file info' box. For example, a publisher seeking images might ask for '**woodland**' '**fungi**' in '**autumn**', or '**edible**' '**fungus**'. If I am looking for images to illustrate a lecture on plant

BELOW Cauliflower Fungus photographed on a very dull day in a pine woodland in southern England.

17–55mm lens at 30mm, 2 secs at f/16

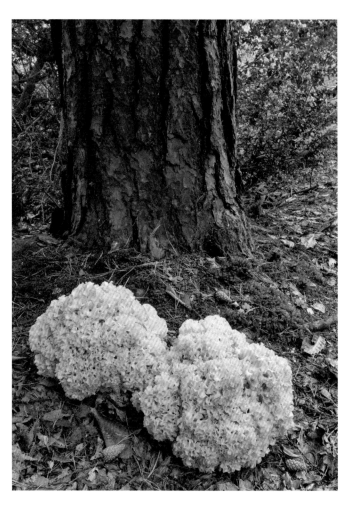

ABOVE The File info box in Bridge™, showing description, keywords and my name as copyright holder.

photography, I might look for **'wide-angle'** and **'habitat'** shots. Try to add as many keywords as possible, to ensure the greatest potential use. While this is a time-consuming operation, it will pay dividends in the long run. To search for images, select the 'find...' command (edit › find).

In Bridge™, multiple images can be selected by holding down the shift key, then captioned and keyworded at the same time. I make a point of making captioning and keywording images one of the first stages in my workflow.

Other useful features of Bridge™ include the ability to rank images with a star rating, and to categorise them with coloured labels. When I do an initial sort, I assign green labels to images that are acceptable, and that I will return to, and purple labels to rejects. I do not discard these straight away, and always make a second check before throwing them away. Image sets, taken to construct panoramas or focus stacks, are, for example, assigned red labels.

In the preview window of Bridge™ is a loupe (magnifier) tool (click the cursor inside the image to bring up the tool) which can be used to check fine detail in an image.

BELOW Screen shot from Bridge™ showing group of images and preview of selected image. Note the magnifier (loupe) in the preview area. Some of the images have coloured labels assigned them, which can be customised to your own needs, and a star rating.

METADATA

The term metadata is used to describe 'data about data'. In the case of digital photography, all camera and other data related to your images can be viewed in Bridge™. This is known as EXIF data, and is very useful. It means you can look back to see, for example, what aperture you used, whether you used flash and what lens you used. Also, the date and time when the image was taken is available. Increasingly, cameras with GPS capabilities are coming on to the market, and the co-ordinates from GPS receivers will be displayed in the metadata box.

Other types of metadata include IPTC, an industry standard format for labelling images, and XMP, which has largely replaced IPTC. XMP can be viewed on various computer platforms and is easily accessible by many programs. It can include a whole range of information about the image, as well as the photographer, and their contact details.

BELOW The same preview image with its associated metadata, containing information relating to exposure, lens, date and various other information.

LABELLING – A WARNING

It is possible to change the names of the labels in the Preferences box. If you do this, but then at a later date buy a new computer, you must rename the labels on the new computer so that they are exactly the same as the old one, or all the labelling colours will be lost.

Case study: Burned-out car in Bluebell wood

LEFT My favourite
Bluebell wood in spring.

*17–55mm lens at 35mm,
1/30 sec at f/8*

RIGHT Immediately
behind the view on the
left I found this
abandoned and burned-
out car. The contrast
between the car and the
bluebells seemed like a
metaphor for many of
the issues facing
conservationists today.

*17–55mm lens at 24mm,
1/10 sec at f/11*

RIGHT Another view,
early the next morning.

*17–55mm lens at 25mm,
1/25 sec at f/8*

On a visit to one of my favourite Bluebell woods in spring I was shocked to find this burned-out car in the middle of it. This was some way from the nearest road – it must have taken a great deal of effort to actually get it there, and even more effort (and cost) for the conservation officials to remove it! I wanted to use this to illustrate modern pressures on our environment, and that it is wanton acts of vandalism like this, and not just large-scale factors like global warming that are destroying ecosystems. I shot the car with a wide-angle lens to include as much of the stunning Bluebell wood behind it as possible. Fortunately, long-term damage to the woodland does not seem to have been too great.

Inkjet printing

If you want to make prints from your images there are two main options: either send them to an external printing company or make your own with an inkjet printer. Getting prints done externally can be a very convenient method – they can usually be uploaded via the internet, but you do lose control of the process, and it is difficult to make fine adjustments. If you do use an external printing company, take the time to get to know them. See if they have guidelines for submitting images, in terms of file format and resolution. For example, should the images be sharpened before you send them and do they have a calibration chart for you to check your monitor?

If you decide to make your own prints at home, you will need an inkjet printer capable of photo-quality printing, (usually called a 'photo' printer) which usually means having more ink cartridges than a conventional office printer. With correct setup, results nowadays can be stunning.

RIGHT **Epson 2880 photo-quality inkjet printer, using eight inks.**

'PHOTO' INKJETS

Inkjet printers work by squirting minute droplets of ink onto the paper. Printers designed for office work use four colours: cyan, magenta, yellow and black. For photography we need much subtler gradations of colours, and photo-quality printers will have other colours, such as light cyan and light magenta, and maybe several shades of black.

MONITORS

Before discussing the mechanics of printing, it is worth looking at the monitor on which you will be viewing your images, and which you want to try to match to the final output. In order to get some sort of consistency, you should ideally calibrate your monitor, to bring it to a known standard. This involves using a special monitor calibrator, such as a Spyder™, or i1Display™, which measures the values of a test target which your actual monitor displays. This will create a profile for your monitor which is loaded into the operating system of your computer. It is worth calibrating your screen regularly as monitor displays will change over time. Theoretically, your images should now look the same on your monitor and any other calibrated monitor.

If you use a laptop for your imaging, the screen may not be as easy to calibrate as a desktop with separate monitor (although Mac laptops have built-in calibration software) – many do not have controls for adjusting brightness and contrast, for example. If you do a lot of printing you might want to consider buying an external monitor for the laptop, which can be calibrated using a calibration device. Some high-end monitors from companies such as Eizo and NEC are supplied with their own colour calibration software, while Apple monitors have a built-in calibration system called Display Calibrator™.

LEFT High quality monitor with hood, in the process of being calibrated with external monitor calibrator. Note that the light from the window is prevented from shining on the screen by the hood.

ABOVE Part of the Apple Mac calibration process built into its monitors.

Tip: Try to arrange for a constant light in your workroom, by having a blind at the window, and avoiding bright lights shining on the screen. More expensive monitors have a hood around the screen which acts rather like a lens hood to prevent stray light striking the screen. Monitor hoods are available separately if your monitor doesn't have one, or you can make one from strips of black card.

PREPARING YOUR IMAGES FOR PRINTING

Making prints can be seen as a two-stage process – first, preparing the image for printing, and second, setting up the printer to receive the image.

Assuming you have colour-balanced your image, using a calibrated monitor, you will then need to resize it for your intended print.

In Adobe Photoshop™, go to image › image size:
The following dialog box will appear, showing the original size of the image, the final print size and various options for resizing.

In the example shown:
The original image (34.4Mb in size) has been resampled to give a 250mm high print, at a resolution of 240 pixels per inch. The final image size is shown as 10.6Mb (you do not need all of the original pixels to print an image at this size). Note the drop-down menu for resampling shows bicubic sharper. For the vast majority of your work you

ABOVE Image size dialog box in Adobe Photoshop™.

PRINTING RESOLUTION

When printing with a photo-quality inkjet printer, a resolution of between 200 and 300 pixels per inch (ppi) will yield excellent results. I generally use 240 ppi for my work. (If you are submitting images for publication, these should have a resolution of 300 ppi).

will use one of the bicubic methods of resampling (or 'interpolating') your images.

CROPPING

The proportions of the image from your camera sensor may not match the dimensions of the final print that you want to make, and you may need to crop it. In the cropping tool in Photoshop™ you can type in the dimensions and resolution needed for the print. Remember that you will inevitably lose a part of the image.

ABOVE **The crop tool in Photoshop™, showing dimensions and resolution.**

SHARPENING

The final stage in the image preparation process is sharpening, which must always be carried out after any resizing at the end of your workflow. Generally the best sharpening filter to use is the unsharp mask (USM), found under filter › sharpen › unsharp mask.

Here you are given three options for adjustment. Sharpening an image basically increases the contrast at boundaries between tones in an image, and the settings in the dialog box determine how that process is carried out. The amount is like the volume control of a radio – do

you want the effect to be high or low. The radius is concerned with the spread of the sharpening effect across a tonal boundary, whilst the threshold governs the areas of the image which are sharpened. A threshold setting of zero will sharpen every part if the image. A threshold setting of 200 only sharpens those areas of the image with great differences between areas of tone.

Entire books have been written about image sharpening, and different photographers employ their own techniques. You will need to do some print tests to see what setting suits you and your work best. Don't be tempted to use the image on the monitor as a guide to image sharpening – you need to make a print to see the real effect. As a starting point, for a 250mm-high inkjet print, I would recommend settings of amount: 200, radius: 1.0, threshold: 3. You do not want to oversharpen images – subtlety is better than an oversharpened image, which can look like an engraving! For PowerPoint™ presentations, or web use, the standard 'sharpen' filter will normally give a good result.

ABOVE **Unsharp mask (USM) dialog box, showing amount, radius and threshold settings. Also, the zoom tool for checking the effect.**

Tip: When preparing images for image libraries or for publication, the general rule is to send the images without any sharpening, so that they can be sharpened by the end-user. Always talk with the library or publisher to see how they want you to submit images to them.

SAVING

Having resized and sharpened your image for printing, save it as a different version. I have a system whereby my 'print' images are saved with the file name plus a 'p' for print, and dimension for size, for example seakalep10.tif. An image of Sea Kale (*Crambe maritima*) has been sized to give a print of 10 inches (254mm). Using that system means I can easily find the file that I used to make a print, and make another without having to reprocess the image.

PAPER

There are dozens of different papers on the market these days, from high gloss to matt, in various weights. Try to find one or two papers that you like, and which suit your images, and stick to them. Get to know how they handle certain colours and tones – which one works best for exhibition use, for example, or which works best for greetings cards. My own favourite for general printing is the Smooth Pearl finish from Ilford. Most manufacturers sell sample packs, or have swatch books available.

PROFILING

Most paper manufacturers produce profiles (technically called ICC profiles) for their papers which can be down-loaded from their websites, and loaded into your computer. This profile tells the computer how the paper produces colours with ink from a particular printer. They are generally very accurate. Make sure that you select this profile in the printer dialog box in the printer profiles menu.

Several companies offer printer profiling services. This involves you making a print from a test file downloaded from their website, which you send to them. From this print the company measures various colours from the target and produces a profile for your actual printer using a particular paper/ink combination. If you change the paper or ink that you use, you will need a new profile. This is well worth considering if you intend making a lot of prints for potential sale, or exhibition. Your aim should be to be able to predict accurately the colour of a print, and that it matches, as near as possible, the image on your screen.

MANAGING COLOUR

In the printer dialog box you have two options, either for the printer to manage colour, or for Adobe Photoshop™ to manage colour. It is probably best to turn off printer management and to select 'Photoshop manages colour'. By doing that the printer software will not make any changes to the image you have produced in Photoshop™.

PRINTING

Before hitting the 'print' button, there are one or two settings to make in the printer dialog boxes. First, you need to tell the printer what resolution you want it to print at. This will be the highest quality 'photo' setting. Also, very importantly, you need to set the media type. Printers vary the amount of ink they squirt onto the paper surface according to the paper type set in the software – more for absorbent paper, less for gloss surfaces. Not setting this correctly is one of the commonest causes of poor print quality, and can cause banding and other problems in prints.

Tip: If you are not using one of the papers listed in the drop-down menu (Ilford paper in an Epson printer, for example) then use the 'Photo quality glossy' setting. This will put the least amount of ink onto the paper.

When the print has emerged from the printer leave it to dry for a few minutes before handling it. The colour may change slightly as it dries, so always assess colour from a dry print.

ABOVE **Dialog box for typical photo-quality Epson printer. Note profile for paper in profile menus, and 'Photoshop manages colour' in colour handling menu.**

RIGHT **Printer options dialog box, showing print quality (best photo) and paper type selected. The all-too-familiar ink level warning is also showing!**

Case study: Cochineal

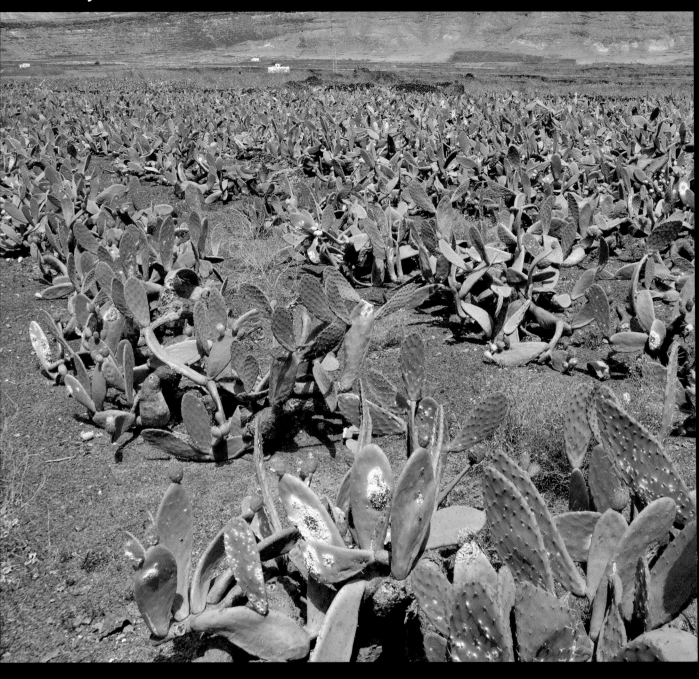

ABOVE General view of field with cultivated Prickly Pear cacti.
Note the white blotches on the leaves.
18–200mm lens at 60mm, 1/640 sec at f/8

Whilst on holiday in Lanzarote recently, I found several fields of Prickly Pear cacti (*Opuntia ficus indica*), seemingly arranged in cultivated rows. Most of the plants had large white blotches on them which, on closer inspection, turned out to be insects and their larvae, specifically a scale insect called the Cochineal (*Dactylopius coccus*). This forms the basis for the production of the red dye cochineal, derived from the ground-up Cochineal insects. Once a thriving industry in many tropical and subtropical countries, it was largely replaced by synthetic dyes, but is now making a comeback in places like Lanzarote. The drink Campari was originally coloured with carmine dye derived from the Cochineal insects, giving it its distinctive red colour. As with other photo stories, I first shot an overall view of the cultivated field of cacti, then close-up shots of the insects, and finally a market stall in the nearby town, selling cochineal products.

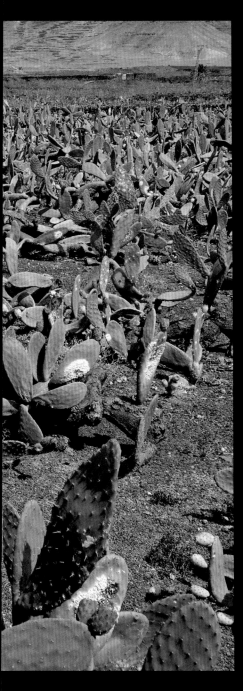

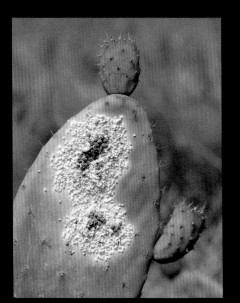

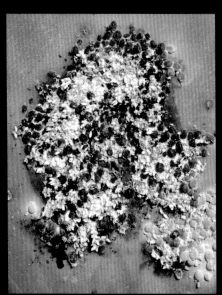

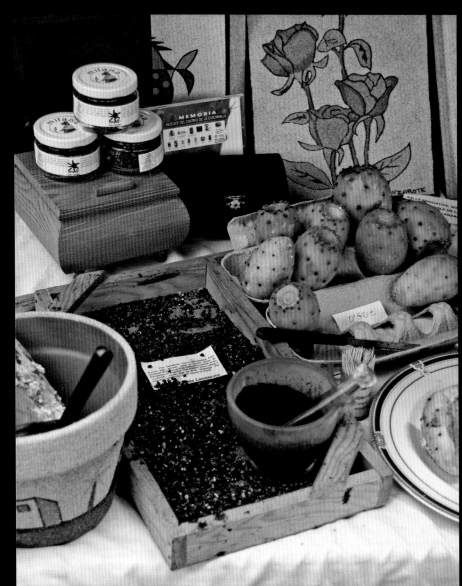

TOP RIGHT **Leaf showing
the Cochineal insects.**
105mm macro lens, 1/1,250 sec at f/6.3

TOP FAR RIGHT **Close-up shot of the
Cochineal scale insects, shot at
approximately half life-size. Note the
red fluid at bottom left.**
105mm macro lens, 1/400 sec at f/14

RIGHT **Market stall with cochineal
products, and Prickly Pear fruit.**
18–200mm lens at 38mm, 1/160 sec at f/4

CHAPTER 6

Advanced Techniques

Digital technology has opened up many more possibilities than when we worked with film. I still remember trying to print three negatives in the darkroom onto the same sheet of paper to produce a panoramic image, and never managed it successfully. Today, stitching several images together can be done at the touch of a button. Similarly, other 'multi-image' techniques such as focus stacking and HDR can help us produce the previously impossible, achieve huge depth of field, or capture subjects with very wide brightness ranges. Time lapse and high-speed imaging are older techniques which can be great fun to try out, requiring technical knowledge as well as the need for improvisation.

High-speed photography

Although plants may not be the subjects that first spring to mind when talking about action photography, many species exhibit mechanisms which can only be captured by using high-speed photographic techniques. Many plants – Himalayan Balsam (*Impatiens glandulifera*) for example – use explosive forces to scatter seeds and spores a good distance away to ensure dispersal. Other plants use different strategies, such as producing copious amounts of pollen or spores which is blown away in the wind.

All plants grow, of course, or have much slower movements. To capture this will require time-lapse photography, which is covered in the next section.

High-speed photography is the term used for capturing short-duration events, often faster than the human eye can perceive. With modern cameras now giving excellent results at high ISO settings, you might find that some subjects work well with available light, but for more controlled results, you will probably need to use electronic flash. The Rosebay Willowherb seeds shown on p.102 were shot at 1/500 sec, which was easily fast enough to freeze them in mid-air.

For faster-moving subjects it may be necessary to use a light beam or other sort of trigger system to fire the shutter or flash.

RIGHT The Ash tree in my garden produces copious amounts of pollen each year, though usually just on one or two specific days, so I had to keep a daily watch on it to check when it was ready to disperse some pollen. I very carefully cut a suitable twig, and brought it indoors into my studio, where I had a pre-prepared set. I used a piece of black velvet as a background, and three small flash guns arranged around it, two from behind, pointing obliquely towards the twig, but at such an angle not to shine into the camera lens. The third light provided a front light from top left of the twig. The twig was supported in a laboratory retort clamp. When all was ready (I had already done some lighting and exposure tests) I tapped the twig with a pencil, and released the shutter via a cable release. A shower of pollen was released, which was frozen in mid-air by the flash. I managed to get around five images from one twig.

105mm macro lens, 1/125 sec at f/11, with three macro flash units

The main issue with high speed photography is ensuring that the shutter is open, and, if using flash, that it fires at the height of the action. In some cases the action is slow enough that you can manually fire the shutter, and, with practice, achieve a good result, as with the image of the pollen being blown from the flowers of an Ash (*Fraxinus excelsior*) tree.

Some events, such as pollen being blown from catkins, or seeds being blown from a Dandelion, can sometimes be captured using daylight, with no extra equipment. Increasing the ISO to 400 or 800 will enable a fast shutter speed to freeze the pollen or seeds.

LEFT The flowers of this Aleppo Pine tree (*Pinus halepensis*) were ripe with pollen when I visited Mallorca in April. A tap on the branch released a shower of pollen. With the camera mounted on a tripod, and a remote release in my left hand I tapped the branch gently, and pressed the button on the release. I achieved around a dozen images. A relatively fast shutter speed was used to partially freeze the pollen in mid-air. I chose a viewpoint giving a relatively dark background of the tree in shadow.

105mm macro lens,
1/1,320 sec at f/5.6

LEFT The seeds of Rosebay Willowherb are readily blown away in the breeze. I set up the camera on a tripod, with a reasonable background behind the plant, and got an assistant to gently blow on the seed head to release the seeds into the air, while I attempted to release the shutter at the right time. The seeds are not pin-sharp, but I felt the slight blurring added to the image, giving an indication of the breeze which had dislodged them.

105mm macro lens,
1/640 sec at f/5.6

Typically, electronic flash guns (speedlights) have a duration of around 1/800 sec when used at full power, but some can be programmed to give very short durations of around 1/35,000 second when used at 1/64th power, for example.

With high-speed flash photography, the main problem is to get the flash to fire at the moment of peak action. Bird and animal photographers using high-speed flash usually use some form of triggering device, such as a light beam system (as the bird flies through the beam it sets off the camera). Discussion of these techniques, though, is beyond the scope of this book. In the case of the images here of the Earthstar fungus (*Geastrum triplex*) and pollen, an assistant dropped water onto the fungus, whilst I attempted to trigger the camera at the right time. In this case, the action was slow enough to enable a good deal of success.

RIGHT I used a similar technique to the Ash tree set-up with these Hazel (*Corylus avellana*) catkins. I added a second twig, with the tiny female flower, to try to illustrate the pollination process more fully.

105mm macro lens, 1/125 sec at f/11, with three macro flash units

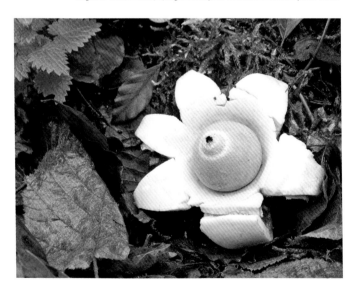

ABOVE AND RIGHT Having photographed it outdoors on a very dull November day, I brought this Earthstar fungus indoors, to capture the spores being ejected from it. I placed it on some moss, found where the fungus was growing, together with some leaves collected at the same time. I made sure that there were several other specimens in the same area, so that removing one would not be harmful to the habitat. I used the same lighting set-up as for the pollen shots, and got an assistant to drop water on the top of the ball of the fungus with a pipette. We managed around a dozen shots, of which three had perfect spore clouds.

First image: 105mm macro lens, 1/10 sec at f/16, second image: 60mm macro lens, 1/125 sec at f/22, with three macro flash units

Time-lapse photography and long exposures

Time-lapse imaging is a way of compressing time, so that lengthy periods of time can be seen in the space of just a few seconds. It is usually seen as moving video, and often time-lapse sequences are the most remembered from TV series such as the BBC's *Frozen Planet*, *The Private Life of Plants* and *Life* (which included an extraordinary time-lapse sequence of Wistman's Wood on Dartmoor, shot over an entire growing season). Time-lapse photography is a technique which dates back to the birth of moving pictures, and early cinema-goers were astonished by time-lapse sequences of flowers and other plants shot by Percy Smith in the early 20th century (some of these have recently become available on DVD – details are given in the reference section at the end of the book).

However, interesting and informative sequences can be produced using still images too, either with multiple images on one frame, or as a series of separate frames. Typical subjects might be flower buds opening, or the development of pitchers in an insectivorous plant. Many cameras now have built-in intervalometers which can be programmed to take images at pre-determined intervals.

BELOW Time-lapse sequence showing development of the pitcher in an insectivorous plant, *Nepenthes alata*. Three different pitchers were photographed for this sequence, and joined together to make one single image in Photoshop™. The images were not shot to the same scale, so the relative sizes are only approximate.

50mm macro lens, 1/125 sec at f/22. Three macro flash heads

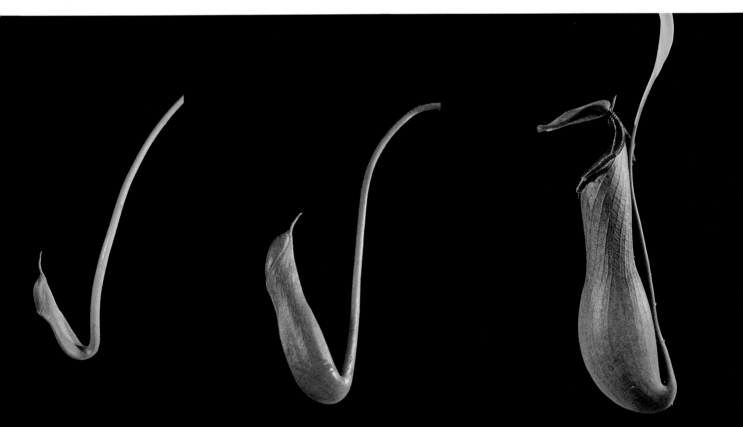

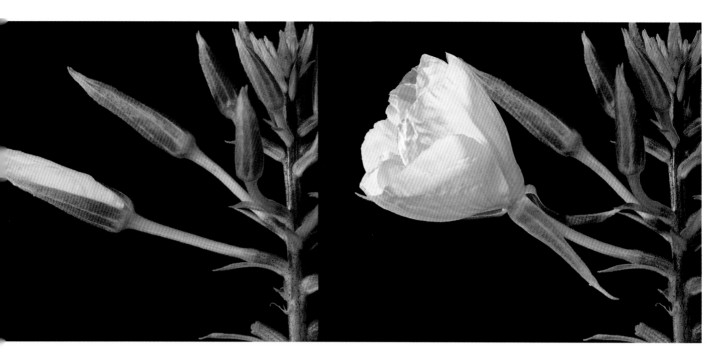

ABOVE I picked some stems with buds of evening primrose late one afternoon, and brought them indoors. I placed one of them in a vase of water, and held the stem in a retort clamp to prevent it moving. I focused on a bud likely to open, and placed three small macro flash units around it – two from the front, and one obliquely from behind. I deliberately chose a black background (black velvet) to illustrate that the flowers open at night. I was surprised at how quickly the flowers opened (in some cases ten minutes) and I missed a couple before I achieved this sequence.

6omm macro lens, 1/125 sec at f/8. Three macro flash units

BELOW This sequence of an insectivorous Sundew capturing a fly was taken over a period of three to four hours, during which time the leaf folded over the fly, firstly killing it, then absorbing body fluids to benefit from the released nutrients. With sequences like this it is important that the camera does not move in relation to the subject, and the lighting remains constant.

6omm lens, 1/125 sec at f/11. Three macro flash units

The main keys to success include constant lighting and exposure for the separate frames of the sequence, a constant camera to subject distance, and no movement of the subject (apart from that being photographed).

You will find it easier, at least to start with, photographing your subject indoors where you can control the background and lighting, and support the subject if necessary. Many of the major issues associated with time-lapse photography are logistical. For example, having a space where you can leave your specimen, camera and lights undisturbed, maybe for several days. Unlike a film sequence, when you need to know roughly in advance how long your 'event' will last, you can, with stills, take a series of images as the event unfolds.

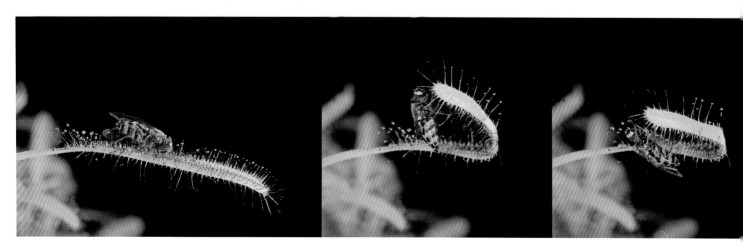

There will be inevitable disappointments, where the subject doesn't perform as you have predicted it will, such as flower buds not opening, and you need to start again. In the case of the Sundew (*Drosera capensis*) shown here, the leaf closed in response to the movement of the trapped insect, but it folded towards the camera, meaning that I had to refocus the camera.

SEQUENCE Sycamore seed spiralling down from the tree. See text for technical details.

17–55mm lens

LONG EXPOSURE

One variant of time lapse is to use a single, relatively long exposure to capture an event, such as a Sycamore seed spiralling down from a tree in autumn, or the leaves of a sensitive plant closing after being touched.

One event that I had long wanted to illustrate was the way that a Sycamore seed 'propellers' down from a tree. I tried to use the 'Repeating Flash' mode on my Nikon Speedlight to produce a series of stroboscopic images, but even on its fastest setting I just got a rather dull series of individual

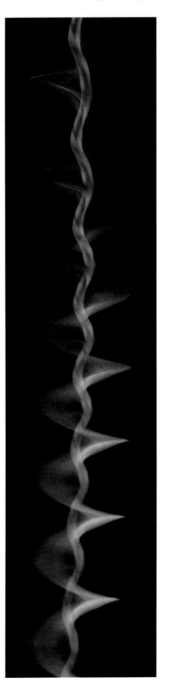

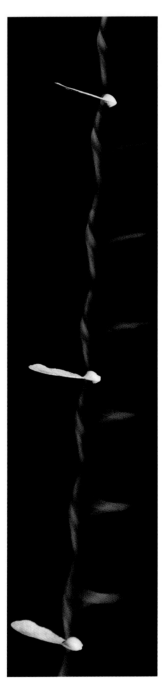

seeds in flight. I particularly wanted to show the corkscrew streak as the seed fell. In the end I used three separate images, merged together in Adobe Photoshop™.

I arranged a large black background in a studio, with two tungsten lights (actually the modelling lights from studio flash units) positioned to light across the front of it. They were masked so that no light fell on the background, or into the camera lens.

I pre-focused on a spot illuminated by the light. An assistant then dropped the seed from a height so that it passed through the lit area. After much trial and error we arrived at an exposure of $^1/_2$ second at f/8 to produce a nice 'streak'. To increase the visibility of the seed I 'painted' it with a yellow fluorescent marker pen.

I then shot an attractive group of leaves and seeds in the same set, using backlighting to give them depth.

For the final part of the image I selected one of the seeds from the failed stroboscopic sequence.

Putting the final image together was relatively simple. I opened the image of the leaves, and used the magic wand tool to select the black background underneath.

I opened the image of the spiral, and using the lasso tool with a five-pixel 'feather' drew roughly around the spiral. I copied this selection, and went back to the first image with the background still selected. I used the 'paste special › paste into' the selected area. This automatically created a layer which I could move into place with the move tool.

I finally opened the failed stroboscopic sequence and selected one of the seed images, and copied it. I returned to the original image, and pasted the seed into it. Again, this created a layer which could be moved.

The final image, of course, is a digital creation, and in no way a 'natural history' image, and there will be photographers who will not agree with it ethically. However, I would class it as a 'photo-illustration' of an event which would have otherwise been virtually impossible to portray.

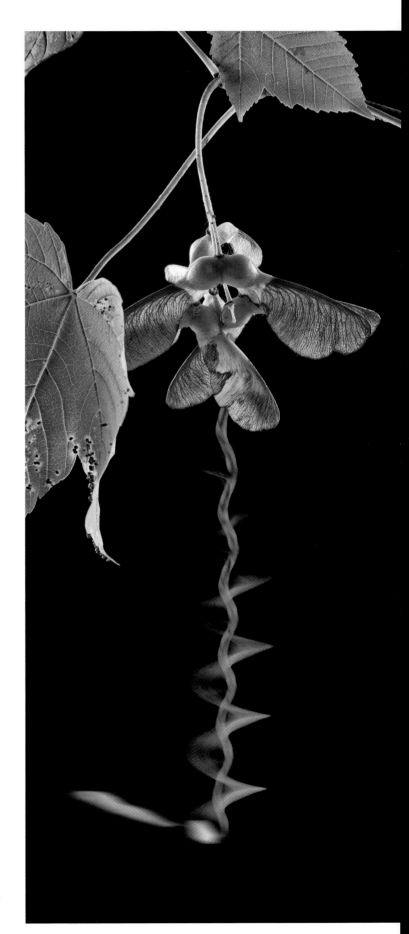

Case study: The Sensitive Plant

I have always been fascinated by the Sensitive Plant (*Mimosa pudica*), which folds its leaves and collapses its stems after being touched, or even in a strong breeze. It also closes up at night, re-opening again in the morning. It is generally thought that the plant evolved this habit to deter animals from eating it, either through the actual movement of the leaves closing, or to make itself as small as possible. The stems revert to their normal position after 15 minutes or so. I grow them from seed, and usually have one or two on a windowsill somewhere around the house. They will sometimes produce small, pretty purple flowers under good growing conditions.

It is easy to do a 'before and after' series, firstly showing the leaves in their normal state, then an image of them closed up. However, I wanted to show some movement in the image, so produced a composite made up from two separate images.

In a darkened room, I firstly shot the undisturbed plant using three small macro flash guns, against a black velvet background. I then turned on a small reading lamp, and positioned it so that it just cast a small amount of light on the plant. Using the same aperture as the first shot, and the camera set to Aperture Priority so that it would change the shutter speed with the lower light level, I then ran a paintbrush over the stem to make it collapse and opened the shutter of the camera, giving a two-second exposure, during which time the blurred movement registered on the image.

In Adobe Photoshop™ I opened both images and made adjustments to shadows and highlights so that they matched in terms of density. In the first image I then selected the black background using the 'magic wand' tool. Switching to the 'blurred image' I drew a rough selection around the blurred area with the lasso tool. I copied this selection. Switching back to the first image with its selected background I pasted the blurred image into the selected area (edit › paste special › paste into). This automatically became a layer, which could be moved into place using the move tool. This layer can be adjusted as though it were an image in its own right – I needed to darken it to match the black of the base image.

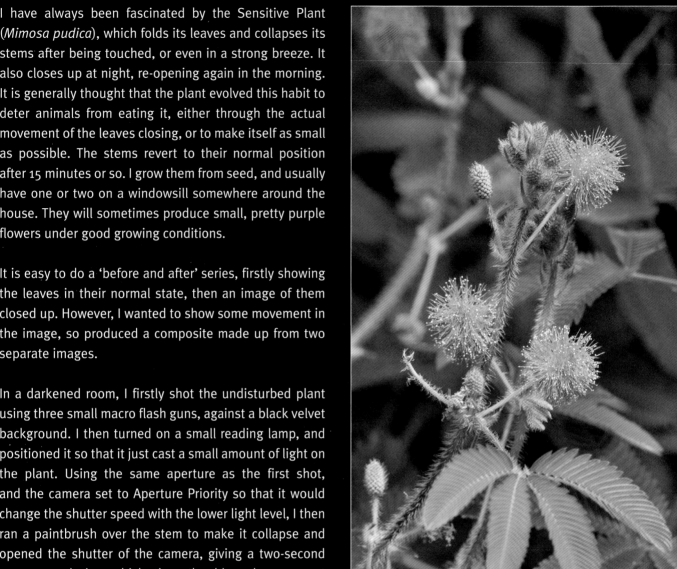

ABOVE Flowers and leaves of the Sensitive Plant (*Mimosa pudica*), growing in the glasshouse of a botanic garden.

105mm macro lens, 1/6 sec at f/11

When I was satisfied I flattened the layers for printing, though also kept a version with the layers for future use.

It is very important with images like this to have the camera on a solid tripod, and to use the same aperture throughout. I also needed to have a couple of different plants, enabling me to practise with one in order to photograph the other.

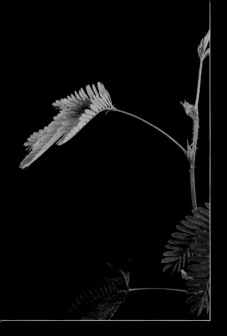

ABOVE The first image of the static plant,
shot with three small flash units.

60mm macro lens, 1/60 sec at f/8

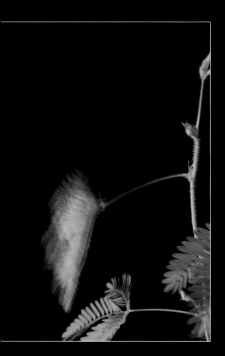

ABOVE The image with the blurred stem
after being touched with a paintbrush.

60mm macro lens, 2 sec at f/8

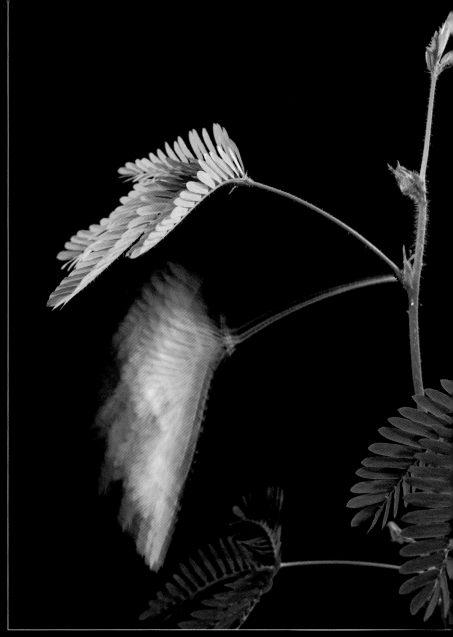

ABOVE The final composite.

RIGHT The two layers shown in
Photoshop™. Note the mask
applied to the layer so that the
blurred image will only paste
into the selected area.

Focus stacking

Focus stacking is a relatively new technique, enabling you to get otherwise unobtainable images with virtually limitless depth of field. It was originally developed by microscopists, but is now readily available for photographers.

The technique enables you to greatly increase depth of field in an image (particularly close-up and macro shots, though it can be used with 'conventional' shots too) without using a small aperture (thus avoiding the effects of diffraction), thus keeping the background out of focus. The effect can be extraordinary, and totally impossible to achieve using conventional photography. It can be done in both studio and location situations, though it does require a 'still' subject.

The basic idea is to shoot a series of images of a subject, from the same viewpoint, focusing on a slightly different plane within the subject each time so that you effectively track through it – as though you were slicing it into thin sections. You can shoot as few as two, or dozens of images that can later be combined into one frame using appropriate software.

SHOOTING

The camera must be on a tripod, and the subject must not move during the exposure process. Lighting must remain constant for all exposures. It is essential to use the same aperture and shutter speed for each shot. You can use a wide aperture, such as f/4, which will help keep the background out of focus if this is required.

Focus on the nearest point of the subject that you want in focus, then the furthest point, and try to estimate how many images can be realistically shot to cover the distance. Although difficult, the distance between each image should remain constant, though this is by no means essential. If the total distance to be covered is 24mm, I would aim for around six images at 4mm apart. You can either refocus the lens (the easiest option) or use a focusing rail to move the whole camera back and forth to the subject. Refocusing the lens is a rather crude method, which can lead to gaps in the series, which show up as out-of-focus bands within the final image. Also, refocusing the lens effectively changes the image size by a small amount, which can in some cases prove a problem when blending the images. However, used with care, this method can work very well in most instances. I often use it on location when I have not taken my focusing rail with me.

Using a focusing rail with a scale, and a geared or rack and pinion movement, enables very fine adjustment in equal amounts, and is by far the best method, although it does mean carrying yet another gadget with you! Suitable rails are available from companies such as Novoflex, Really Right Stuff and Kirk Enterprises.

Some software packages such as Helicon Focus™ (using the utility Helicon Remote™) and Zerene Stacker™ offer automated functions, for controlling camera rails or lens focusing.

SOFTWARE

The facility is built into Adobe Photoshop™ (CS5 and 6), and performs very well. Other dedicated programs include Helicon Focus™ and Zerene Stacker™.

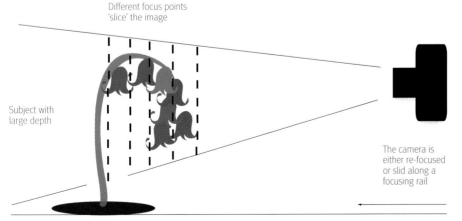

Different focus points 'slice' the image

Subject with large depth

The camera is either re-focused or slid along a focusing rail

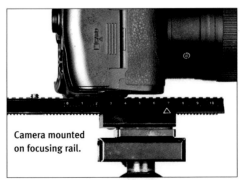

Camera mounted on focusing rail.

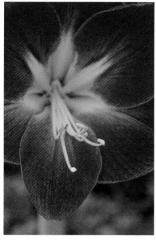

LEFT The furthest and nearest points of the flower needed to be in focus. I shot six images to cover the distance.

BELOW The six images loaded as layers in Photoshop™.

RIGHT The Auto-Align facility, for correcting any slight misalignment of the images during the photography.

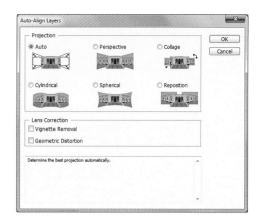

RIGHT Auto-Blend dialog box, with 'Stack Images' selected.

BELOW The final image of Amaryllis (*Amaryllis belladonna*) 'Naughty Girl' showing the whole flower sharp from the tip of the stamens to the base.

All six images: 105mm macro lens, 1/125 sec at f/5.6

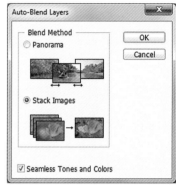

FOCUS STACKING IN PHOTOSHOP™

1 Having shot the series, view them in Adobe Bridge™, and select all of them.

2 Go to 'tools › Photoshop › load selected images into Photoshop layers'.

3 Select all of the layers in the layers dialog box, then go to edit › auto-align layers. This will solve the problem of any slightly misaligned images.

4 Finally, go to edit › autoblend, and select the 'stacking' option. This operation may take some time as you will be handling a large amount of data (6 x 30Mb images is 180Mb of data to process).

Having got your final image, go to the layers submenu and flatten the stack. Enhancement of the final image using levels, curves and so on can now be carried out as normal.

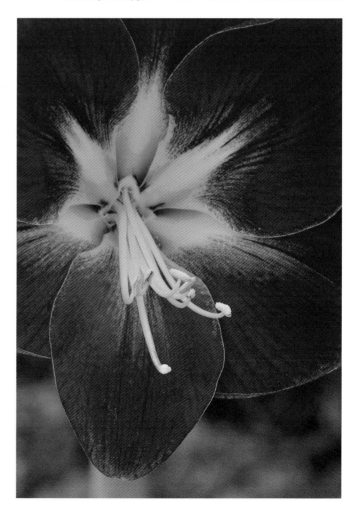

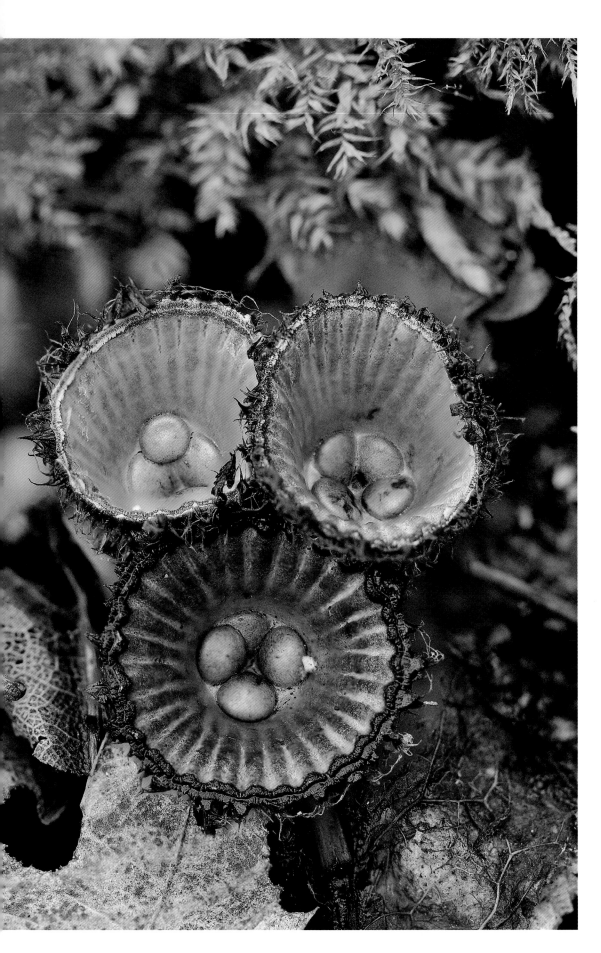

LEFT I found this common, though often overlooked, Fluted Bird's Nest Fungus (*Cyathus striatus*) in a wood in Devon in August. The total height from the tip of the rim to the 'eggs' containing the spores in the bottom was around 2.5cm. I shot four images and stacked them to produce one sharp image. Note the piece of moss on the left-hand side which was above the plane of the fungus, and which wasn't included in the stack.

105mm macro lens,
1/80 sec at f/5.6

RIGHT The leaves of this Meconopsis (*Meconopsis paniculata*) 'Ginger Snap' looked stunning covered in raindrops. I shot four images to get them sharp from top to bottom.

105mm macro lens,
1/200 sec at f/5.6

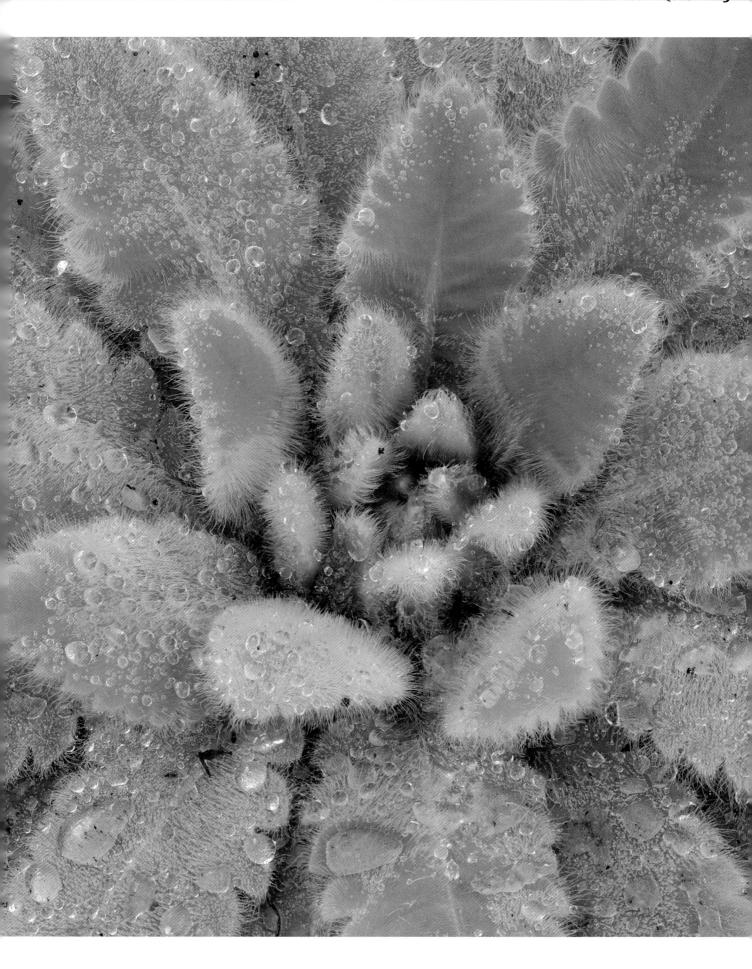

Panoramic imaging

The basic idea behind the production of digital panoramas is to produce two or more images of the same scene, overlapping so that they can be digitally 'stitched' together to produce one continuous image. They are a great way to show plants in their habitats, such as woodland interiors, coastal or mountain habitats. Complete 360-degree panoramas are possible, as are vertical panoramas of trees (an extraordinary vertical panorama of a Giant Redwood tree was published in the October 2009 edition of *National Geographic* magazine, combined from 84 separate images).

Specialist equipment is available to enable you to accurately level the tripod head and find the exact centre of the lens to avoid distortion, but it is possible to create perfectly acceptable panoramas with an ordinary tripod, camera and spirit level.

The key issues for successful panoramas are:

1 Get the camera level

2 Make sure that the images in the series overlap by at least 25 per cent

3 Use the same exposure and white balance throughout the series (i.e. manual settings), as well as manual focus.

SHOOTING THE PANORAMA

1 Select an appropriate scene. Try to include some foreground interest and visualise how the final image will work when stitched together.

2 Level the tripod – many models have bubble heads to help get them level. You may need to adjust the leg lengths to achieve this. Mount the camera onto the tripod, and use a spirit level (or digital 'virtual horizon' setting in the camera if it has one) to get the camera level. Small two-bubble spirit levels are available which sit in the hot shoe of the camera. It is important to ensure that the camera is as level as possible as you pan round the scene being shot. This may take some time to achieve.

3 Any focal length of lens can be used, but don't use one that is too wide or distortion may prevent the software from stitching the images perfectly. A focal length in the region of 40–50mm is ideal (if you are using a zoom lens, it is essential that the same focal length is used for each image). Don't use a lens with too short a focal length or you may run into distortion issues. Ideally, the camera should rotate around the centre (nodal point) of the lens, but for most purposes it will not matter too much if it doesn't. Do not use autofocus or the camera may refocus as you pan around the scene.

4 Use the manual exposure mode. Take a meter reading with the camera meter from an average part of the scene, and use this exposure for all of the images in the sequence. If an automatic or semi-automatic setting is used, the exposure may vary across the length of the panorama as the camera adjusts to changing light levels across the image. Similarly, turn off auto white balance (AWB) and set the colour temperature manually to the most appropriate setting for the scene being photographed (sunny, cloudy). Finally, do not use a polarising filter for panoramas.

5 When exposing the images, ensure an overlap of at least 25–30 per cent with each image to enable the software to find areas of common content to match up. Some tripod heads have a scale, calibrated in degrees, to help get the same overlap for each pair of images. I often do this by eye, which works well most of the time.

By their very nature, panoramas are long and thin. To increase the height of the final image, try turning the camera vertically. You will obviously need to shoot more images to get the same length of image.

STITCHING THE PANORAMA

There are many programmes available for producing panoramas (try typing 'stitch, panorama' into Google) – some of which are free. Adobe Photoshop™ and Adobe Photoshop Elements™ have the 'Photomerge' facility for stitching images, which is very good. (It is possible to overlap the images manually in Photoshop™, and it is worth trying this to see how the software works.)

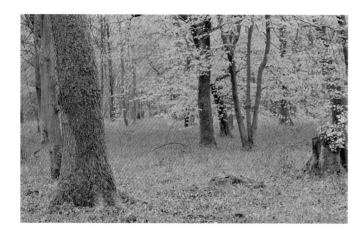

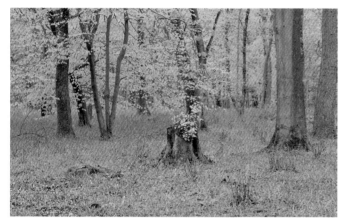

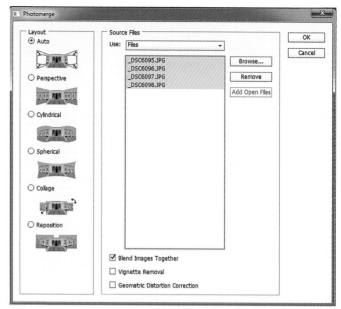

LEFT The component images of the Bluebell panorama, shot on a very dull, overcast day.

ABOVE The Photomerge screen in Adobe Photoshop CS5™.

17–55mm lens at 44mm, 1/50 sec at f/5.6

Some of the software packages allow you to save the images as QuickTime files, with the capability of zooming in and out, or panning round the image. This can be very effective on a website for example.

The main technique in Photoshop™ is as follows.

1 Using Adobe Bridge™, select the images you want to stitch together, and load them into Photoshop™'s 'Photomerge' facility (tools › Photoshop › photomerge).

Tip: In Bridge™ I assign a red label to the images in a stacked or panoramic series. If I am out all day, and have shot a panoramic series in between lots of other images, I try to segregate the series by shooting a blank frame at the start and the end of the series.

2 The Photomerge box should appear. There are several options for stitching together the images. I generally use the auto option, which works well most of the time. Select the images, and press OK. The stitching operation may take some time (if you are stitching together ten 30Mb images there is 300Mb of data to process).

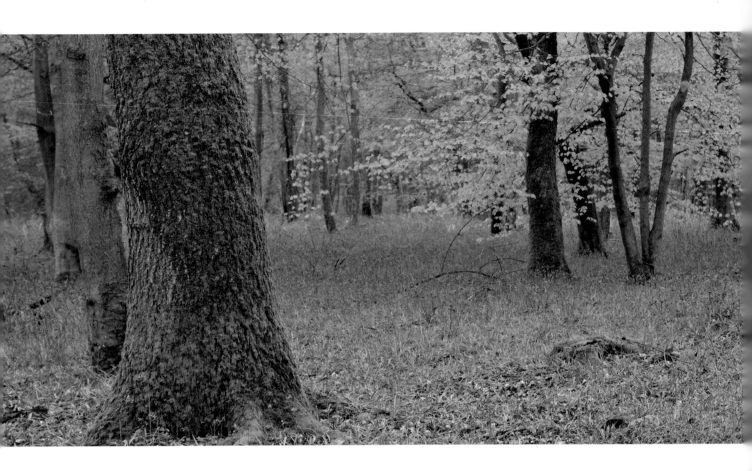

ABOVE Panorama of Bluebell wood in spring, composed of four overlapping images.

RIGHT Bald Cypress (*Taxodium distichum*) trees in Florida swamp, showing buttressed trunks. Three shots were stitched together in Photoshop CS5™.

17–55mm lens at 34mm, 1/40 sec at f/6.3

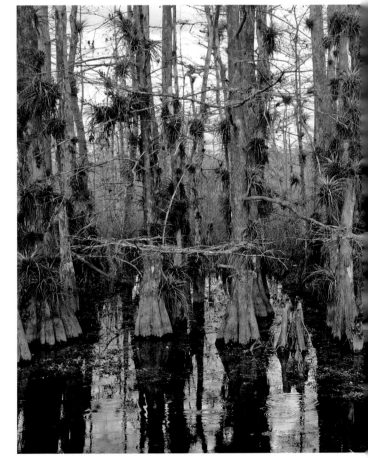

If you have been careful when shooting the images, you should now have a perfectly stitched panorama. You may find a little 'stepping' at the top and bottom of the frame which can be removed either by using the cropping tool, or 'filled' using the 'content aware' fill tool (image › edit › fill › content aware), or retouched using the clone tool.

When you are satisfied with the panorama go to the layers dialog box, and flatten the layers. You can then apply your normal enhancement techniques to the whole image.

'Macro panoramas' are also possible. This is where you shoot a series of images at close range to a subject, such as lichens on a tombstone, for example. I use my Benbo™ tripod with its centre column aligned horizontally. I extend it fully in one direction, then gradually move it along so that it tracks parallel to the plane of the subject.

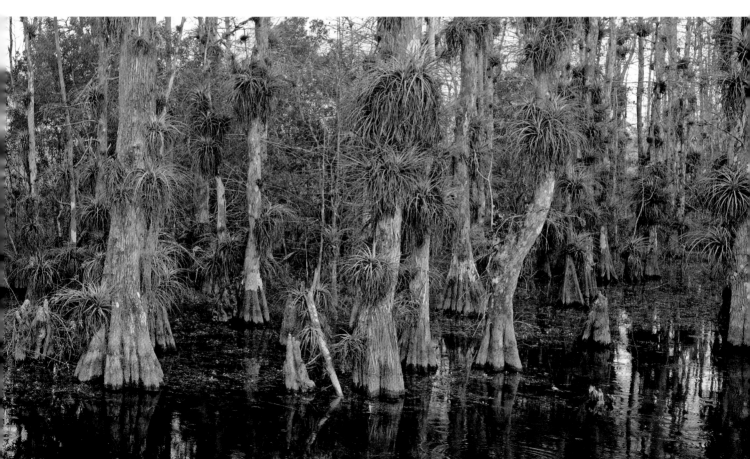

High dynamic range imaging (HDR)

This is another relatively new technique for helping deal with scenes where the contrast range is beyond what the camera sensor can record. It is used mainly by landscape photographers, and is being used increasingly as a creative tool for producing often surreal or bizarre imagery. Its use in plant photography is limited, though it may, on occasion, be a very useful tool. Adobe Photoshop™ has an HDR facility and there are several dedicated software packages such as Photomatix Pro™.

The basic idea is to shoot a series of bracketed exposures of the scene – the general recommendation is two stops apart. The camera needs to be mounted on a tripod, and there should be no movement of the subject (if there is some movement due to breeze, there is a facility in the software for removing 'ghosts', caused when parts of an image do not marry up). The series is then loaded into the software (in this case Photomatix Pro™) – one giving shadow detail, one for correct mid-tones, and another for the highlights.

In the first example, I wanted to photograph this Sycamore (*Acer pseudoplatanus*) tree in a lavender field. The light was very dull, with a heavily overcast sky. Despite waiting over two hours, the light did not improve. I decided to try an HDR image. I shot three exposures, at 1/60 sec at f/11

LEFT AND BELOW Sycamore tree in Lavender (*Lavandula* sp.) field. Image composed from three bracketed images, two stops apart.

17–55mm lens at 44mm

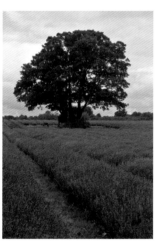

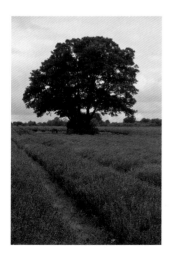
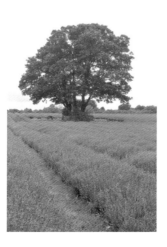
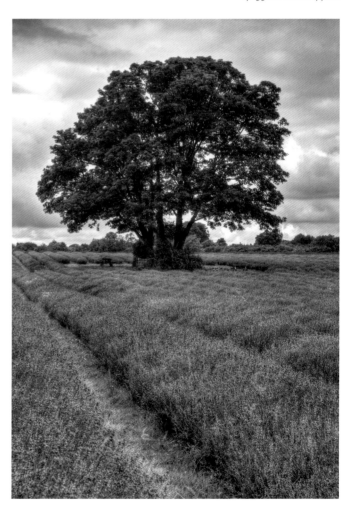

(the metered exposure), 1/250 sec at f/11, and 1/15 sec at f/11. I loaded these into Photomatix Pro™, and selected the 'photographic' preset (there are a large number of other presets including 'painterly', 'surreal' and 'grunge' – the names of which speak for themselves). The effect is to greatly increase the contrast in the sky and bring out detail in the mid-tones.

Another method to try with very high contrast scenes is to produce an HDR image from just one Raw file. A major feature of Raw files is their ability to capture a much wider range of tones than can be displayed on a monitor. Very often highlight and shadow detail can be 'recovered' using the exposure slider.

The second example is the image of Ramsons, or Wild Garlic, first shown in chapter three on lighting. The scene had very high contrast, and I waited for a cloud to cover the sun before shooting it. However, I opened the original high-contrast version in Adobe Raw Converter™, and processed it three times using the exposure slider, once to give detail in the shadows, once for the mid-tones and once for the shadows. Even making the image very dark did not recover all details from the highlights, and there are many areas which are completely burnt out. I loaded the three versions into Photomatix Pro™ and applied the 'photographic' preset.

The result will not be to everyone's taste, but could possibly be used to rescue an otherwise unacceptable image. It is worth comparing this result with the overcast image in the section on light in chapter three.

Wild Garlic in streambed. HDR from one high-contrast image.

10–20mm lens at 12mm

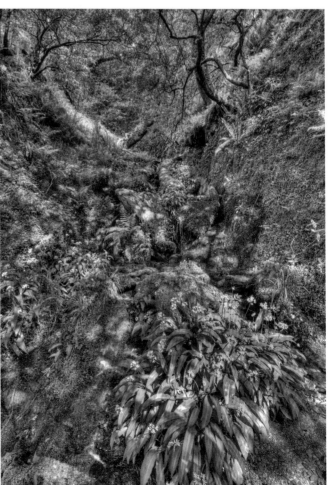

BRACKETING

Bracketing is where you shoot an image at the exposure indicated by the meter, then one or more other exposures both under and over the indicated one. For example, if the meter indicates an exposure of 1/60 sec at f/8, you might bracket for one stop on either side of that – 1/30 sec at f/8 and 1/125 sec at f/8. It is advisable to do this with high-contrast scenes, to ensure you have recorded all necessary detail.

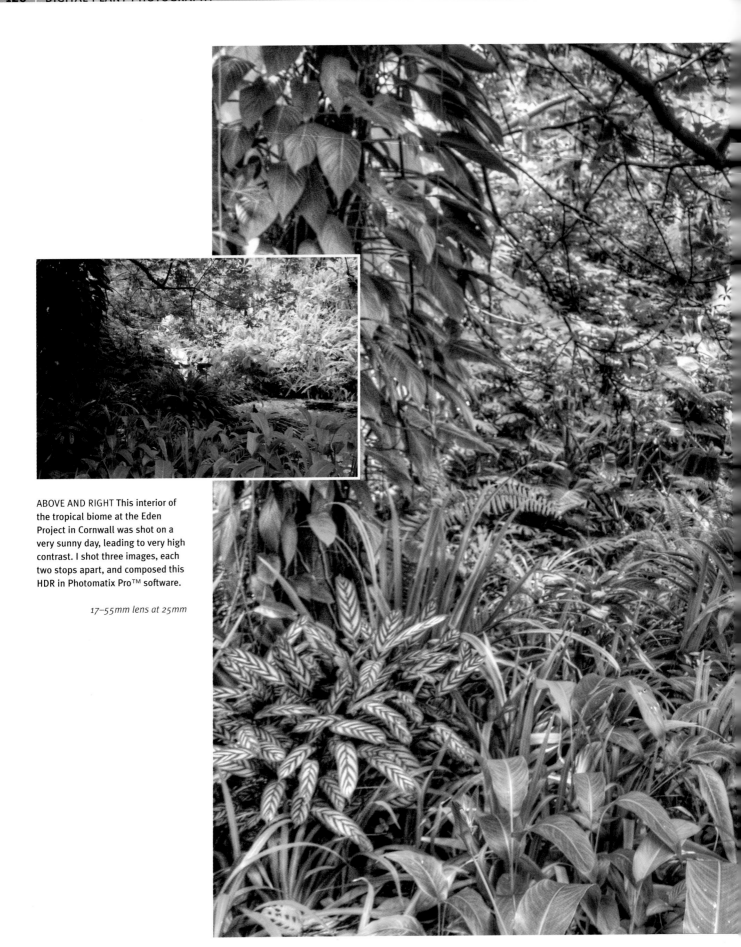

ABOVE AND RIGHT This interior of the tropical biome at the Eden Project in Cornwall was shot on a very sunny day, leading to very high contrast. I shot three images, each two stops apart, and composed this HDR in Photomatix Pro™ software.

17–55mm lens at 25mm

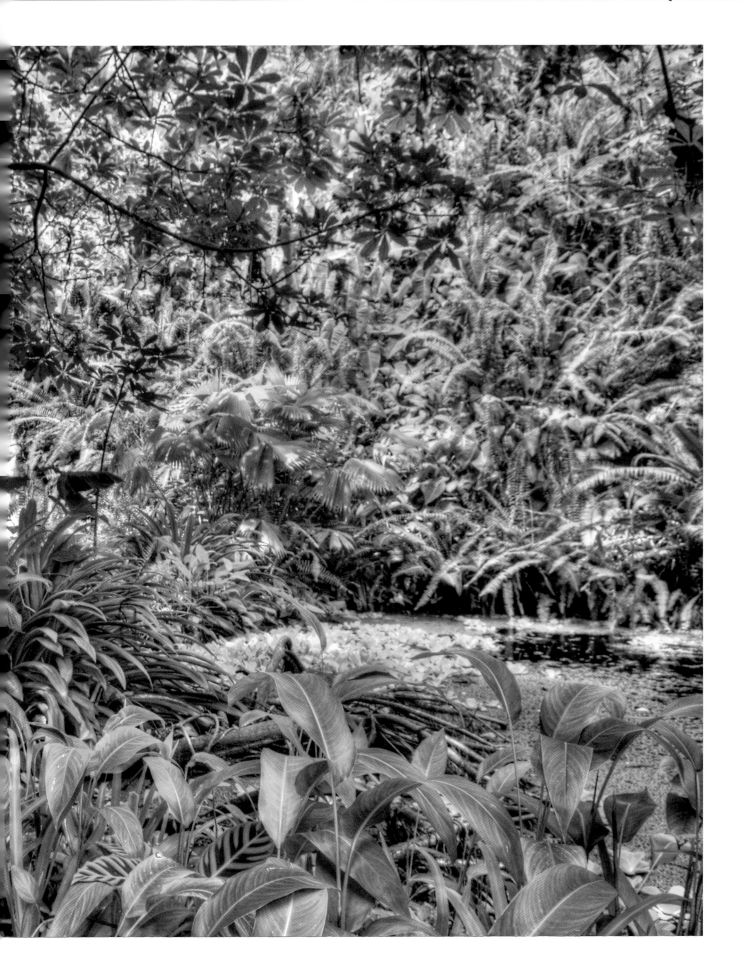

Themes

Working to a theme can greatly enhance your photography, allowing you to tell stories with your images, or build up collections of images of particular subjects. I am always working on several themes at the same time, maybe leaves or bark of trees in autumn, orchids in early summer, or patterns and textures throughout the year. The limit is really your own imagination.

Black-and-white/monochrome images

Many plant subjects can make excellent black-and-white or monochrome images, particularly those with well-defined shapes, textures or patterns. Many great photographers, such as Edward Weston, Georgia O'Keeffe and Robert Mapplethorpe, produced some superb black-and-white images of plants. I find that images of foliage generally work well.

RIGHT I love the architectural shapes of this Agave plant (*Agave attenuata*) growing in a glasshouse in a botanic garden in England, which seem to work better in black and white than the subtle shades of green of the original.

105mm macro lens, 1/13 sec at f/16

Most cameras nowadays have a black-and-white option in their menu, but, unless you are absolutely certain you will never need a colour version I would always recommend shooting in colour, and converting to black-and-white afterwards. Shooting Raw files is perhaps the best option, as the images can be produced as colour or monochrome in the Raw converter.

TERMINOLOGY

Strictly, most black-and-white images should be referred to as 'greyscale', in that they contain pure black, pure white, and a range of grey tones in between. Monochrome images are greyscale images that are coloured or toned, for example, in sepia or blue.

In Adobe Photoshop™, there are several options to produce a greyscale image, but probably the best one is to use the 'Black and White' control (image › adjustments › black and white).

Using this option, the image remains as three coloured channels (red, green and blue), but each channel is de-saturated to produce grey. Each of the channels can then be lightened or darkened – so green leaves can be lightened or darkened, or a red flower can be similarly altered. One option is to check the 'tint' box, which enables you to put a coloured tint over the images.

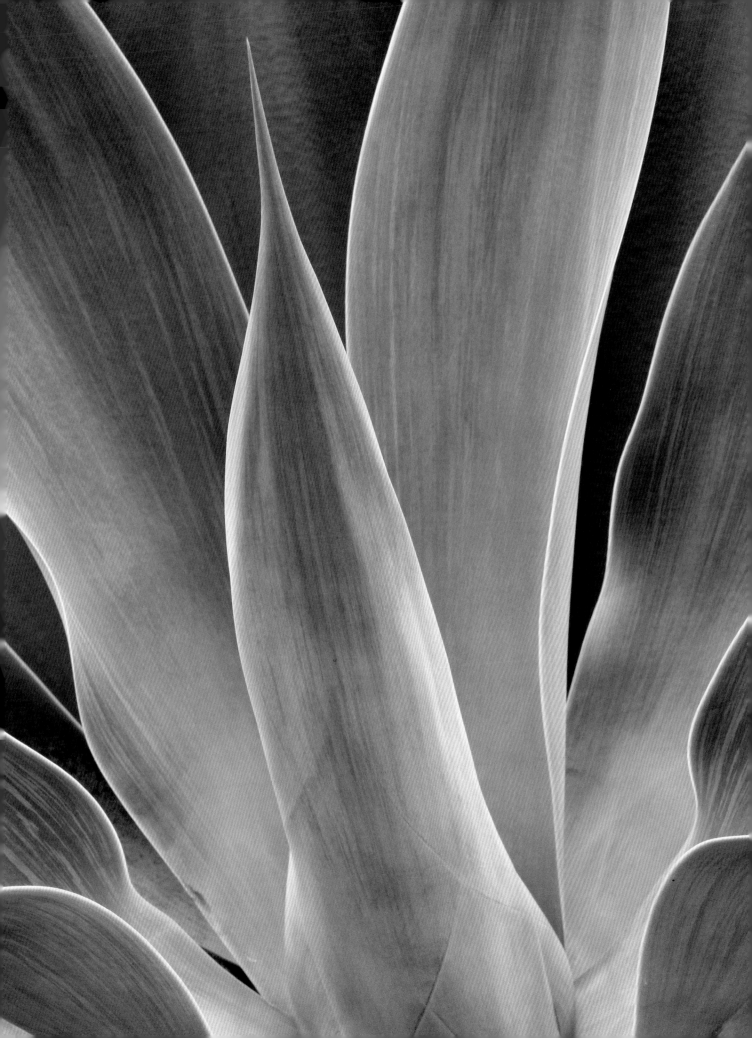

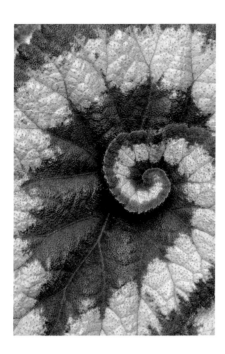

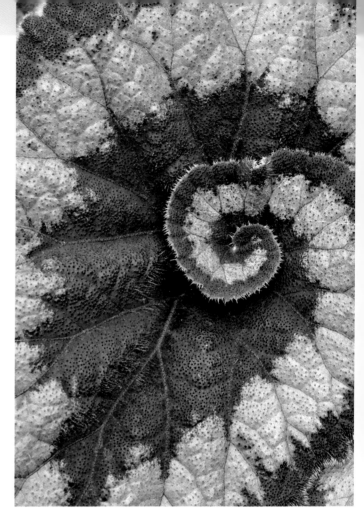

LEFT AND RIGHT
This lovely Begonia (*Begonia* sp.) 'Escargot' works well as a greyscale image, with its well-defined graphic shape. Note how I have chosen to lighten the red line in the original to make it stand out in the greyscale version.

105mm macro lens,
1/10 sec at f/16

PRINTING BLACK-AND-WHITE IMAGES

It can be difficult to produce truly neutral black-and-white images from a colour inkjet printer. They try to produce a neutral grey tone by mixing equal amounts of the six or more colours in the printer, which is an extremely difficult task, and the end result is usually a greyscale image with a slight tint. One option is to have a separate printer, containing a 'quad black' cartridge – one that gives four shades of grey, rather than coloured ink. This can produce outstanding black-and-white prints. A fifth, colour cartridge can be added in some cases, to produce a toned image.

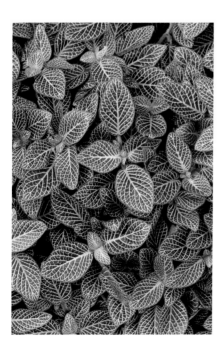

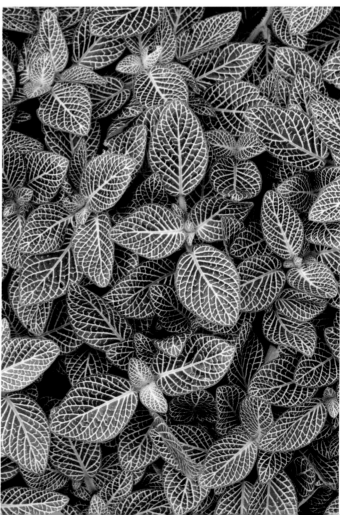

LEFT AND RIGHT
The leaves of the Mosaic or Nerve Plant (*Fittonia albivens*) work well when converted to a greyscale image with the contrasting white pattern on the leaves. The image was shot in the glasshouse of a botanic garden.

105mm macro lens,
1/6 sec at f/11

This leaf of the Giant Rhubarb (*Gunnera manicata*) was shot in late autumn as it was dying down for the winter. I converted the original to a sepia-toned monochrome image using the 'Black and White' control in Photoshop™. Note the 'tint' box has been checked.

Original image: 70–200mm lens at 200mm, 1/6 sec at f/16

Botanical illustration

Botany has a great tradition of technical illustration, with artists producing wonderfully detailed pictures of plants in a variety of media. The difference of course between the drawing or painting of plants and photographing them is that artists can bring together various elements into their images at any time, and be very selective in what they paint or draw. A plant 'portrait' can be composed of various elements drawn together from work over several seasons.

Digital technology now enables botanists and photographers to make their own versions using Adobe Photoshop™, which can be built up over a long period of time. Probably the best current exponent of the technique is Niki Simpson, whose website is given at the end of the book. My own much simpler example of the Snakeshead Fritillary was compiled using seven images taken over a period of two seasons. The main image was deliberately shot against a

BELOW **A composite image of the Snakeshead Fritillary, composed in Adobe Photoshop™.**

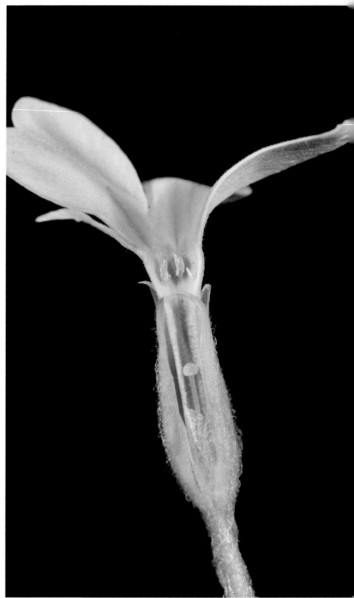

ABOVE AND RIGHT There will be instances where you will want to illustrate an aspect of a flower or other part of a plant, when only dissecting it can reveal hidden structures. Wild Primroses (*Primula vulgaris*) are found in two forms: pin-eyed and thrum-eyed, to ensure cross-pollination within a population. To illustrate the differences I took two flowers from my garden and cut away the front with a scalpel. I then held each flower by its stem in a 'helping hand' clamp against a black velvet background, and used diffuse daylight to photograph them both to the same scale.

105mm lens, 1 sec at f/11

white background. Parts of chosen images were selected in Photoshop™ using the 'quick selection' tool, or the 'magic wand' tool. Selected areas were copied and pasted into the final composition, where they were resized (edit › transform › scale). The image was saved with all of its component layers so that changes could be made to the composition at a later date.

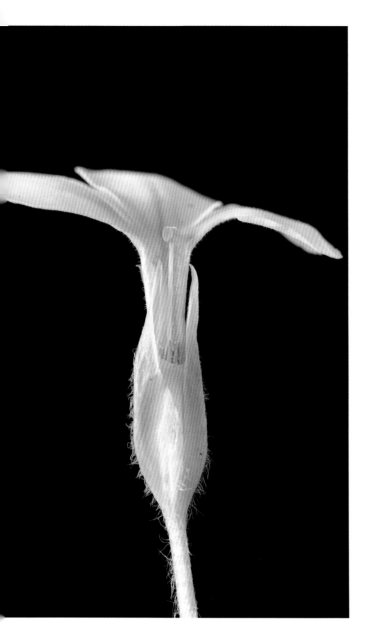

SCALE

To enable precise measurement of a subject from a photographic image, some sort of scale is needed. Rulers or objects such as coins can be used. They must be placed in the same plane as the main plane of the subject. In the illustration here I placed a commercially available scale, used by medical and forensic photographers, alongside the subject. They are available from the address listed in the reference section at the end of the book.

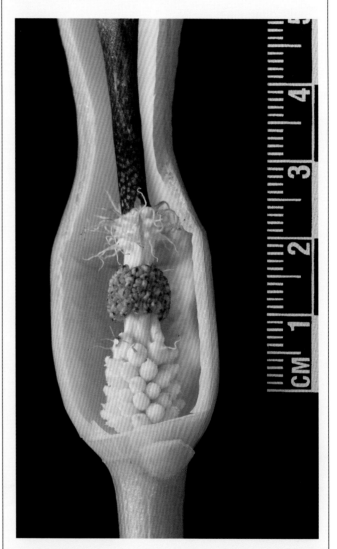

ABOVE I also cut away the front of this Cuckoo Pint (*Arum maculatum*) flower to reveal the inner structure, showing the ring of stiff hairs which trap insects inside the spathe overnight where they become dusted with pollen. The hairs wither in the morning, allowing the insect to escape and visit another flower. I placed a scale used by medical and forensic photographers in the same plane as the specimen.

105mm macro lens, 1/2 sec at f/11

No attempt was made to produce the image to scale. A refinement to the technique would be to add a scale to each of the components so that relative size could be determined. Also, when taking the original images, inclusion of a grey reference card would help with producing a neutrally colour balanced image.

One version had the layers flattened for printing.

When producing images for technical reference, it is important to use shadow-free lighting, to ensure that no detail is lost anywhere within the image. Using two lights of equal strength is one option, or as shown here, diffuse daylight through my study window.

Flowers

Flowers are, of course, the most popular of all plant subjects for photography. They are found in most habitats of the world, from the highest mountains to the driest deserts, and in a huge range of colours, shapes, textures and sizes. Some orchids, for example, even produce their flowers entirely underground.

Along with the variety of flowers is the range of approaches you can take to photograph them. Portraits of individual flowers, the whole plant and the plant in its habitat are obvious approaches, but you might also try to photograph flowers by a theme, such as British orchids, irises or roses for example. Some flowers grow en masse in woods, meadows or fields, making a wonderful spectacle, which can sometimes be difficult to capture with a camera. My

own particular favourite flower is the Snakeshead Fritillary and every year I visit a meadow where wild fritillaries grow in profusion, trying to get different images.

Many flowers, such as orchids and bell-shaped flowers, have great depth, which is often too great to be captured successfully in a close-up, even with a small aperture, and you may need to try the relatively new technique of focus stacking (see chapter six) to bring the whole flower into focus. Others, such as umbellifers and daisies, are relatively flat, and will benefit from being photographed with the camera parallel to the flower.

I always prefer to photograph flowers with natural light if at all possible.

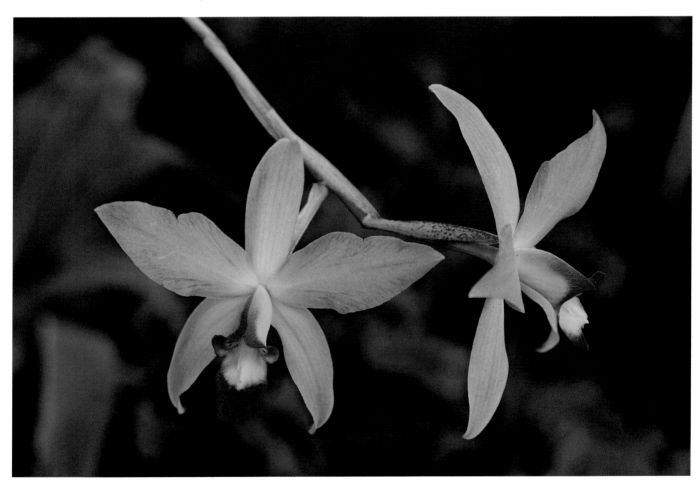

ABOVE I photographed this cultivated orchid (*Laelia anceps*) 'Dawsoniana' in the glasshouse of a botanic garden, where there was a large specimen with many flowers. After concentrating on single blooms I found a stem with two flowers at almost 90 degrees to each other, so that I could show both a front-on view of the flower and a side-on view at the same time. As the orchid was near the door to the glasshouse there was a constant breeze, and I had to take several shots before I got one that was sharp. The dark background is an area underneath some dense tree ferns.

105mm macro lens, 1/50 sec at f/8

RIGHT Although Rosebay Willowherb is thought by many to be a weed in the UK, I love photographing it, always looking for different aspects to illustrate. Here I have focused very specifically on the tip of the stigma, letting the rest of the flower run out of focus.

105mm macro lens with 1.4x converter, 1/400 sec at f/8

BELOW RIGHT Although they are every gardener's nightmare, I find bindweeds in general make wonderful photographic subjects. This particularly beautiful species (*Convolvulus sabatius*) was growing in the alpine house of a botanic garden, where it covered some contrasting sandstone rock. I made sure the camera was parallel to the main group of flowers, and used an aperture of f/11 to ensure sufficient depth of field to cover the depth of the flowers. The diffuse light from a cloudy sky was perfect to show the flowers without distracting shadows.

105mm macro lens, 1/100 sec at f/11

BELOW On a recent trip to northern Spain I found lots of these beautiful Sawfly Orchids (*Ophrys tenthredinifera*) and their hybrids, growing in flower-filled alpine meadows. I used a 105mm lens with 1.4x converter to isolate this specimen from the out-of-focus background, but decided to use a viewpoint showing the pink blur of other specimens to provide colour to the background.

105mm macro lens with 1.4x converter, 1/160 sec at f/8

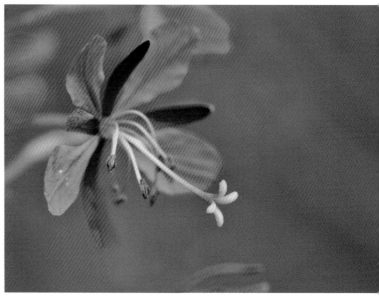

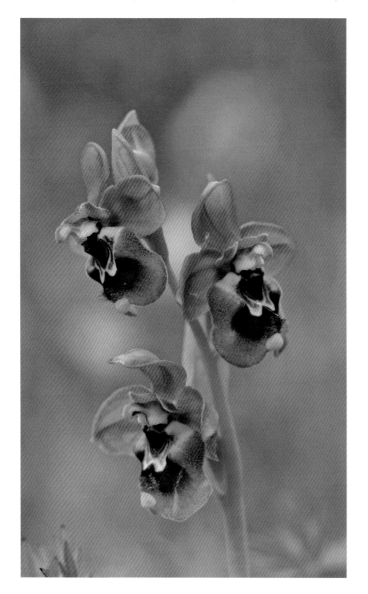

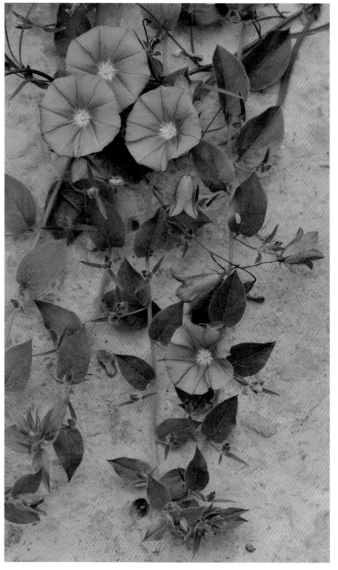

RIGHT I used a long telephoto lens to throw the background behind this Snakeshead Fritillary out of focus. I think it is very important both botanically and pictorially to include the upper leaves of fritillaries in portraits of the flowers.

70–20mm lens with 1.4x converter (effectively 280mm), 1/125 sec at f/5

OPPOSITE Chicory (*Cichorium intybus*) is one of my favourite wild flowers. I generally find that it flowers in the mornings, and has shut by midday. I love the blue colour, though it can be difficult to get it right in a photograph. For this image I used my grey card technique, outlined in chapter three. It was photographed on a windy roadside verge. Chicory has a fascinating history, including being used as a coffee substitute for hundreds of years.

105mm macro lens, 1/640 sec at f/9

BELOW We are fortunate in the UK to have some stunning displays of wild flowers in our spring woodlands, including Bluebells, Snowdrops (*Galanthus nivalis*), Wild Daffodils (*Narcissus pseudonarcissus*) and Ramsons or Wild Garlic. Here, this mass of Ramsons was photographed early in the morning in soft light in spring. There was very little wind, so I was able to stop the lens down to f/16 to get sufficient depth of field to cover most of the scene. I deliberately included some of the coppiced Hazel trees in the image to give an indication of the habitat.

17–55mm lens at 28mm, 1/8 sec at f/16

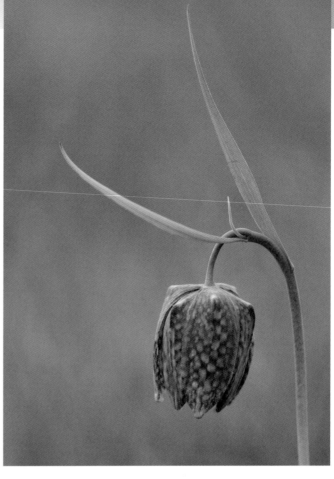

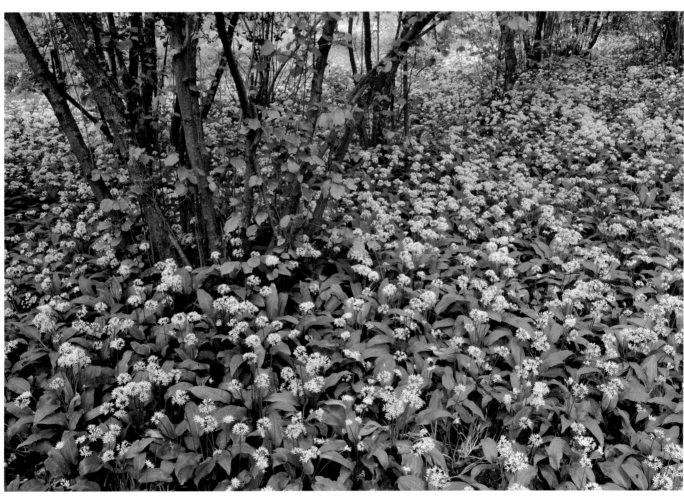

Foliage

Foliage is the term used to describe a group of leaves of flowering plants. Leaves of different species grow in very specific patterns to capture as much light as possible, and the leaves of flowering plants are found in a multitude of colours, shapes and textures. Gardeners grow many plants, such as hostas (*Hosta* spp.), cannas (*Canna* spp.) and epimediums (*Epimedium* spp.), specifically for their foliage, while many wild plants, particularly trees, can have spectacular foliage, especially in autumn. For a successful foliage image I feel that, in general, you should try to fill the frame with the subject, and, as far as possible, have all parts of the subject in focus. Position the camera so that it is parallel to the main plane within the subject, use a small aperture if possible to ensure a good depth of field, and eliminate as far as possible any out-of-focus areas.

BELOW This Japanese Maple (*Acer palmatum dissectum*) looked stunning in bright but overcast conditions in autumn, with the stone wall adding extra interest in this English botanic garden.

17–55mm lens at 40mm, 1/80 sec at f/8

RIGHT Hostas are a favourite food of slugs, so finding a specimen with perfect leaves is always a bonus. Here I have placed the camera directly overhead, looking down into the leaves. An overcast sky is ideal for retaining detail in all parts of the image.

105mm macro lens, 1/40 sec at f/16

RIGHT These spiny leaves of the Pyrenean Eryngo (*Eryngium bourgatii*), growing in northern Spain, were shot at f/16 to bring as many as possible into focus. A kneeling mat was almost essential here as there were many other specimens in the immediate vicinity.

105mm macro lens, 1/15 sec at f/16

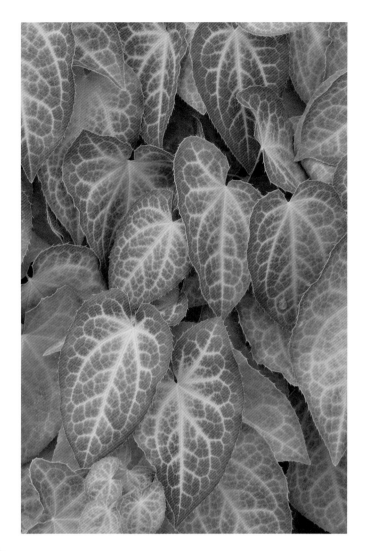

ABOVE LEFT Epimediums are generally grown as ground cover in gardens and can have wonderfully subtle colours and tones. I was careful to include at least one complete leaf in the image.

105mm macro lens,
1/80 sec at f/11

ABOVE This Dawn Redwood (*Metasequoia glyptostroboides*) was photographed in autumn in a botanic garden where it grows on the edge of a lake. The colour of the water in the lake perfectly mirrored the colour of the leaves. A reasonably fast shutter speed was used to freeze any possible movement of the branch in the strong breeze.

70–200mm lens at 200mm,
1/640 sec at f/5.6

LEFT On the face of it a picture of dying leaves, this in fact is one of the world's most valuable commodities – tobacco (*Nicotiana* sp.) leaves, which have been hung to dry before processing.

70–200mm lens at 190mm, 1/40 sec at f/8

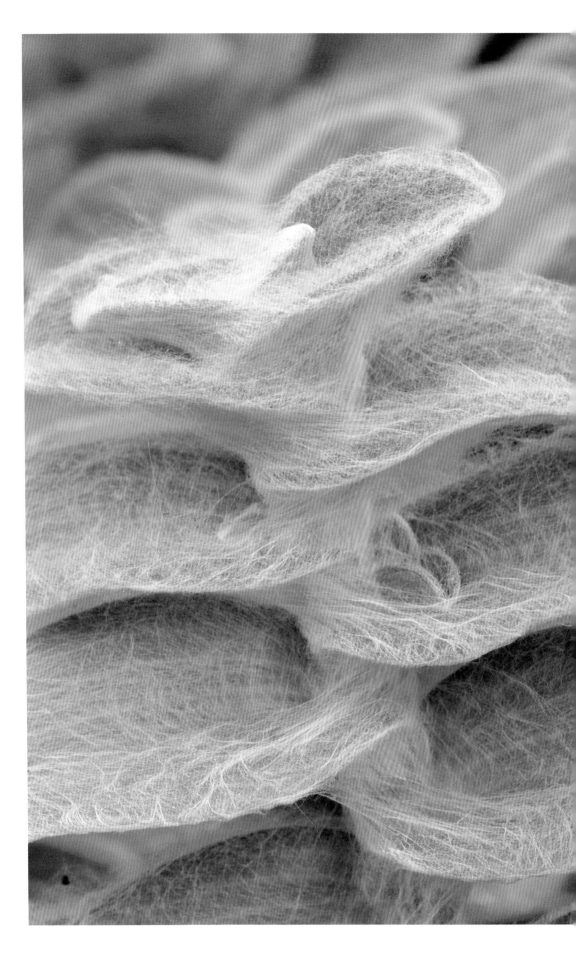

RIGHT This close-up of *Tradescantia sillamontana* shows the leaves almost completely covered by fine white hairs, protecting the plant from direct sunlight and excessive evaporation. The leaves are arranged in a very precise geometric pattern. I shot it in a glasshouse, and used a small aperture to bring as much of it into focus as I could.

105mm macro lens,
1/13 sec at f/16

Fungi

Although techniques and considerations for photographing fungi will be similar to the various true plants, one fundamental difference is their erratic and unpredictable appearance. Probably more than any group of plants they are dependent on a specific temperature and moisture to proliferate – a location brimming with specimens one year can be completely devoid of them another year, following a very dry spell for example. Another increasing problem in certain areas is over-picking, often by people employed by restaurants. I sometimes arrive at my favourite wood early in the morning, only to find some specimens have been picked. Mushroom collecting is now banned or discouraged in some areas.

FRUITING BODIES

Fruiting bodies of fungi come in a myriad of shapes and forms, from the traditional toadstool, to beautiful cauliflower-shaped forms and bizarre alien-looking species. They are found in most habitats, and even when I am photographing flowers in spring and summer, I keep an eye open for them. They are found in both a wide range of habitats, and on different substrates from trees to rock, animal dung and on other plants. Many grow in very specific habitats, or in association with particular trees; for example, the classic red, white-spotted fairytale toadstool, the Fly Agaric, grows only in association with birch trees (*Betula* spp.). It is always worth trying to give an indication of this association in your images.

Many fungi appear overnight, so searching for them in the morning is best, before slugs and other animals have had a chance to nibble them.

Fruiting bodies of fungi vary enormously in size, and it is always worth considering placing a natural object, such as a leaf, pine cone or acorn, next to them to provide a natural scale.

Because they tend to be more solid than flowering plants, and so less affected by wind, it is often possible to use long shutter speeds to enable you to use a small aperture.

SPORE PRINTS

One feature that mycologists use to identify many mushrooms and toadstools is the colour of their spores. Traditionally, the best way to see this is to make a spore print. Cut the stipe (stem) from the cap with a sharp knife, and lay the specimen face-down onto a piece of black or white paper. If the spores are white or brown, these will show up against black card; white spores obviously need black card to show up. Cover the specimen with a bowl or large cup, and leave undisturbed for 24 hours or so. Then gently lift off the specimen, and there should be a print formed by the spores, showing the pattern of the gills on the card. These in themselves make interesting subjects for photography.

ABOVE Spore print of cultivated mushroom (*Agaricus* sp.). I removed the stipe from a fresh specimen of a cultivated mushroom, laid it face down onto a sheet of white card, and covered it with a bowl. After around 12 hours I carefully lifted the specimen to reveal a spore print consisting of brownish spores. I laid the print on the floor by the patio window, and used the diffuse daylight from a heavily overcast sky to photograph it.

105mm macro lens, 1/25 sec at f/11 with +1 stop exposure compensation

More interesting pictorially, though not giving so much information about the gills, is to mount the specimen with its stipe onto a piece of card. You will probably need a long pin (50mm) up into the stipe, then down through the card into a foam or polystyrene block. Cover the specimen with a large bowl or box, as airtight as possible, and again leave undisturbed for 24 hours or so in a draught-free room. Spores will be dispersed from the cap of the specimen, often in a very beautiful pattern.

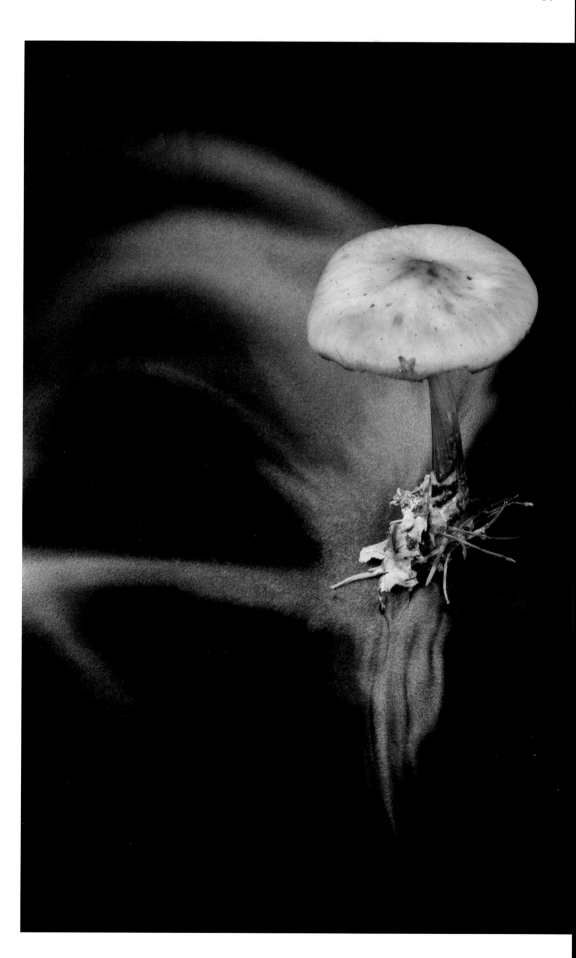

RIGHT This Butter Cap toadstool (*Collybia butyracea*) was collected and brought indoors where it was placed on a black velveteen material, and covered with a reasonably well-fitting glass bowl. I left it overnight, when spores were distributed from the toadstool in a swirling pattern. I then shot the whole scene the following morning using the diffuse light coming through my studio window.

55mm macro lens, 1/60 sec at f/22

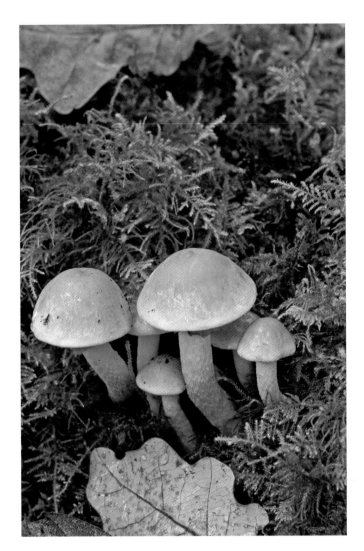

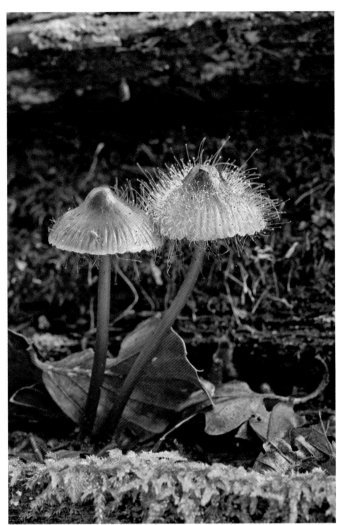

ABOVE Sulphur Tuft fungus (*Hypholoma fasciculare*) growing among moss at the base of an oak tree. I added the oak leaf at the bottom of the image to provide both a natural scale and frame to the image. I held a small white reflector underneath the specimen to lighten the underside slightly.

105mm macro lens, 1/6 sec at f/11

ABOVE RIGHT Bonnet Mould fungus (*Spinellus fusiger*) growing parasitically on Saffrondrop Bonnet (*Mycena crocata*). Although I have often seen this species in woodland, this particular specimen was almost perfect, and growing in a great position in superb light.

105mm macro lens, 1 sec at f/11

RIGHT Fungi come in many forms and colours. Here, a Purple Jelly Disc fungus (*Ascocoryne sarcoides*) was found growing on a fallen log in autumn.

105mm macro lens, 1/2 sec at f/11

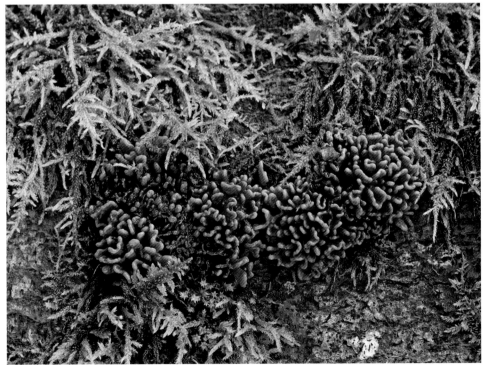

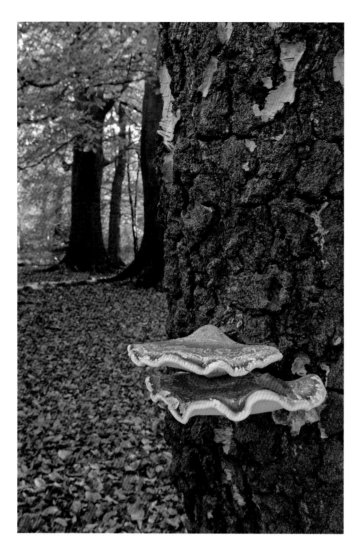

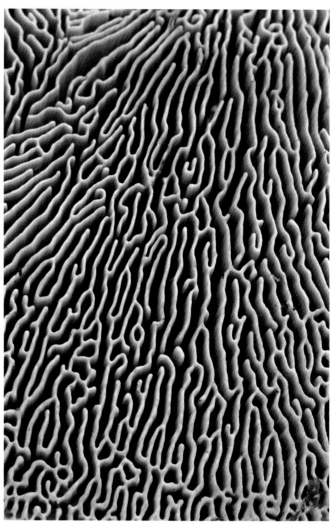

ABOVE Birch Bracket fungus (*Piptoporus betulinus*) growing on the trunk of a birch tree in a mixed woodland. A wide-angle lens was used to show the position of the fungus. This particular species was once used by barbers to sharpen their razors, giving it the alternative name of the Razor Strop fungus.

17–55mm lens at 35mm, 1/2 sec at f/11

LEFT Signs like this one, in Richmond Park, Surrey, are now common in places like the New Forest, Epping Forest and the Royal Parks in southern England. I find it useful to shoot images of them to add variety to talks that I give about plants and their conservation.

17–55mm lens at 35mm, 1/100 sec at f/8

ABOVE The undersides of many fungi are just as interesting as the tops. I found this specimen of the aptly named Oak Mazegill fungus (*Daedalea quercina*) lying on the ground where it had been knocked from its wood substrate. The actual specimen was around 5cm in length, so I used my macro lens to get a close-up view of the gills.

105mm macro lens, 1/2 sec at f/16

RIGHT This spectacular fungus, the Golden Scalycap (*Pholiota aurivella*), was growing about 3 metres high on a damaged section of an ancient Beech tree in a wood in Sussex. I needed a telephoto lens mounted at the top of my fully extended tripod to obtain a sharp image. I used the 'mirror lock up' technique, together with a remote release, to ensure a sharp image.

70–200mm lens at 200mm, 1.6 sec at f/11

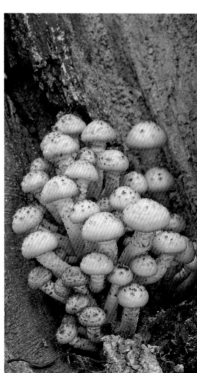

Gardens

Working in gardens, either your own, those belonging to other people, or larger formal botanic gardens, has many advantages for the plant photographer. First, gardeners strive to grow perfect specimens, in a good position to show them to their best advantage. Second, it may prove much easier to find and photograph a particular plant in a botanic garden than in the wild. If you are building up a collection of images of alpine flowers, for example, there may be one or two species that you have not been able to find in the wild, or you have been in the right location but at the wrong time, and which you might find in the alpine house of a botanic garden. If you are lucky enough to live near to a good botanic garden you can make repeat visits to photograph plants in their peak condition, or at different times of the year.

BELOW This stunning scene, of a mature Japanese Flowering Cherry (*Prunus shirotae*) with an understorey of Grape Hyacinth (*Muscari armeniacum*), in an English botanic garden in spring, lasts for just a few days, and I made several trips to catch the scene at its best. This particular day was very still, allowing me to use a small aperture to get sufficient depth of field to cover virtually the whole scene.

17–55mm lens at 30mm, 1/6 sec at f/22

ABOVE When photographing a plant in a botanic garden I always make a point of photographing the label, to ensure correct identification when I get home.

105mm macro lens, 1/30 sec at f/5.6

If you are visiting a botanic garden, do check to see if they allow the use of tripods. Some will only allow tripods in the grounds, but not the glasshouses, whilst others may charge for their use. Most gardens charge a fee if the images are to be used for commercial purposes. Never stand or put a tripod on a flower bed without permission. There may be seedlings about to appear just underneath the surface.

In botanic gardens, many of the plants will be labelled, ensuring (most of the time!) correct identification of your subjects. I always make a point of photographing the label, when I have photographed a plant in a garden. Plant labels in floral borders are more of a problem, though, and may become intrusive in pictures. Never move a plant label without asking permission.

I often grow plants in my own garden for the express purpose of photographing them. Sometimes I will grow them in pots, which I can then move around the garden to get the best background or light. Others, such as Snowdrops and Snakeshead Fritillaries, are grown in the lawn. I have a small pond, where again I can grow aquatic and marginal plants. Having a range of plants in your own garden means that you can monitor them carefully, to photograph them when they are at their peak, or when a perfect lighting situation appears.

I often use gardens as a test bed for trying out new equipment or techniques.

LEFT I always seek out old textured walls or rockeries to see if they have interesting plants growing in them. This clump of the Bellflower (*Campanula garganica*) was growing on an old lichen-covered wall surrounding an alpine house in a botanic garden.

18–200mm lens at 60mm, 1/40 sec at f/11

BELOW LEFT This astilbe (*Astilbe* x *arendsii* 'Venus') was growing alongside some steps leading through a rockery. I deliberately left a small portion of the step to provide a contrast with the foliage.

17–55mm lens at 44mm, 1/60 sec at f/11

BELOW I visited this particular garden in early spring specifically to photograph camellias, but a heavy overnight frost had damaged many of the flowers of this particular specimen (*Camellia* x *williamsii* 'Mary Christian') and they had fallen to the ground, where I thought they made a superb, subtly coloured image. I used my tripod to position the camera directly overhead, and shot the scene in dull, overcast conditions.

105mm macro lens, 1/6 sec at f/11

RIGHT An autumn visit to an arboretum is always worthwhile, particularly if the maple trees have turned red. For this image I shot the cones of a Japanese Larch (*Larix kaempferi*) against the out-of-focus background of Japanese maple trees. I used a relatively wide aperture to keep the background well out of focus. The water drops are dew from the previous night. I used a silver reflector held at the bottom left of the frame to lighten the underside of the cones.

105mm macro lens, 1/15 sec at f/5.6

BELOW This stunning display of astilbes was growing in a boggy part of a rock garden next to a small waterfall. Using a relatively long shutter speed has blurred the water nicely, but because of a constant breeze several exposures were required to ensure the plants were sharp.

17–55mm lens at 34mm, 1/8 sec at f/11, with polarising filter

BELOW RIGHT Another feature of autumn are dogwoods such as this *Cornus sanguinea* 'Midwinter fire', which really glows when the sun hits it. I found a clump with a dark background to show up the red twigs.

70–200mm lens, with 1.4x converter (effective focal length 280mm), 1/320 sec at f/5.6

RIGHT This magnificent flower border containing agapanthus and helenium is actually a focus stack from three images, one focused on the foreground, another on the mid-ground and another on the background. I couldn't stop the aperture down beyond f/8 as there was a stiff breeze blowing at the time.

17–55mm lens at 45mm,
1/50 sec at f/8

Working in glasshouses

Glasshouses in botanic gardens offer a great opportunity to photograph plants from all parts of the world. In larger gardens such as Kew, Wisley or the Eden Project in the UK, they are often zoned according to the climate region they are trying to simulate – desert, tropical, moist and dry temperate for example.

It is worth checking before your visit to see if a permit is required to use a tripod. Even if you do have a permit, do take great care when positioning the tripod so that you do not cause an obstruction, and don't place tripod feet on planted areas. Although you are generally immune to the effects of weather in a glasshouse, there is often a gentle but constant breeze, either by the door, or from air blowers which are often used to circulate the air in alpine houses, so it is worth checking to see if your subject is moving or not.

CONDENSATION

If your camera is cold when you enter a warm glasshouse, condensation will quickly form on the relatively cold metal and glass surfaces. Do not try to wipe it off, particularly from the lens as it will cause smearing. Instead you need to wait for the camera to warm up when the condensation will gradually disappear. You will need to be patient – I have known this to take up to 30 minutes. Although this is frustrating, you can use the time to scout out suitable specimens for photography. If you know this is likely to happen you can put your camera under the car heater on the way to the glasshouse to keep it warm, or I have even put a warm hot water bottle in my camera bag on the way to the garden.

Probably a medium focal length lens such as a 100mm macro will be of most use, though I often use a 70–200mm to reach plants at the back of planted borders.

If the window glass is clear, then the light will vary with the weather outside, but with those glasshouses with whitewashed glass or translucent blinds over the glass you will often find the light bright but diffuse. In some dense tropical houses the light may be very dim, and long exposures or flash will be needed to achieve good results.

One annoying problem that you will probably find when working in a glasshouse, and which you can do very little about, are the circular white drying marks which appear on foliage after they have been watered.

LEFT This superb display of alpines is changed frequently as flowers bloom and die, so is always worth a visit when I visit this particular garden. The main problems from a photographic point of view are the labels, pot rims and a constant breeze from the door and air blower in the corner.

17–55mm lens at 30mm,
1/50 sec at f/11

RIGHT This exotic Parrot's Flower (*Heliconia psittacorum*) was in the tropical section of a large glasshouse. I had to darken the rear leaf using the shadows/highlights control in Adobe Photoshop™.

105mm macro lens, 1/30 sec at f/6.3

ABOVE **Leaf of the Common Taro or Elephant's Ear** (*Colocasia esculenta*). Glasshouses often have specimen plants with large leaves. They can look wonderful when backlit. In this case I managed to get underneath this one with my camera and tripod, taking care to get the camera parallel to the surface of the leaf to get maximum depth of field. I had to wait for several minutes for the leaf to settle down, particularly with the relatively long shutter speed.

18–200mm lens at 150mm,
1/45 sec at f/5.6

ABOVE RIGHT **Passion flowers** such as this one (*Passiflora* x *violacea*) make wonderful photographic subjects. In this case I deliberately wanted to show the leaves and buds as well as the main flower.

105mm macro lens,
1/6 sec at f/11

RIGHT **Cacti and succulents** make great subjects for photography, with their huge range of shapes and forms. I shot this African Milk Tree (*Euphorbia trigona f. rubra*) with a long lens to fill the frame with the bizarre shapes.

70–200mm lens at 190mm,
1/13 sec at f/8

ABOVE This Urn Plant (*Aechmea fasciata*) was growing in a very sunny position on the floor of a glasshouse. I used a white reflector to lighten the shadows on the left-hand side.

105mm macro lens,
1/250 sec at f/8

RIGHT This superb arum (*Amorphophallus konjac*) was growing in a pot on the floor of a glasshouse in a botanic garden. There was just one specific position where I could get a reasonable background without showing the metal supports of the glasshouse, or the rim of the pot in the image. Fortunately the light was near perfect.

17–55mm lens at 45mm,
1/80 sec at f/6.3

Producing composites

Composite images are a useful way of showing a number of different aspects of your subject in one image. We have already partially covered this in the technical illustration section, but here we will look at more creative applications, perhaps for exhibition display. Shown here are a couple of examples of composites of 12 images arranged in a formal grid pattern. Obviously you can choose the number of images, and whether they are all the same size or not. You can also add text if you want.

Although Adobe Photoshop™ can display a grid (view › show grid) I prefer to make one in Adobe Illustrator™, and save it as a template, into which I can drop the images.

RIGHT **A template produced in Adobe Illustrator™, with space for 12 images. Programs like Illustrator™ make it very easy to produce templates like this, with the ability to change image size and shape, and the option of different background colours. It is also possible to produce a grid like this in Adobe Photoshop™, though not as easily.**

BELOW **A finished composite with close-ups of fungi.**

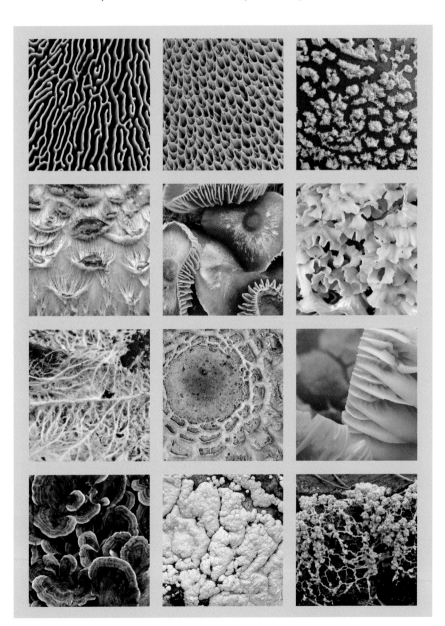

I generally make up a grid in Illustrator™, choosing the overall size, number of cells, and a colour for the background (I usually prefer grey or white). In the two examples shown here, they were produced to A3 format (42 x 29.7cm at a resolution of 300 ppi), so that I could make an A3 print, or smaller versions. Each cell is 8.57 x 9.05cm.

I then prepare my selection of 12 images, by resizing them to 8.57 x 9.05cm, at a resolution of 300 ppi. This can be done quickly using the crop tool in Photoshop™, where you can type in the dimensions required, and the resolution. Make sure you save the new resized version with a different name otherwise you will overwrite the original file.

Tip: To speed up the resizing of multiple images you can set up an 'action' in Photoshop™, where you record the various steps in a process, then replay it over the remaining images.

FAR LEFT Image of a Beech leaf about to be cropped, with the required dimensions in the crop box options at the top.

LEFT The crop tool can be repositioned. The area outside is greyed out to help you crop the required area.

BELOW Final composite of autumn leaves, all of which were produced by scanning them in a flatbed scanner.

Having resized and saved the 12 images, you can now start to place them into the grid. Open an image, and in the select menu click on 'select all'. This will put an animated line around the whole image. Click on 'copy' (edit › copy). This will put a copy of the selection into the computer's memory. Next, open the grid, and, using the magic wand tool, select the first cell by clicking with the tool inside it. You should have an animated line outlining the cell. You now need to paste the image into the selected cell, by using (edit › paste special › paste into). The image should appear perfectly in the cell. You can repeat the operation with the remaining images to fill the grid.

Producing composite images like this is great fun, and, because each image is pasted into the cell it becomes a layer, which can then be edited, moved or replaced at a later date if you change your mind, or get better images to include.

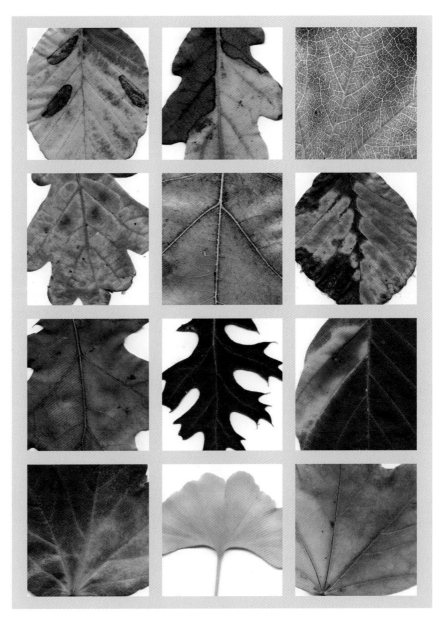

Other flowerless plants

Flowerless plants such as mosses, lichens, liverworts, ferns and seaweeds are, in my opinion, greatly neglected by photographers, but can make fascinating and often beautiful subjects, albeit rather challenging ones on occasion. I suspect that the fact that many are difficult to identify, and do not have common names, may be a deterrent for many people.

By their very nature these subjects tend to be small, although, some, such as the *Polytrichum* moss shown here, can be the dominant plant in an area. Similarly, seaweeds will be the dominant plant on a rocky shoreline, often growing in distinct zones. Ferns too can make great subjects, though it can be difficult to isolate a single specimen. Many species are very specific in terms of their habitat, and wide-angle shots of them with their location are very useful.

LEFT This large area of boggy ground near Snowdon in North Wales was dominated by hummocks of the *Polytrichum* moss (*Polytrichum commune*). I came across it on an early morning walk on a dull dreary day in October. A small aperture was needed to give sufficient depth of field, necessitating a long exposure.

18–200mm lens at 26mm, 1/4 sec at f/16

ABOVE This particular churchyard in south Devon, England, has a superb range of lichens growing on the tombstones, which have been extensively studied over the years by students from the local field studies' centre. Here I used a wide-angle lens to show a typical tombstone with the church in the background.

17–55mm lens at 17mm, 1/80 sec at f/10 with polarising filter

LEFT AND ABOVE Rocky seashores are good places to search for lichens, where there is a good range of species specific to this habitat. I firstly shot the whole scene in south Devon, England, with a wide-angle lens, trying to show the distribution of lichens on the shore. I then shot a close-up of two of the species, *Xanthoria parietina* and Sea Ivory (*Ramalina siliquosa*). Despite a strong breeze, with the camera on a sturdy tripod I was able to stop the lens down to f/16 to get sufficient depth of field to render the whole image sharp.

First image: 10–20mm lens at 15mm, 1/125 sec at f/8 with polarising filter; second image: 105mm macro lens, 1/60 sec at f/16

BELOW While most lichens are small and often inconspicuous, Lungwort (*Lobaria pulmonaria*) is a spectacular species growing only on ancient trees, only in areas of clean air. Indeed it is used by ecologists as an indicator of pollution-free environments. I had searched for it for several years before finding it on a dull February day on several ancient trees in northern Scotland. I used an 18–200mm lens at 18mm to show the lichen in its habitat on an oak tree near a stream, then at 120mm for the close-up, showing the red fruiting structures.

First image: 18–200mm lens at 18mm, 1/15 sec at f/11, fill flash; second image: same lens at 120mm, 1/3 sec at f/11

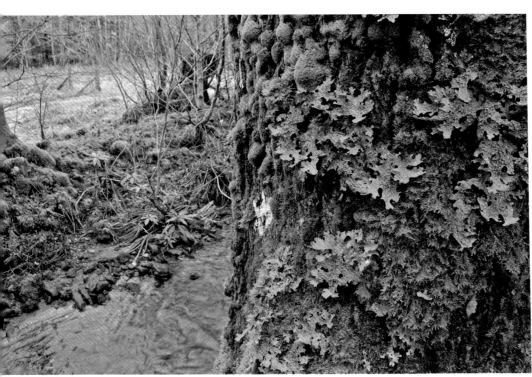

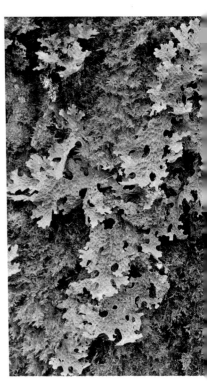

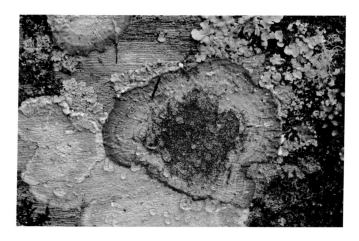

ABOVE This Christmas (or Blood) Lichen (*Cryptothecia rubrocincta*) was growing low down on the wooden planking of the boardwalk in the Corkscrew Swamp Sanctuary in Florida. I needed to get the camera near to ground level so that I could get the plane of the sensor parallel to the lichen. I used a right-angle finder to save me from lying flat on the ground.

105mm macro lens, 1/40 sec at f/8

BELOW I found these liverworts (*Lunularia* sp.) growing in a very damp spot in an undercliff in a Devon woodland. I had to be very careful not to get water drops on the front surface of the lens. I used a silver reflector at the bottom left to lighten the specimen.

10–20mm lens at 16mm, 2 sec at f/11

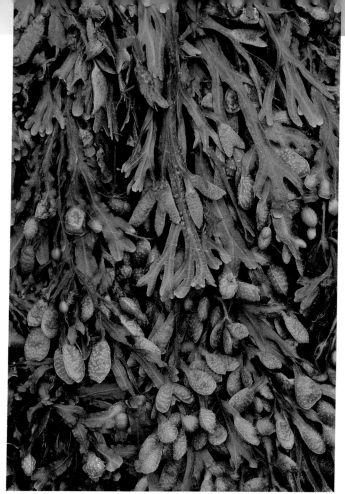

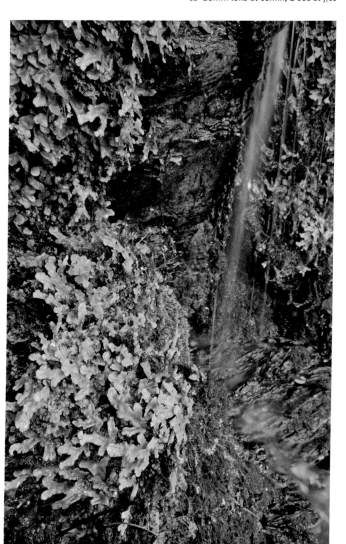

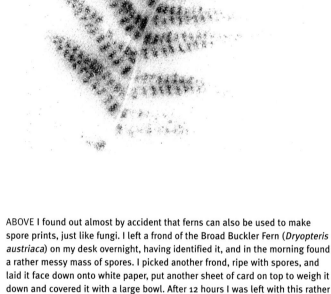

ABOVE LEFT **Seaweed** such as this Bladder Wrack may at first glance be rather dull and uninspiring, but even within one small area there can be a good range of tone and colour to record. By arranging for the camera to be parallel to the main plane of the plant I was able to get most of the plant in focus.

105mm macro lens, 1/80 sec at f/11

ABOVE **Channelled Wrack** (*Pelvetia canaliculata*) can be identified by the distinct grooves or channels on the rear of the stems. I flipped one over to show this feature in a simple close-up image.

105mm macro lens, 1/80 sec at f/20 with polarising filter to reduce reflection from the shiny surface

ABOVE I found out almost by accident that ferns can also be used to make spore prints, just like fungi. I left a frond of the **Broad Buckler Fern** (*Dryopteris austriaca*) on my desk overnight, having identified it, and in the morning found a rather messy mass of spores. I picked another frond, ripe with spores, and laid it face down onto white paper, put another sheet of card on top to weigh it down and covered it with a large bowl. After 12 hours I was left with this rather imperfect but recognisable spore print.

LEFT **The Royal Fern** (*Osmundia regalis*) is found in wet, boggy areas, and grows to a substantial height. For this image I chose to go in close, to isolate some of the leaves (technically known as pinnules).

105mm macro lens with 1.4x converter, 1/100 sec at f/8

RIGHT This unfurling frond of the **Australian Tree Fern** (*Cyathea cooperi*) in the glasshouse of a botanic garden reminded me of a fossil ammonite, and illustrates how some shapes such as spirals are found throughout the natural world.

105mm macro lens with 1.4x converter, 1/10 sec at f/5.6

LEFT Perhaps the best known of all alien species in the UK is Common Rhododendron, which has become a major pest in many parts of the UK, in particular the Snowdonia region of North Wales, where entire hillsides are carpeted with it. For the first shot I wanted to take it in a typical position in Snowdonia, with a mountainous backdrop.

17–55mm at 30mm,
1/320 sec at f/8

BELOW For the second shot I wanted to show that even in an isolated peak bog on the west coast of Ireland, Common Rhododendron is starting to invade, and is becoming an increasing problem.

18–200mm lens at 34mm,
1/30 sec at f/9

Case study: Aliens

Over the last few years I have become increasingly interested in alien species – non-native plants that have become established in the countryside, and which very often become rampant due to the lack of natural predators. There is often some debate as to what actually constitutes an alien, non-native species, but there are some obvious examples. As photographers I feel we almost have a duty to document their effect on the countryside, to help ecologists in their fight against these species. Illustrating the spread of a species in a specific area over a period can be very useful as a research tool. I have for several years now photographed a pond in southern England at the same time each year, which has been overrun by Parrot Feather.

Typical examples of alien species in the UK countryside are Japanese Knotweed, Common Rhododendron (*Rhododendron ponticum*), Giant Rhubarb and New Zealand Swampweed (*Crassula helmsii*). Obviously, photographing them required the same techniques as with any other species, but I do, as far as possible, try to show the effect that they are having on the environment.

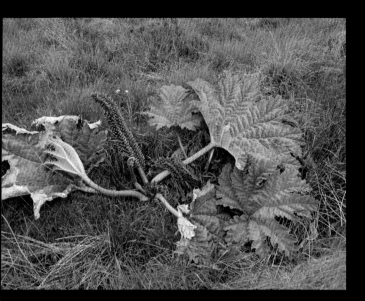

ABOVE This shot shows a Giant Rhubarb plant suffering from the effects of herbicide applied by local farmers.

18–200mm lens at 22mm, 1/40 sec at f/9

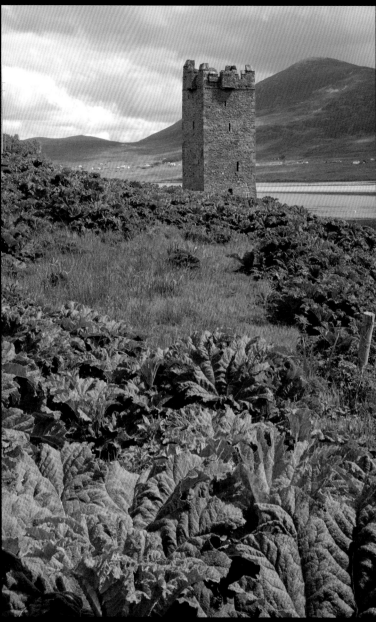

ABOVE Parts of the west coast of Ireland have become home to another troublesome alien, the Giant Rhubarb, with its huge prickly leaves that will eventually swamp out any other vegetation. In the shot it is seen carpeting the ground around an old fortification on Achill Island, in County Mayo, Ireland.

18–20mm at 32mm, 1/30 sec at f/16

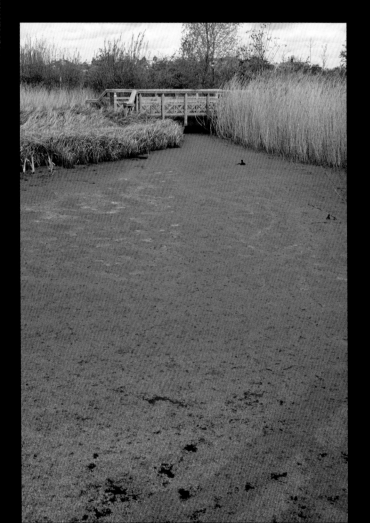

LEFT Azolla (*Azolla filiculoides*) is a water fern from the USA, often sold in garden centres as an ornamental plant. It has become established in the wider countryside, often carpeting lengths of waterway, as with this scene at a nature reserve in southern England. This is an old shot, from 2005. Since then, the managers of the reserve have been able largely to eradicate it.

18–50mm lens, 1/250 sec at f/8

Patterns, textures and colour

Plants make wonderful subjects when used for photographing patterns, shapes, texture or colour. Patterns such as circles and spirals abound in the natural world. Circular flowers tend to be radially symmetrical, for example, water lilies or roses, whilst leaves often grow in circular rosettes. Circular shapes tend to work best when photographed directly overhead.

Spiral shapes are to be found everywhere, too, in tendrils, young fern croziers and the arrangement of florets and seeds in a sunflower for example. Here, the pattern follows a specific mathematical sequence, the Fibonacci series.

Generally, for best results with patterns, fill the frame with the subject so that there are no distracting elements.

TEXTURE

To emphasise texture on subjects such as tree bark, a low-angled glancing light may be most appropriate, whereas for pattern a softer light may work best.

COLOUR

The whole spectrum of colour exists in the plant kingdom, from the gaudiest orange and red flowers to the subtlest shades of green and purple. Gardeners will often produce borders picking out specific colours, purples or whites for example.

When photographing plants specifically for their colour it is worth considering whether the colours within an image complement or harmonise with each other or contrast, producing an image which jars and is difficult to look at.

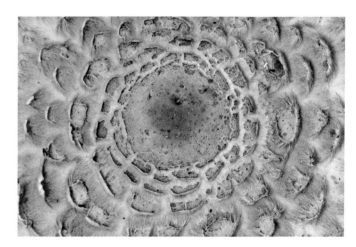

LEFT I found this superb flowering cactus (*Mammillaria varieaculeata*) in a botanic garden glasshouse. I positioned the camera directly overhead to achieve maximum depth of field.

105mm lens with 1.4x converter, 1/250 sec at f/8

ABOVE I nearly did not take a photograph of this Parasol Mushroom (*Macrolepiota procera*) as it was rather tatty, and growing in a very unattractive place. The cap, however, was in good condition.

105mm macro lens, 1/6 sec at f/11

ABOVE I found this boletus (*Boletus* sp.) toadstool lying on the ground, having been kicked over by a horse. The underside was perfect, and made a great pattern image. I placed it on a log, propped it up with a twig, and used my 105mm macro lens at a magnification of 1:4 (a quarter life size) with a small aperture to give maximum depth of field across the frame. The light was very dull.

105mm macro lens, 1/4 sec at f/16

ABOVE This lichen (*Ochrolechia* sp.) was growing on the side of a tombstone in a graveyard. I aligned the camera parallel to it and cropped in tight to show the texture.

105mm macro lens, 1/200 sec at f/11

BELOW As one of the leaves of my ancient aspidistra (*Aspidistra* sp.) house plant started to die off it produced a superb array of yellow, brown and orange colours. I removed it from the plant, taped it to a north-facing window, and aligned the camera so that it was parallel with the leaf.

60mm macro lens, 1/30 sec at f/8

ABOVE I found this extraordinary pattern on the stem of this Pheasant's Tail (*Anthurium schlechtendalii*) on a very dull day in a botanic garden glasshouse.

105mm macro lens, 1/125 sec at f/5.6

RIGHT This sunflower (*Helianthus* sp.) looks stunning in close-up, with its spiral pattern of florets. I chose the viewpoint deliberately to include a green background.

105mm lens with 1.4x converter, 1/100 sec at f/8

ABOVE A group of these red-hot pokers (*Kniphofia* sp.) were growing in a mixed border in a botanic garden, primarily planted with reds and blues. I liked the way the bands of colour in the background matched the banding on the flower.

70–200mm lens with 1.4x converter, effectively 300mm, 1/320 sec at f/5.6

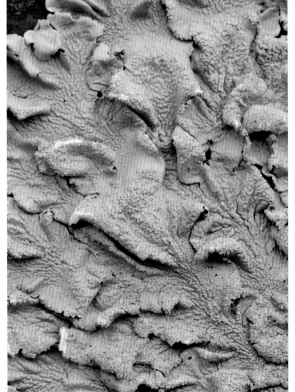

ABOVE LEFT These heleniums (*Helenium* sp.) 'Sahin's Early Flowerer' looked stunning in mid-August. I photographed them on a very dull, overcast day with a wide-angle lens, producing an image of strong contrasting colours. I was careful to fill the frame with them.

10–20mm lens at 18mm,
1/60 sec at f/11

ABOVE By contrast, this image of *Agastache* 'Blue Fortune' is much more subtle, with two main complementary colours.

17–55mm lens at 55mm,
1/25 sec at f/8

LEFT The surface of this lichen (*Parmelia* sp.) looked wonderful in close-up. A soft top light from a hazy sun accentuated the texture without dark shadows. Magnification was nearly life size in the camera.

105mm macro lens,
1/200 sec at f/11

Plants and insects

The majority of flowers are pollinated by insects, and many others by mammals, such as bats, or birds, such as hummingbirds. Many fungal spores, such as those from stinkhorns, are distributed by insects, whilst others can only germinate if they pass through the intestines of mammals. Many plants, such as arums for example, have elaborate mechanisms for attracting insects to them. Photographing these relationships can be a rewarding, if sometimes tricky project.

Gardeners will be all too aware of the impact of insects and other invertebrates in the garden. Hostas decimated by slugs, lilies devoured by Lily Beetles (*Lilioceris lilii*), or mullein (*Verbascum* spp.) leaves swarming with Mullein Moth caterpillars (*Cucullia verbasci*) can all make interesting subjects for the camera.

Unlike most plant photography, where you can set up a tripod and reflectors if necessary, most insect photography requires that you are able to move quickly, particularly to capture those pollinating flowers.

If your aim is to show the plant and its pollinator, then you do need to get in very close, as you need to show enough of the flower for it to be recognisable.

A macro lens of 100mm or longer will be most useful – maybe up to 200mm. My own favourite combination is my 105mm Nikon macro lens with a 1.4x or sometimes 1.7x converter.

Flash may be useful here, and many insect photographers use special rigs to hold one or two flash units.

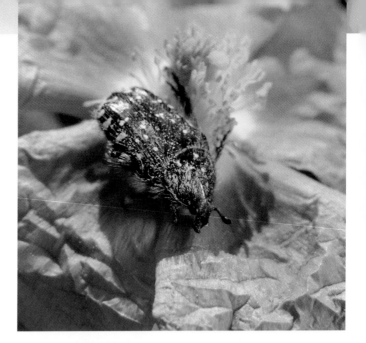

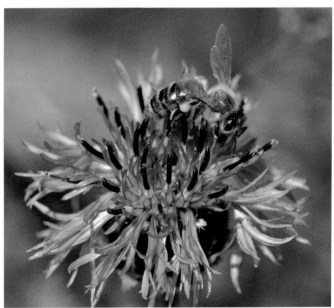

TOP On a trip to Mallorca in spring I found hundreds of White-spotted Rose Beetles on Grey-Leaved Cistus flowers. They were all covered in yellow pollen.

105mm macro lens, 1/320 sec at f/11

ABOVE Honey Bee (*Apis mellifera*) collecting pollen from a Greater Knapweed (*Centaurea scabiosa*) flower. Rather than chasing insects around it is often worth staying by one particular flower to see if insects visit it. In 20 minutes this flower was visited by around 12 bees and other insects. Note the pollen basket on the leg of the bee.

105mm macro lens with 1.4x converter, 1/320 sec at f/8

LEFT Himalayan Balsam with approaching Honey Bee. I spent many hours photographing a clump of this highly invasive plant, and all the insects that visited it. I used the Nikon twin macro flash system described in chapter one, balanced with daylight.

105mm macro lens, 1/60 sec at f/11, twin macro flash

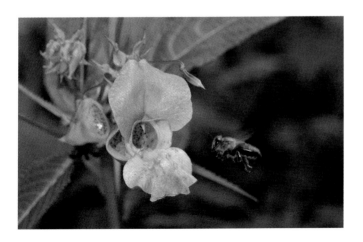

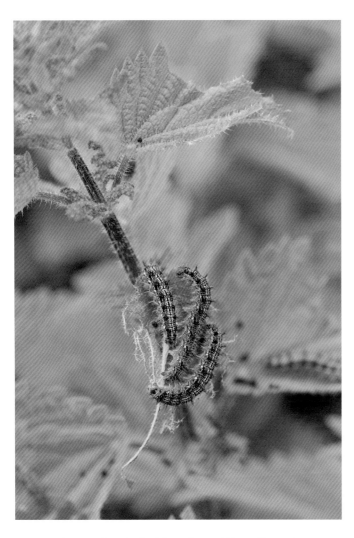

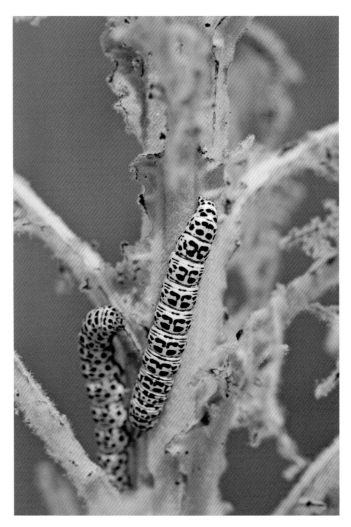

ABOVE Nettles are a favourite foodplant of vanessid butterflies, such as Peacocks (*Inachis io*), Red Admirals *(Vanessa atalanta)* and Small Tortoiseshells (*Aglais urticae*). Here, a group of Small Tortoiseshell larvae are feeding on Stinging Nettles (*Urtica dioica*) on a clifftop by the sea.

105mm macro lens, 1/160 sec at f/5.6

ABOVE Caterpillars of the Mullein Moth can devour entire mullein plants if left unchecked. Here, a helpful gardener in a botanic garden left these specimens for me to photograph during a workshop before getting rid of them.

105mm macro lens, 1/1,250 sec at f/5.6

LEFT Insect damage to a leaf in the tropical glasshouse of a large botanic garden.

105mm macro lens, 1/160 sec at f/8

RIGHT The Buddleia or Butterfly Bush (*Buddleja davidii*) is widely grown in gardens to attract butterflies, but is also found on wasteland in cities where it has colonised readily. Here, a Peacock butterfly is seen on a plant growing on an abandoned airfield in southern England; the background is the tarmac.

105mm macro lens with 1.4x converter, 1/250 sec at f/8

Plants and people

The relationship between plants and people goes back to the dawn of civilisation, when the cultivation of grasses for food started. Since then a huge variety of plant species have been used at some time for food, beverages, medicine, clothing, building and countless other uses. It can make a fascinating long-term photographic project to document some of these uses. Many botanic gardens have excellent displays of plants and their uses, for example, the Eden Project in Cornwall and the Chelsea Physic Garden in London.

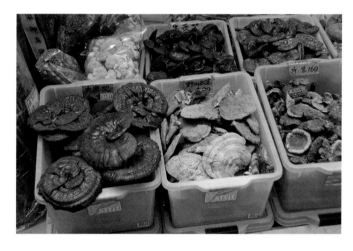

ABOVE Cultivated fungi, mainly brackets, for sale in a Hong Kong street market. This is the only shot in the book which was handheld, with my 'travel lens', an 18–200mm zoom.

18–200mm zoom lens, 1/40 sec at f/5, with vibration reduction activated

ABOVE The Madagascar Periwinkle is a common, easy-to-grow house plant, but is very valuable for its medicinal properties, containing several chemicals not found in any other plant. It is used in the treatment of various cancers, and is grown commercially throughout the southern hemisphere. Here it is growing in the tropical section of a botanic garden glasshouse.

105mm macro lens, 1/80 sec at f/8

LEFT Rice (*Oryza* sp.) is, of course, one of the most important cereal crops in the world, and is often grown in less industrially developed countries than other cereals. Images of rice being grown in paddyfields are common, but I wanted to show a close-up of the small wind-pollinated flowers. This was shot in a rather dark area of a glasshouse where there was a constant breeze. I needed to shoot a dozen or so images to make sure I got one sharp.

105mm macro lens with 1.4x converter, 1/40 sec at f/8

ABOVE AND BELOW LEFT
Aloe vera has been used for thousands of years, both medicinally and as a cosmetic. I took our house plant onto the patio on a dull overcast day, and photographed a leaf to show the spines along the edge, using the lawn as an out-of-focus background. Then to show the yellow sap which exudes from a cut leaf, I carefully removed one from the plant and cut it diagonally with a scalpel. I held it vertically in a clamp stand on a table, and waited for the sap to drip out.

Leaf: 105mm macro lens, 1/60 sec at f/11, sap: 105mm macro lens, 1/60 sec at f/5.6

ABOVE The Castor Oil Plant (*Ricinis communis*) is a poisonous but valuable crop for its medicinal and lubrication properties. Here it is growing in a mixed border in a botanic garden.

70–200mm lens at 100mm, 1/40 sec at f/11

Telling a story

While a single 'portrait-style' image of a plant can be very informative, it is worth exploring different ways in which more information about a plant can be conveyed pictorially, either within a single image, or in a sequence. You might, for example, want to illustrate the whole life cycle of a plant, from seedling through to maturity and decay in a sequence, or show close-ups of a plant together with images of it growing in its characteristic habitat.

Rather like a film script, sequences can be planned in advance, with an establishing shot, followed by medium and close views, and then other specific shots such as seed dispersal or insect pollinators.

The series of this rare Starfish Fungus (*Aseröe rubra*) was shot over a period of four weeks, and required around 15 visits to the site to get all the images required. This fungus, growing in a woodland in Surrey, UK (just five miles from my home), is originally from New Zealand, and somehow found its way to the woodland in the 1990s. This is still its only site in the whole of the northern hemisphere! It seems to appear later than most other fungi, often into November.

It is one of the 'phalloid' fungi, a group which includes the stinkhorns, which start as an 'egg' growing in the ground, from which emerges the main stem, often expanding rapidly overnight in ideal conditions. Although I would have liked to photograph the same egg maturing, I never managed to be there at the right time. Leaves, pine needles and pine cones were left in the images to provide a natural scale for the specimens. Unfortunately, the habitat shot was not very inspiring pictorially, but still gives a good idea of where the fungus was growing. This is part of an ongoing project to document all aspects of this species.

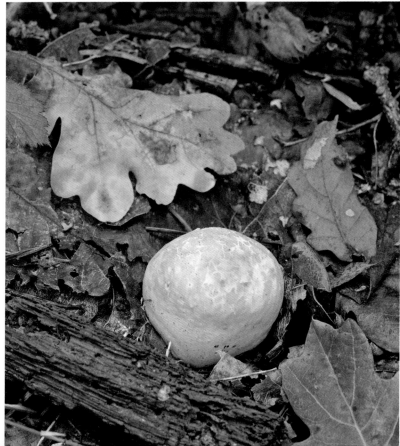

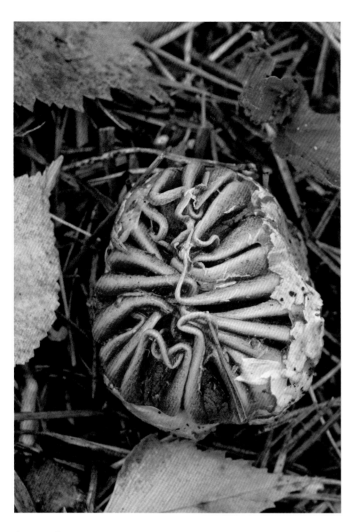

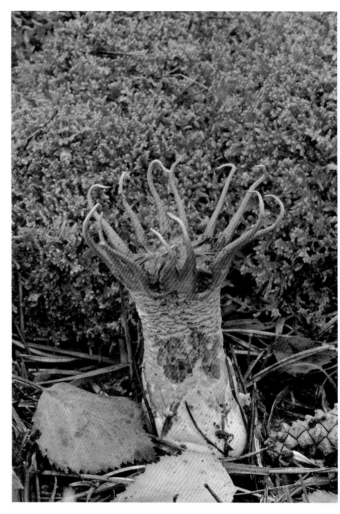

STARFISH FUNGUS SEQUENCE

ABOVE LEFT **Establishing shot** showing typical habitat of the fungus.

17–55mm lens at 17mm,
1/5 sec at f/11

ABOVE **'Egg' starting to open.** Notice the appearance of the red 'tentacles', like a scene from the film *Alien*!

105mm macro lens, 1/6 sec at f/16

ABOVE **Fully open specimen.** The leaves and pine cone were carefully positioned to show the relative size of the specimen.

105mm macro lens, 1/4 sec at f/16

BELOW **A pair growing together.** Most of the specimens found were growing singly.

105mm macro lens, 1/4 sec at f/16

LEFT **'Egg'** from which the fungus emerges overnight, growing on rotting wood. I placed the oak leaves in the frame to give comparative scale.

105mm macro lens, 1/5 sec at f/11

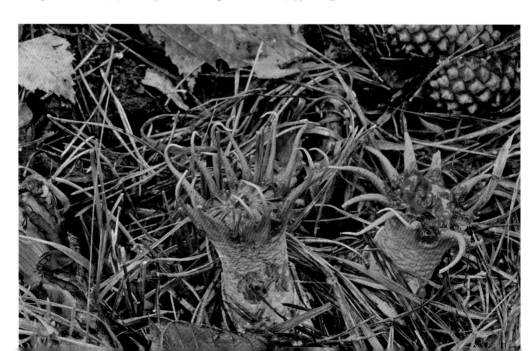

Trees

It might be thought that, because of their size, trees would make relatively easy subjects. However, it can be surprisingly difficult to find good isolated specimens for portraits, and sometimes their flowers are out of reach. But for all the problems, trees make wonderful subjects at all times of year, with new fresh leaves and flowers in spring, autumn colours and bark in winter.

Good places for specimen trees are botanic gardens, or farmers' fields, where trees have often been left alone and ploughed around. Side or back lighting can accentuate their shape.

TREE BARK

Bark makes a wonderful long-term project, and can be taken in winter when little other subject matter is available. For the most effective shots, zoom in on a section and eliminate any sky or background. Make sure the whole area is sharp by using a small aperture. Soft directional lighting helps to accentuate texture.

ROOTS

Exposed tree roots can make interesting images. Many species such as mangroves have aerial roots, whilst others can have their roots exposed if soil is eroded from the base.

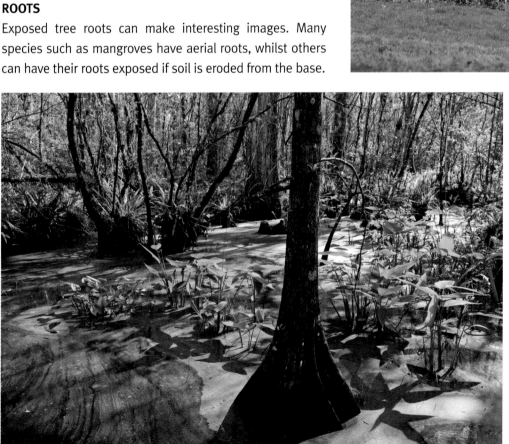

ABOVE This isolated Sycamore tree was growing at the edge of a local farm. I chose it for the oilseed rape in the background. I liked the lines of the hedges, field and skyline which seemed to frame it. I shot it early one morning before the sun was too harsh.

70–200mm lens with 1.4x converter (effectively 420mm), 1/200 sec at f/11

LEFT This Bald Cypress tree was in the Big Cypress Swamp in Florida, and shows a characteristic swamp habitat. The water surface is covered in pollen from the trees.

17–55mm lens at 33mm, 1/50 sec at f/11 with polarising filter

LEFT AND ABOVE Tree bark makes a great subject for photography, as well as being of economic interest. In this case these Cork Oaks (*Quercus suber*) were photographed in Sardinia shortly after being harvested for their cork. The number 8 refers to the year of harvesting – 2008.

First image: 18–200mm lens at 42mm, 1/125 sec at f/11; second image: 18–200mm lens at 82mm, 1/100 sec at f/8

RIGHT London Plane trees (*Platanus hybrida*) are a common feature in many cities of the world, due to their resistance to pollution. In this case I photographed the leaves and fruits of one against the backdrop of the London Marathon in 2012.

18–200mm lens at 44mm, 1/320 sec at f/5.6

ABOVE **A Beech seedling with a mature tree in the background. I wanted to try to illustrate how a small seedling grows into a large tree.**

10–20mm lens at 15mm, 1/30 sec at f/11

RIGHT **With this Beech seedling, I used a different approach to compare the size of the tree and the seedling.**

17–55mm at 25mm, 1/30 sec at f/8

FAR RIGHT **Strangler Fig (*Ficus aurea*) growing on a cypress tree in the Corkscrew Swamp Sanctuary, Florida. The fig starts life as an epiphyte in crevices in trees. The roots of the seedlings grow downward and gradually envelop the host tree while also growing upward to reach the sunlight above the canopy. The original support tree can die, leaving the fig skeleton with a hollow core.**

17–55mm lens at 38mm, 1/10 sec at f/7.1

Using your images

Once you have mastered the techniques of plant photography, you will want to look at how best to use your images. For some people, that will be giving talks, making prints for exhibition, or self-publishing their own books, while for others it will be tempting to try to sell their images, possibly even as a career. This is not easy – there are many people out there with the same idea – but with a lot of hard work and persistence, excellent technique and knowledge, there will always be a demand for the highest quality plant images.

Ways to use photographs

It is highly likely that at some time, if you have a good collection of plant images, you will be asked to give a talk with them. This might be to the local horticultural society, local camera club or Rotary Club for example. The best way of delivering a talk is to project your images via a digital projector using a program such as PowerPoint™ or Keynote™ (Mac). One key word of advice here is to add variety to your talk. Don't just show a series of close-ups of flowers without putting them into some sort of context. I have been to several talks where the presenter has shown a wonderful series of close-ups of flowers, without ever showing a single one in its habitat, for example.

Technically, for projection purposes, the images need to be resized to 72ppi, and then the number of pixels that you want the image to appear on the screen. You can choose to fill the screen with your images, though this is difficult with vertical shots (as many plant images tend to be). I prefer to have a border around the images (I tend to use grey – a coloured border may clash with the colours in your images).

RIGHT There is a good demand for high quality framed prints, either in galleries or craft fairs. The frames shown here are ready-made, and the prints made with archival ink and paper.